ACID	LSD-25, lysergic acid diethylamide.
ACID HEAD	A regular LSD taker.
ACID TEST	A term coined by the Kesey group to label a rock-and-roll dance performed to multiple sound and light effects.
BUM TRIP	A bad LSD experience.
BUSTED	To be arrested.
CAP	Capsule, often used as "a cap of LSD."
CUBEHEAD	A regular LSD user. Sugar cubes are one form of black-market LSD.
DMT	Dimethyltryptamine, a short-acting psychedelic that is injected or smoked.
DROP A CAP	Swallow a capsule of LSD.
FLIP	Go psychotic.
FREAKOUT	A bad LSD experience.
GRASS	Marijuana.
GREAT WHITE LIGHT	Relating to the visual aspects of transcendental experiences during one stage of which conceptual vision may be seen as all-encompassing white light.
GRATEFUL DEAD	A West Coast rock-and-roll group under the entrepreneurial aegis of Owsley Stanley.
GUIDE	A person who "baby-sits" for the psychedelic user during a session.
GURU	A person who acts as one's teacher and guide in matters of fundamental intellectual concern.
"H"	Heroin.
HIGH	A state of euphoria or extreme pleasure which may or may not be induced chemically.
IF IF	The International Federation for Internal Freedom, created in 1962 by the original Harvard Research group for work not affiliated with the University.
KARMA	Fate. The force generated by a person's actions that is held in Hinduism and Buddhism to be the motive power for the round of rebirths and deaths endured by him until he has achieved spiritual liberation and freed himself from the effects of such force.
MANDALA	A graphic mystic symbol of the universe that is typically in the form of a circle enclosing a square and often bearing symmetrically arranged representations of deities. It is used chiefly in Hinduism and Buddhism as an aid to meditation.
MANTRA	A Vedic hymn, prayer, or mystic formula used devotionally in popular Hinduism and Mahayana Buddhism.
MAYA	The powerful force that creates the cosmic illusion that the phenomenal world is real.
MCG	Microgram. A thousandth of a milligram.
MG	Milligram. A thousandth of a gram.
NIRVANA	The state of freedom from Karma, the extinction of desire, passion, illusion, and the empirical self. The attainment of rest, truth, and unchanging being: Salvation-contrasted with samsara.
POT	Marijuana.
PSYCHEDELIC	Mind-manifesting.
SANSARA	Variation of samsara. Hinduism and Buddhism: the indefinitely repeated cycle of birth, misery, and death caused by Karma.
SATORI	A sudden enlightenment and a state of consciousness attained by intuitive illumination representing the spiritual goal of Zen Buddhism.
STONED	Denoting other than normal consciousness, induced by chemicals or the use of alcohol.
TRAVEL AGENT	In the context of psychedelic use, the person who provides the trip.
TRIP	A psychedelic experience.
TURN ON	To alter awareness, with or without chemicals.
VODKA ACID	Vodka that contains LSD, considered by many to be the most readily available preservative for the chemical.

Designed by Howard Schiller,
Designwise Studios

Each font is chosen to represent the
different voice in the conversation.

LSD

RICHARD ALPERT, PH.D., AKA RAM DASS

Love Serve Remember Foundation
Former Director of Castalia Foundation
Former Director of SOLCO

SIDNEY COHEN, M.D.

Former Chief of Psychosomatic Service
Wadsworth Veterans' Administration Hospital
Los Angeles

LAWRENCE SCHILLER

Photojournalist and Author

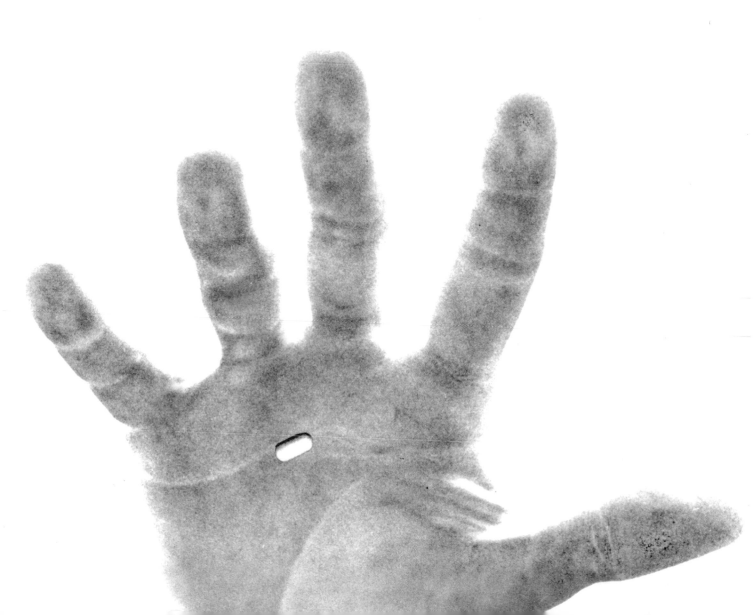

Acknowledgements

The editors of Life,
who gave me the initial assignment
to photograph the LSD story in 1966

To Judi,
and most of all my parents who over the years
have always encouraged me
in my chosen profession.
—LAWRENCE SCHILLER

My lawyers have advised me to say that my
comments are in no way to be construed as
advocating the violation of any state or federal laws.
—RICHARD ALPERT, AKA RAM DASS

In 1966 Dr. Cohen's contract with the publishers stated that
any money accruing to him from the sale of this book is to
be donated to the Los Angeles Medical Research Foundation.
At this time his share of royalties will be held for his estate.

Edited by Carol Sturm Smith

2023 Commemorative Printing

Softcover ISBN: 979-8-9860483-1-4
Hardcover ISBN: 979-8-9860483-2-1
Softcover Library of Congress Control Number: 2022937249
Hardcover Library of Congress Control Number: 2022943333
Published by WS Press, Newtown, PA

Printed in the United States of America

What are the psychedelic drugs?

Is the lsd state reality or illusion?

Can you understand this issue
without having had "the experience?"

Is the freedom to take lsd an inalienable right of man?

Why do some people have horrible lsd experiences?

Can one escape the games of life with lsd?

Why has a link been suggested between
the lsd experience and mysticism?

What are the implications for religion
if a chemical religious experience is a possibility?

What is the relationship between
the lsd experience and creativity?

Who should have lsd?

Who should give lsd?

Who should control lsd?

Why are the State and Federal prohibitive laws
being enacted against the psychedelics?

What is the relationship between
marijuana and the psychedelics?

Why do lsd users like to turn other people on?

What is your estimate of the future of the psychedelics?

Foreword

Jessica Hundley

What pushes our shared evolution on this planet forward? In the past, periods of immense and rapid advancements in civilization—the Renaissance, the Enlightenment—progress was made through the development of the intellect. The advent of the printing press, for example, resulted in the spread of knowledge and literacy. In many ways, our society progresses as our minds and consciousness evolve. During the 20th century and into the 21st, there has been perhaps no greater influence on the evolution of the Western cultural psyche than Swiss chemist Albert Hofmann's synthetization of the ergot fungus into the compound lysergic acid diethylamide, better known as LSD.

Hofmann's intentional ingestion, in 1943, of what he would later call "my problem child," and his subsequent documentation of that experience, would blow open the doors into the inner realm of self and ignite nothing short of a revolution. By the time the young photojournalist Lawrence Schiller pitched his LSD story to *LIFE* magazine in 1965, lysergic acid diethylamide was being used by millions of people in America, which was in the throes of political and social upheaval that feel eerily reminiscent of what our country is now experiencing. There was a stark divide between conservatives and liberals. There were racial inequalities, socio-economic divisions, civil rights demonstrations and protests, and the intentional severing of the frayed umbilical cord that had once connected families and generations. Countless young people were raising a middle finger at "the man" and seeking a new path forward.

Much like in the early 2020s, there was also, simultaneously, a renewed interest in the esoteric, in mysticism, in the deeper exploration of what lies beyond the patriarchal capitalist confines. There was sexual liberation and a redefinition of gender roles. And, for the first time in the history of Western civilization, there was a cheap, easy-to-manufacture, man-made consciousness-expanding drug that could be found pretty much at any nightclub, street corner or college campus. The result was a moment full of both catharsis and controversy, as each side—right and left, hippies and squares—pulled hard at their respective ends of the tug-of-war rope.

It is exactly this moment that, in all its excitement and tension, Schiller captured in his *LIFE* photo essay and subsequent book. The text for the latter came in the form of a debate, a list of questions answered in a he-said/he-said testimony by two of key figures of the era, Richard Alpert and Sidney Cohen, each representing opposite sides of the same coin. Alpert was the infamous psychology professor who, alongside his colleague Timothy Leary, was thrown out of Harvard for conducting controversial LSD research, both on students and on themselves. In 1966, Alpert had already begun his transformation into the reluctant guru and spiritual leader Ram Dass; his own experience with psychedelics led him on a journey to the East and into this new identity. Cohen was a clinical professor at the University of California, Los Angeles, and a respected physician who had for years researched the effects of LSD on patients in government-sanctioned clinical trials. In the late 1960s he would serve as director of the Division of Narcotic Addiction and Drug Abuse of the National Institute of Mental Health.

Schiller approached the two men in early March of 1966 with a list of queries concerning LSD verging on cosmically philosophic, including "What are

the implications for religion if a chemical religious experience is a possibility?" and "Is the freedom to take LSD an inalienable right of man?" Schiller then stepped back and allowed the two to have their say. The unexpected result is perhaps one of the most deeply informative documents on psychedelics ever published. Alpert, with his playful Zen koan meta-mysticism, and Cohen, with his stern and grandfatherly concern, together offer profound insights into a substance which (they both agree) could unlock the vast potential of the human mind. Schiller's series of black-and-white photographs provide the perfect visual accompaniment to the Cohen and Alpert's contest of wills. The images are strangely intimate and calming, the subjects allowing Schiller to join them on their LSD trips without apparent inhibition or self-consciousness. Under the influence of the drug, they seem to drift out of their bodies, or rather, go deeper inside themselves. Schiller captures beatific smiles, gentle weeping, meditations in grassy meadows and long gazes into the void. His fly-on-wall approach conveys an objectivity that is nearly clinical, save for the bone-dry wit of his captioning. This is photojournalism in its truest form—detached, unbiased, exacting—Schiller's shutter clicking only on those moments that feel the truest.

The resulting photo essay, "A Remarkable Mind Drug Suddenly Spells Danger LSD," would be published in *LIFE* magazine March 25, 1966, just weeks after Leary's infamous trial in Laredo, Texas for using his teenage daughter to illegally transport marijuana from Mexico into the States. By then, Schiller had already begun working on the first edition of the book, *LSD*. Published later that spring, the book would be first distributed on newsstands across the country, including sitting innocently alongside issues of *Good Housekeeping* at supermarkets. This celebratory reprint you hold in your hands is based on that original pressing, which, one imagines, must have certainly caught the eye of curious housewives and rebellious teenagers killing time in the small-town checkout line.

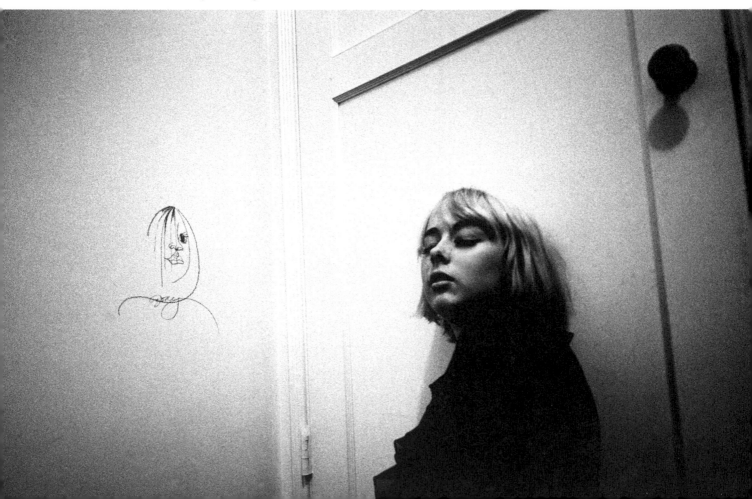

With the book *LSD*, Schiller, Cohen, and Alpert would offer an authentic document of an era and of a moment that feels both resonant and relevant today. After decades of legal battles, sublimation, and secrecy, LSD and other psychedelics and plant medicines are experiencing a resurgence. There has been a strident push for legalization of LSD in the United States and abroad, as well as a growing number of medical research and clinical trials exploring psychedelics and their effects on mental health. Journalists such as Michael Pollan and scholars such as Paul Stamets have advocated for the use of plant medicines and mushrooms for not only the health of our minds, but also the health of the planet.

Today, just as in 1966, a growing dissatisfaction and distrust of the government, of societal norms, of convention, and of "the man" have millions of people searching for a new path forward. And a young generation of seekers, many feeling disassociated from traditional religions and gender identities, are searching for spiritual connections—to spirit, to source, and to themselves. For many, psychedelics may offer a unique opportunity for inner exploration and ultimately transformation. Yet, the controversies remain, and debates continue. Should the doors of perception remain open? Or be closed shut and locked tight? As Alpert, prescient, exclaims, in his conclusion, "We must study and reflect upon these matters in order that our collective wisdom will determine the course of human events—a course which just might lead us to the realization of who we really are. Those who have eyes will see those who have ears will hear!"

Alpert certainly saw and heard. His entire life would be devoted to encouraging the expansion of our shared consciousnesses. In his incarnation as Ram Dass, he would advocate for the use of psychedelics as a path to illumination, love, and compassion. He would turn millions on through his lectures and writings and the establishment of his foundation, Love Serve Remember. Ram Dass's seminal book, *Be Here Now*, first published in 1970, continues to speak to seekers around the globe. With his contribution to *LSD*, he was already developing the core foundation of teachings that would inform all his work to come. In response to Cohen's final statement in the book, "Where do we go from here?" Alpert countered, "'Nowhere is Sidney's prediction of where the psychochemical (r)evolution is taking the 'young people' who are exploring inner space. I prefer to read that word as NowHere, and fervently hope that he is right—that LSD is bringing man back 'to his senses,' to an appreciation of his everyday world as one of miracle and beauty and divine mystery."

– Los Angeles, 2022

Jessica Hundley is a longtime writer, producer and director specializing in music, film, counterculture and psychedelia.

Introduction
Lawrence Schiller

There can come a time, in the field of journalism, when a story becomes more than just a story, when it becomes a part of your life and even takes on a life of its own. It's like seeing what you think is a small puddle of water and discovering, on coming closer and looking in, that the puddle is actually a well that goes far deeper than you could have imagined. You realize that you have to probe further, to find out all you possibly can about it.

This time came for me at 2:45 one morning in 1966 when I arrived at a small apartment near "Capsule Corner." On Fairfax Avenue, just on the boundary between Hollywood and Beverly Hills, California, Capsule Corner is but one block away from a well-known delicatessen called Canter's, where, between two and six a.m., conversations are more about LSD, usually called acid, and marijuana than pastrami and pickles. At that time, four kids sat in this little two-room apartment, all under twenty-one, all acidheads: a student, an insurance trainee, a member of a rock and roll band, and a seller of LSD. They were playing Monopoly. But this was no ordinary game. The money they were tossing around so nonchalantly was the real thing—$35,000 of hard cash. They were all waiting for the distributor. When he eventually arrived, close to 40,000 doses were bought by these four middlemen. At the going West Coast prices in 1966, LSD would have grossed $120,000 all within a few weeks, sold at local universities, high schools, teen-age night clubs, and street corners. That happening, that one moment, was enough to really open my eyes to the issue.

2 A.M. at Canter's Delicatessen in 1966, on the corner of Fairfax and Oakwood in Los Angeles.

At that time, I was in the process of investigating the use of psychedelic drugs, particularly LSD (lysergic acid diethylamide), a derivative of lysergic acid obtained from ergot, a parasitic fungus that grows on rye heads. It is so potent that the average black-market dose is one-three hundred thousandth of an ounce. Such incredibly small amounts mean that an eyedropper full is enough for 5,000 doses. Lysergic acid, purchased from a pharmaceutical firm, sold for about $20 to $40 a gram. Back then, on the black market in England, Canada, Mexico, or Czechoslovakia, a gram costs $500, and in the United States, $1,700. One gram of synthesized lysergic acid diethylamide, LSD-25, when sold at black-market retail prices, was worth approximately $25,000, or $3 to $5 a dose. Back then, LSD could have been purchased in many forms; the most common was a saturated sugar cube, a capsule containing baking soda mixed with LSD, and a do-it-yourself vial of liquid. Prior to the mid-60s, I learned, suppliers usually had to cross international or state boundaries to obtain LSD. At

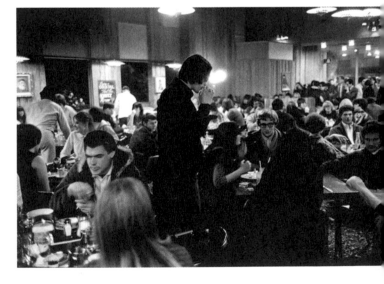

the time I was shooting my essay on LSD, a knowledgeable college or high school chemist, with a fair yield, could make enough for himself—or even enough to supply his whole state. All he needed was a small lab and a vacuum pump. Further, LSD is a colorless, odorless drug.

One contact told me about the time he was returning to the United States

10

after picking up some six grams of LSD. Just before entering Customs at the Gulf of Mexico, he emptied his hair tonic bottle and filled it with the acid. He cleared Customs with his toilet articles, even though a Customs official looked closely at the bottle before he approved closing the bag. Up the ramp his bag went and, when the suitcase was opened at home, he discovered that the bottle had broken. One of his suits had been saturated with the acid. He thought, "Do we cut the suit into small pieces and sell them? Do we wash the suit and sell the water?" No. The suit, now worth thousands of dollars, was hung up and thereafter was the center of focus at many an LSD party. It was literally chewed on for months to come and sent more people on trips than any tourist office could hope for.

It is hard to imagine the fantastic growth of LSD use in the United States since the 1960s. The man responsible for distributing a large percentage of black market acid up until that time in this country told me: "Back then all of the LSD came from Sandoz, a Swiss chemical manufacturing firm. It was earmarked for animal research and marked poison—not for human consumption. Unknown to Sandoz, the hundred microgram ampules soon found their way into the black market and there was enough around for anyone who was interested." After that supply ran out, chemists went into business and a very high quality of acid came into its own. It was advertised underground as "crystallized three times."

I believe approximately four million Americans took LSD in 1965, judging from conversations with suppliers. At that time, about one out of ten took it more than once a year and one out of eight took it at least every month. Perhaps as many as 70 per cent of all users were high school and college students, including dropouts.

When a ward psychiatrist at UCLA confirmed that 10 per cent to 15 per cent of the students there had taken LSD, and added that in 1965 one out of every six admissions to the Neuropsychiatric Institute at UCLA in 1965 was attributed to LSD, I thought that the story was a local one. But when I started to check the facts I found that the use of LSD was not local; it was everywhere and fast becoming a national issue. In '65 I presented these facts to Time, Inc. and was assigned to do the story for Life Magazine. Gerald Moore, a Life reporter, came aboard, as did other Life researchers.

In late October of 1965, my travels started with a girl at Berkeley. She called her LSD supplier and I found that frank disclosure of my purpose was best. I told him I was a journalist, what I was doing and what I wanted—the whole story. He was suspicious at first but, as we talked, he began to understand that I was interested in seeing and eventually presenting all facets of the subject. He agreed to be my guide into his part of the acid scene.

It wasn't a 9 to 5 day; it became a part of my life, twenty-four hours a day. As I got my feet wet, I talked to hippies, to students, to white-collar workers, to authorities like Dr. Sidney Cohen—to anyone with any experience or information. I soon found out just how little most people knew. Nobody was, and nobody claimed to be, an expert. I wanted pictures and I was told, "All you'll get will be people looking at the walls—if anyone will let you in with a camera in the first place." But I felt that people would cooperate. They did. Then as now, many LSD users are sincere in what they are doing and believe it to be important; some even have a missionary quality about them. Some took it for kicks, and those didn't care whether or not I took pictures. A few liked to advertise their rebellion, and wanted to be photographed in the act. Many said "No." They were admittedly afraid of losing their jobs or being judged by uninformed people. Almost all asked if I had taken LSD. I could not say no immediately for that would have ended the cooperation. I explained that my purpose was reporting and not social criticism.

Over a period of eight weeks, contacts gave me the names of others, and

as my knowledge grew, further doors to yet other LSD users opened. An eighteen-year-old girl in Los Angeles gave me the name of the president of a major corporation listed on the New York Stock Exchange. A seller gave me the phone number of an established sculptor. One boy introduced me to a major supplier, and I confirmed that even the editor of one of the most respected magazines in this country admitted taking LSD.

The majority of the users knew surprisingly little about the drug and what it can be all about. They didn't understand the dangers of a negative experience and they didn't know how to assimilate and use the bene-fits of a good trip. Some had read about LSD but few had looked at the subject closely.

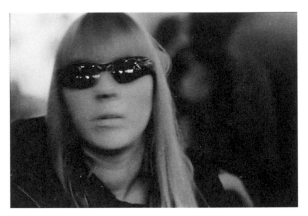

Reactions differed widely. When I ques-tioned them, one said it was like the atom: "Acid can be a beautiful nuclear reation lighting up cities or it can be Hiroshima, an event that you must live with forever." A computer expert declared, "It puts you in a different dimension. There is no way to communicate it. It dissolves the boundaries between concepts." A corporation official explained, "There is a void in the area of behavior and biochemical learning research. With the present laws on LSD, I cannot recommend to my company that they experiment with the chem-ical." Many quoted from books and articles by Dr. Richard Alpert, AKA Ram Dass, and Dr. Timothy Leary on religious experiences, and stated they, too, had experi-enced similar revelations. A college girl, after her first trip, said: "It was like a shower on the inside," and a high-school student stated, "It is like being in a snake pit."

In 1966, sunglasses often cover dilated pupils in cities across the country.

One financier invited me to travel with him. We boarded a jet and he placed a piece of chewing gum slightly saturated with LSD in his mouth. He put the headset of the multichannel music center on his ears and leaned back. Four hours later, he looked around and said "That's my type of trip." By then I knew enough to under-stand how one can benefit from the chemical when it is taken knowledgeably and responsibly. I began to understand why, in Charlotte, N.C., a group of businessmen had founded a club and were meeting once a month to take LSD and discuss their experiences. It was a release from the pressures of their lives. I found that Ph.D.'s at Ampex and Rand, educators, writers, musicians, artists, middle-class businessmen, and housewives were finding their own reasons for experiment.

But in New York, city officials stated that LSD could be a potentially dis-abling weapon, and in Amsterdam, that same week, teen-agers threatened to dis-orient the population by placing only a few ounces of LSD in the city's water supply.

I asked myself, "Should only certain people have LSD? Should specific peo-ple be given the right to give LSD? Who should control LSD?" Moreover, can it be controlled when 100,000 doses of an odorless, colorless, and tasteless chemical can be dissolved and transported on a handkerchief?

As I traveled, places that I had passed by, signs I had seen before, took on a new meaning. A night club on the Sunset Strip called The Trip was obviously a gath-ering place for heads. An out-of-the-way place called The Doors of Perception was now associated with Aldous Huxley and his experiments with mind-expansion chem-icals. Even The Brave New World was now the name of a private club and I found that the majority of its members experimented with many drugs. All across the country, gathering places for LSD users had sprung up, and it was obvious that people did not worry about walking the streets and spending the evening out under the influence of this chemical. Shirt buttons and car bumper stickers that read, support your local

travel agent and newspaper advertisements for "vodka acid" further illustrated that the psychedelic explosion was here. Touring entertaining groups billed their show "Can you pass the acid test?," and a California license plate "LSD025" became worth at least $500. I no longer questioned why, in movie audiences, people were wearing sunglasses. I knew that they were shielding dilated pupils and I soon found out that there was nothing like watching a movie under the influence of LSD, with every moment amplified in one way or another. Some folk-rock songs are the results of acid experiences and their words take on a separate meaning for users.

Soon after my pictures were published in Life Magazine in 1966, I again visited both Sidney Cohen and Richard Alpert. These two men represent opposing views on many aspects of the overall subject. Sidney Cohen, an M.D., is considered an authoritative source from the scientific and medical viewpoint; Richard Alpert AKA Ram Dass, a Ph.D. in psychology, was a former Harvard University professor whose research in 1963 with mind-expansion chemicals questioned the accepted methods of exploration. Strangely enough, they had never met. Moreover, they had never had the opportunity to express their views on the same issues and questions, even though they were authors of books on the subject of LSD. In 1966 I approached them about doing a book with my photographs, which was published later that year.

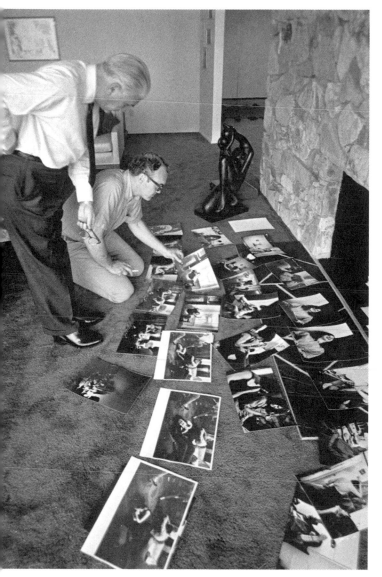

Dr. Cohen and Dr. Alpert, AKA Ram Dass.

After a great deal of thought, they met for the first time in my home to work out the most effective form of confrontation. It was essential that the reader be able to judge and draw their own conclusions. In my home, we selected the photographs together and agreed on the most important questions. Neither author saw the other's answers until they were finished. They exchanged their material and then wrote a rebuttal/ conclusion. In this way, neither was influenced by the other's answer to a specific question. The conclusions, in a sense, are not only rebuttals but Alpert's and Cohen's definitive statements on LSD at this time.

I hoped then—as I do in reissuing it for a new audience today--that this book will give the reader not only a visual trip into what was happening then, but some of the answers to questions we are still asking. I personally have found that there is no end to this story or clear-cut answer to the issue.

Like my well, full with water, I find there is no bottom.

Preface
Sidney Cohen

When one of my colleagues heard that this book was in the making he came loping over to the office and indignantly asked: "Why are you having anything to do with that nut, Alpert?"

"First of all," I answered, "he was not a nut as of the last time I spoke with him—a week ago. True, he broadcasts a point of view with which you and I disagree. What should we do about this? Should he be ignored, insulted, or ostracized? None of these will be effective; in fact, they would help him. He must be engaged, and his views effectively answered. I see my dialogue with him as an opportunity to provide information and an alternative set of attitudes about these drugs, particularly to young people. I suppose that I will have to do some thinking about some basic questions concerning the nature of this life. I believe that if people will consider two points of view, not one, many of them will make a

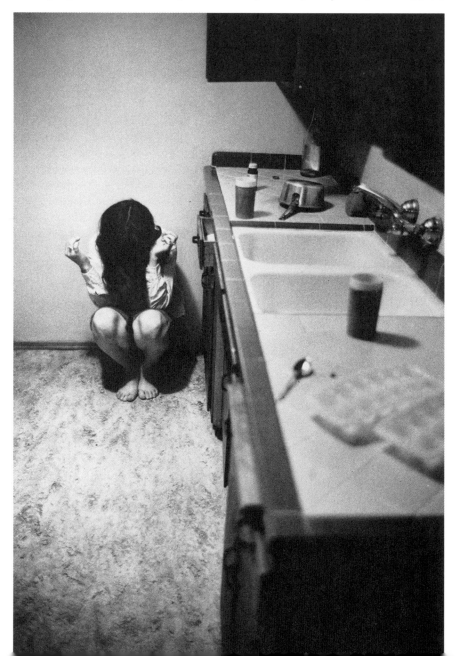

Taking an unsupervised LSD trip contrasts with the benefits of the drug when taken knowledgeably and responsibly.

more intelligent choice about taking LSD as it is being taken these days."

I am willing to believe in the sincerity of Richard Alpert. Still, I think that he has done a fair amount of harm by disseminating such notions as: "The worst that can happen to you [after taking LSD] is that you will come back no better than you were." This, as you will see, is assuredly not so. The seductive utterances of the Leary-Alpert group have been, in part, responsible for the burgeoning black market. This may or may not have been their intent, but it is so. The antics of the "acidheads" over the past few years have led to a severe tightening of restrictions on LSD research, to the point that in this country all investigative work with the psychedelics is grinding to a halt. Meanwhile, out on the street, LSD or something like it flows in awesome quantities from amateur chemist to wholesale pusher to retail pusher to ultimate consumer. Or should one say consumer of the Ultimate? Indeed, he is consuming the most potent of mind-shaking drugs as unconcernedly as an after-dinner mint.

Some of the best friends of LSD are its worst enemies. In their way they have aborted much of the careful study of this most important agent. They have managed to shock the citizenry to the point that all hope of safely, cautiously and gradually introducing the psychedelics into our culture is lost. This was a hope held by those who understood the nature of cultural change, like Osmond, Heard, Bateson, and others, years before Leary and Alpert knew of the existence of LSD.

I therefore welcome the opportunity to deal with the issues that LSD raises. Clearly, this book is no collaboration with Richard Alpert, neither is it a debate. It is a bilateral presentation of information and opinions. I know that the presentations will express widely divergent positions. If any areas of agreement are found, it will be gratifying.

Before attempting to answer the questions posed, I present a statement of my position to help the reader evaluate the specific responses. These opinions will eventually become obvious, but it may be preferable to be explicit now.

1. I believe that the best possible designed investigations of LSD are necessary, for it is an important aid in inquiring into many areas of human mental activity.

2. I hope that not only psychiatrists and psychologists but also members of other disciplines will collaborate in studies which impinge on issues relevant to their field of interest.

3. The question of making LSD available to those who wish to undergo the experience is worthy of careful consideration. These should be candidates carefully selected for emotional stability, motivation, and the expectation of benefit. The conditions under which the opportunity of such an experience should be given will require careful forethought.

4. I cannot see any desirable effects resulting from unprepared, unprotected, random LSD taking among adolescents seeking an evasion of life stress or a pleasurable interlude. The drug is much too hazardous (and too valuable) for this purpose.

Up to a decade ago it was not uncommon to read as a footnote to many scientific articles: "The opinions and conclusions expressed in this paper are those of the author and are not to be construed as official or necessarily reflecting those of ———." The blank space named a governmental agency with which the author was affiliated. Although that footnote has disappeared from journals and books, it may be worthwhile to be explicit on this point. My views are my own.

Preface

Richard Alpert, Aries AKA Ram Dass

From one perspective, what follows is a very personal statement, for the psychedelic experience is a very personal experience. One teaches only through being. I have tried in this manuscript to be just who I am. There are inconsistencies in what follows: that is because my own views about LSD and the other psychedelic chemicals are far from being totally integrated as yet.

I am not trying to be a scientist (thus I can be enthusiastic), or a mystic–visionary (thus I can be wrong), or far out (thus I can show concern), or far in (thus I can enjoy humor); nor am I trying to seduce or alienate anyone (which frees me from having to say either what I ought or ought not to say). At the outset, I advised Sidney that I did not want to debate.

What I do want to do is to provide you, the reader, with a consciousness-expanding experience by sharing with you the many complex feelings which this topic evokes in me: a deep sense of awe, and love; humor, both cosmic and terrestrial; and spiritual concern. I have tried to do just that. If you are reading the manuscript from one perspective only, you may at times think me evasive. At no point, however, am I trying to be. I realized along the way that some of the questions were at the wrong level of discourse. In those cases I tried to answer at the level which felt most in tune with how I saw the world at the moment.

From another perspective this is a tribal product. I have had psychedelic sessions with many, many people. To share such an experience with another human being means that you share consciousness, and from then on he has become a part of you forever, and you a part of him, in a very meaningful sense. What then are my ideas, more or less, than the amalgam of all of our ideas? I have quoted freely and at length because often one of us said it as it should be said.

To list the tribe members who are, in the creative sense, coauthors would be an endless and Herculean task. They and I know who we are—and that is enough. As I prepared this manuscript, however, I had a chance to flip through, so to speak, my mental file of creative insights which have come my way since the first psychedelic experience. The data were perfectly clear: the most creative thinker in the psychedelic field is Timothy Leary. It is from him that many of the ideas in this manuscript come. This fact is not to imply either his approval of this presentation or even his continued espousal of the ideas. It is simply an acknowledgment of a person who has brought me a great distance on my own journey.

Speaking of that journey, I found myself constantly wishing that I was further along the spiritual path personally, so that I might better be of service to you, my fellow man, in this endeavor.

It is my conviction that LSD is important ... IF ... we can use it wisely and responsibly. The wisdom and responsibility must come not just from a few experts (for there are no real experts in the unknown) or officials, but from the very many of us who care.

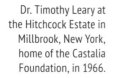

Dr. Timothy Leary at the Hitchcock Estate in Millbrook, New York, home of the Castalia Foundation, in 1966.

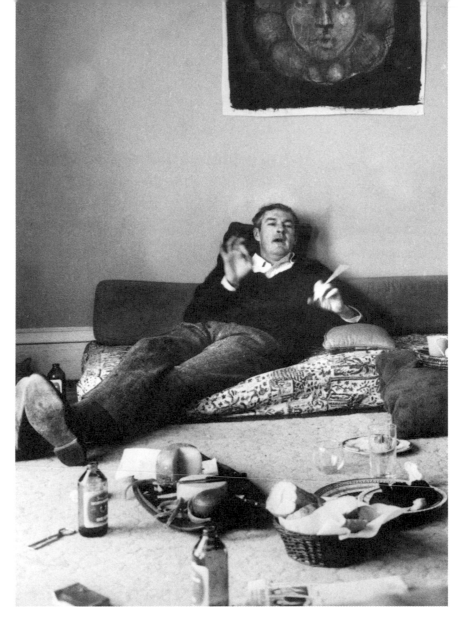

A SPECIAL NOTE ON DANGER

Late one night, not long ago, I came upon the scene of a highway accident. Teen-age college students who had been drinking at a near-by bar had failed to execute a curve at high speed and had smashed into an abutment, killing instantly the three boys and three girls who were occupants of the car. That accident was but one example of the toll of thousands of human lives that the mixing of drinking and driving takes on our highways every year. And yet ... that one accident killed more people than LSD ever has in the fifteen years it has been available. The statistics are very clear: LSD is safer (on a percentage basis) than alcohol or, for that matter, cigarette smoking. As far as damage to mental health, the suicide and hospitalization statistics are unequivocal: LSD is less dangerous than a four-year liberal arts college education. As you read the inflammatory articles in the press concerning LSD and listen to the well-meaning but inaccurate pronouncements of the legislators and State and Federal agents attempting to impose more and more harsh punishment for possession of LSD, it would be well to keep these statistics in mind.

Q.
What are the psychedelic drugs?
Are they a unique class of substances?

ALPERT

"A gratuitous grace," said Aldous Huxley in Copenhagen, 1961.

"I am LSD. I look like this.

"I am easy to make. I am controversial. Color me Rainbow.

"My family are called 'The Psychedelic Drugs.' We expand consciousness.

"My brothers and sisters are made up of five groups. The lysergic acid derivatives, of which LSD (diagram above) is an example, form only one of five chemical categories which compose the psychedelic 'drugs.' The other four are:

(1) phenylethylamine derivatives, of which mescaline is an example; (2) tryptamine derivatives, of which psilocybin is an example; (3) piperidyl benzilate esters, of which JB 329, or Ditran, is an example; and (4) phencyclidine (Sernyl).

[R. Metzner, "The Pharmacology of Psychedelic Drugs"—a thorough review of the chemical and biochemical aspects—in Psychedelic Review I, 1963.]

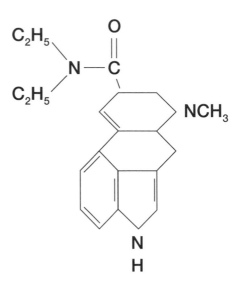

Chemical Structure of
Lysergic Acid Diethylamide

"I have, in addition, a number of other brothers and sisters who have not yet come to the public's attention."

"We are psychedelic chemicals, usually taken orally, and derived primarily from central nervous system, and in doing so we serve as keys to free the individual to experience new states of consciousness." The term psychedelic means 'mind opening' or 'mind-manifesting.'"

The central metaphor is as follows. The human brain contains over ten billion cells. Any single cell can be in interconnection with up to twenty-five thousand other cells. About one billion impulses flood into the cortical computer each second. The potentialities of consciousness at any one second are thus seen to be of the order of $(1,000,000,000) \times (10,000,000,000)^{25,000}$

The educated adult utilizes about five thousand concepts to experience the world within and without. An astonishing filtering and constricting process occurs which reduces the enormous potentials of consciousness to the few cultural modes of experience routinely employed.

Psychedelic drugs are seen as interfering with or counteracting these reductive processes so that the subjects are able to experience immediately, beyond the limits of the learned cultural programs.

The process of going outside, going beyond learned modes of experience (particularly the learned modes of space-time-verbalization-identity), is called ecstasis. The ecstatic experience. Ex-stasis.

The science of ecstatics is the systematic measurement, description, and production of the ecstatic state—that is, the expansion of consciousness.

This process has been studied by every culture in recorded history under many

names—<u>samadhi</u>, <u>satori</u>, <u>numina, nirvana</u>, mystic or visionary state, transcendence. Those who are concerned with conformity and adjustment like to call the ecstatic state psychotic. Psychoanalysts use terms such as "primary process" or "regression in the service of the ego."

> It has been known for centuries that the ecstatic process can be produced by techniques which alter body chemistry—fasting, contemplative focusing of attention, optical alterations, yoga exercises, sensory deprivation, and the ingestion of foods and drugs. The drug-induced <u>ecstasis</u> is now called <u>the psychedelic experience</u>.
>
> [Timothy Leary, Richard Alpert, and Ralph Metzner, "Rationale of the Mexican Psychedelic Training Center," in <u>Utopiates: The Use & Users of LSD-25</u>, ed. R. Blum. New York: Atherton Press, 1964, p. 179.]

The uniqueness of the psychedelic chemicals will become abundantly clear as one reads on through this book.

COHEN

The psychedelics have many other names, each reflecting some notable characteristic of the experience. The word "hallucinogen" is seen in the medical literature most frequently because the visual distortions and occasional hallucinations are so remarkable. In this book we are using psychedelic, "mind-manifesting," a word suggested by Aldous Huxley to Humphry Osmond. It is a neutral word, but it has taken on a positive flavor in recent years. A psychedelic experience may be anything from an elated "trip," full of fun and other goodies, to a profoundly mystical event.

There are many psychedelics, but those that concern us here are LSD, mescaline, DMT (dimethyltryptamine), and psilocybin. Peyote, from which mescaline was derived, has both a religious and secular usage. Three varieties of morning glory seeds have some psychedelic quality, and they were popular until LSD became so plentiful. As LSD becomes more difficult to obtain, the seeds of the colorful morning glory will come into demand again. Marijuana also belongs to this class of drugs, and, although rather weak, is still the most widely used of all. Sometimes claims are made for the more potent psychedelics that they are "religious" or change the person for the better. One does not hear any such claim made for marijuana, which is admittedly taken for the relaxation, the "kicks," or to erase the concerns of the day.

All these drugs evoke marked changes in the perception of time, space, and self. The central question is: What do these alterations mean?

LSD in capsule form.

The uniqueness of this group of drugs is that a relative lack of confusion accompanies the profound mental changes. They are not completely unique in that deliriants will produce similar illusions, hallucinations, and ecstatic experiences, but these are accompanied by more clouding of the mind. Toxic deliriants such as *Datura stramonium* (Jimson Weed), henbane or *Atropa belladonna* (Deadly Nightshade) do psychedelic things but with less mental clarity. They were constituents of witches' brews and still are taken sporadically to become intoxicated.

Passages in De Quincey's *Confessions of an English Opium Eater* sound exactly like psychedelic experiences. This would mean that for some people the narcotics induce LSD-like experiences. And listen to this: "I was suddenly confronted by an overwhelming conviction that I had discovered the secrets of the universe which were rapidly made plain with incredible lucidity. The truths discovered

seemed to be known immediately and directly with absolute certainty." Was this an LSD report? It sounds as though it could have been, but in this instance no drug was taken. It is from the autobiography of a schizophrenic.[1]

The psychedelics are a most remarkable class of pharmaceuticals, but their properties overlap with other groups of drugs. They are definitely not "cortical vitamins" or "nerve cell lubricants," unless one exists in a Wonderland like Alice where, "words mean what you want them to mean."

Hashish (a stronger marijuana), peyote, the psilocybe mushroom, and other psychedelics have been around for centuries. Whether we can call the current increase in consumption a revolution is uncertain. Its use is admittedly snowballing; perhaps we might speak of a psychedelic avalanche.

Q.

Is the lsd state reality or illusion?
Does it give a glimpse of the real reality?

ALPERT

More real than Reality??

This is perhaps the most fascinating of all the questions in this book. In this section I am going to quote at some length from three authors, all of whom have thought deeply about this question. The first is William James writing in 1902 about his psychedelic experiences with nitrous oxide, in his classic text, The Varieties of Religious Experience. The second of these is one of our greatest visionaries, Aldous Huxley. The third is word-wizard Alan Watts, a leading philosopher of space-age mysticism. All of these men have made chemical psychedelic explorations. (My own dilemma with regard to this question is explored on page 97. "How has LSD affected your life?")

Some years ago I myself made some observations on this aspect of nitrous oxide intoxication, and reported them in print. One conclusion was forced upon my mind at that time, and my impression of its truth has ever since remained unshaken. It is that our normal waking consciousness, rational consciousness as we call it, is but one special type of consciousness, whilst all about it, parted from it by the filmiest of screens, there lie potential forms of consciousness entirely different. We may go through life without suspecting their existence; but apply the requisite stimulus, and at a touch they are there in all their completeness, definite types of mentality which probably somewhere have their field of application and adaptation. No account of the universe in its totality can be final which leaves these other forms of consciousness quite disregarded. How to regard them is the question—for they are so discontinuous with ordinary consciousness. Yet they may determine attitudes though they cannot furnish formulas, and open a region though they fail to give a map. At any rate, they forbid a premature closing of our accounts with reality. Looking back on my own experiences, they all converge towards a kind of insight to which I cannot help ascribing some metaphysical significance. The keynote of it is invariably a reconciliation. It is as if the opposites of the world, whose contradictoriness and conflict make all our difficulties and troubles, were

melted into unity. Not only do they, as contrasted species, belong to one and the same genus, but <u>one of the species</u>, the nobler and better one, <u>is itself the genus, and so soaks up and absorbs its opposite into itself</u>. This is a dark saying, I know, when thus expressed in terms of common logic, but I cannot wholly escape from its authority. I feel as if it must mean something, something like what the hegelian philosophy means, if one could only lay hold of it more clearly. Those who have ears to hear, let them hear; to me the living sense of its reality only comes in the artificial mystic state of mind.

[William James, <u>The Varieties of Religious Experience</u>. New York: New American Library (Mentor Books), 1958, p. 298.]

...Nothing in our every-day experience gives us any reason for supposing that water is made up of hydrogen and oxygen; and yet when we subject water to certain rather drastic treatments, the nature of its constituent elements becomes manifest. Similarly nothing in our every-day experience gives us much reason for supposing that the mind of the average sensual man has as one of its constituents, something resembling, or identical with, the Reality substantial to the manifold world; and yet, when the mind is subjected to certain rather drastic treatments, the divine element, of which it is in part at least composed, becomes manifest, not only to the mind itself, but also, by its reflection in its external behavior, to other minds. It is only by making physical experiments that we can discover the intimate nature of matter and its potentialities. And it is only by making psychological and moral experiments that we can discover the intimate nature of mind and its potentialities. In the ordinary circumstances of average sensual life, these potentialities of the mind remain latent and unmanifested. If we would realize them, we must fulfill certain conditions and obey certain rules, which experience has shown empirically to be valid.

[Aldous Huxley, Introduction to <u>The Perennial Philosophy</u>. New York: Meridian Books, 1962.]

Classical illustrations of <u>maya</u> [illusion] include the apparently continuous circle of fire made by a whirling torch, and of the continuity of time and moving events by the whirring succession of <u>Ksana</u>, or atomic instants. Physicists use similar metaphors in trying to explain how vibrating wavicles produce the illusion of solid material. The impenetrability of granite, they say, is something like the apparently solid disk made by the blades of an electric fan: it is an intensely rapid motion of the same minute orbits of light that constitute our fingers. Physics and optics have also much

to say about the fact that all reality, all existence is a matter of relationship and transaction

Our difficulty in accepting for ourselves so important a part in the actual creation or manifestation of the world comes, of course, from this thorough habituation to the feeling that we are strangers in the universe—that human consciousness is a fluke of nature, that the world is an external object which we confront, that its immense size reduces us to pitiful unimportance, or that geological and astronomical structures are somehow more real (hard and solid?) than organisms. But these are actually mythological images of the nineteenth and early twentieth centuries—ideas which, for a while, seemed extremely plausible, mostly for the reason that they appeared to be hardboiled, down to earth and toughminded, a currently fashionable posture from the scientist. Despite the lag between advanced scientific ideas and the common sense of even the educated public, the mythology of man as a hapless fluke trapped in a mindless mechanism is breaking down. The end of this century may find us, at last, thoroughly at home in our own world, swimming in the ocean of relativity as joyously as dolphins in the water.

[Alan Watts, "A psychedelic experience: fact or fantasy?" In LSD: The Consciousness-Expanding Drug, ed. D. Solomon; intro. T. Leary. New York: Putnam's, 1964, pp. 126–127.]

COHEN

One thing is certain. Under LSD one has the overwhelming feeling that it is the real reality. If feelings were enough, the answer to these questions would be easy and brief. But let us ask ourselves why, under LSD, the world looks as it did on the morning of Creation, why every paradox is resolved and each opposite is so neatly reconciled? Why has every moment expanded to infinity? Why does one enlarge to encompass the All or contract into nothingness?

LSD does a number of things to the brain. One of these is that, in large amounts, the discriminating, critical capacity is lost. The ability to observe oneself, to evaluate the validity of one's ideas and swift flowering fantasies, is lost. The strangest illusions seem overpoweringly true. The vague generalities of *The Tibetan Book of the Dead* as rendered in *The Psychedelic Experience*[2] take on an enormous significance. Colors are more so, things are more so and assume meanings far beyond their ordinary connotation. All this happens because of the loss of the ability to evaluate and scrutinize. This is also why, for purposes of therapeutic self-examination, much lower doses are used. At these lesser levels the observer ego remains intact, split from the self, but intact.

LSD also acts on the filtering mechanism of the brain. It is here that the myriad inflow from all the senses is sorted and evaluated with only the important messages rising to conscious awareness. LSD has a disinhibiting or releasing effect which allows a flood of sensory signals to come to consciousness and then spread from one sensory pathway to others. It opens the reducing valve of Bergson wide, and we are overloaded with sensation. The emotional correlate is ecstasy, the visual is the blinding, white Light.

Well, isn't this Reality?

Why do we need self-awareness, reducing valves, observer egos, and the rest? Furthermore, what use is sanity? Look at where it has brought us. It seems strange that sanity should require a defense, but the counterrevolution to the strains and pressures of the three-century-old scientific revolution is upon us. The advance of science has left so many persons a materialistic, scarcely

He explored for over an hour.

believing, frightened lot. The power to destroy is available but not yet the wisdom to use man's peak achievement, his reason. Thus we have the spectacle of evolving man, capable of rational thought and of awareness of self, still unable to implement his knowledge so that he can live like a human being. It is no wonder that we yearn to get away from it all, to go back to that egoless state when we were at one with our environment. It is pointless to call it a regression; words do not alter its attractiveness for those who need more than harsh sanity. Our nerve fails. We want pleasure without obligation, answers rather than problems, magic, not uncertainty. The tensions, the bitterness, and the shearing stresses make living in the midst of explosive upheavals difficult. We speak with concern about population explosions. The impact on man living through information, transportation, energy, communication, and the technological explosions is equally stressful.

Some of us quite understandably seek out the spiritual equivalent of Rousseau's return to nature—with drugs if necessary. The answers are simple and at hand. All one needs is the faith to believe the mystic.

Few are willing to accept the alternative. The alternative is the recognition that we are an evolving species and that Final Truths are not discernible at this phase of our development. We must be satisfied with a willingness either to accept truths as sufficient to the day, or (and this is more difficult) to contemplate the questions without expecting answers.

If we look at the anatomic evolution of the brain, the areas that seem to be growing fastest are those which involve increased self-awareness and increased associational and critical activities. Our destiny seems to be moving in the direction of an enhanced consciousness and a greater capacity for rational processing. Can we turn our brain back?

What of Nirvana? What about the unutterable pleasures, infinitely prolonged? Isn't this the way we ought to live? Shouldn't we dwell in this state of at-oneness forever? The answer from Ramakrishna, St. Jerome, and others who knew it best is "No." It is not a place to remain, it is probably incompatible with remaining. Dryden's lines: "Great wits are sure to madness near allied,/ And thin partitions do their bounds divide," applies here. Unsanity and insanity are polar to each other, yet they are bent into an almost complete circle with only the thinnest of partitions between. The value is in bringing back to sober sanity that which has been experienced, and the restructuring of the sane life from the lessons of the transcendental experience. Then the here and now pressures may become less pressing and the beauty around us more visible. The cosmic or unsane experience alone is not enough; the difficult task of restructuring this existence still remains. Van Dusen stated it in another way after returning from a psychedelic experience: "The One beyond time and space and the One of the Commonplace were the same. This was the most bitter lesson of all. Things exactly as they are, are paradise. I looked for heaven and found the commonplace."

Once, a dozen years ago, in the thrall of LSD I managed to wonder what I would think if the condition I was in had come on without having swallowed

some small purple pills.

"Then I would believe in a meaning to life, in a meaning to death, that I had seen the meaning in the universe," I answered myself.

"But what difference does it make that a few molecules of a drug have brought you here?"

"Ah, but what if it is only the drug playing a trick on my brain?"

The question remains: Is it a psychochemical mirage or a priceless glimpse of reality? Now, a dozen years later, I would suggest that it is another facet of illusion just as our sober state is.

Q.
Can you understand this issue without having had "the experience"?

ALPERT

Most people find it difficult to imagine the unimaginable—to dream "beyond their wildest dreams." So if by "experience" we mean any experience (chemically or otherwise induced) in which an individual has transcended himself, then I would say that you cannot understand this issue without having had "the experience."

The introduction of the microscope provides an excellent metaphor. Imagine that you lived before the invention of the microscope and someone told you one day that he had looked through this special glass and discovered that all the things we saw with our naked eye as being solid were in fact not solid at all. You might with reason be skeptical of this fellow's story and ask him to describe what he saw. But how would he do it? There were no words available to him for the things he saw, and so how could he possibly tell you about it? After a frustrating attempt to do so, perhaps even using sketches, he might take you by the sleeve and invite you to look into the glass for yourself. But after all, in that clime and time, what responsible person would do a thing like that? Or recall the theologians saying to Galileo, "We will not look through your telescope because we already know how the universe is ordered. Aristotle, Scripture, and Tradition have pointed the way for centuries. If your telescope were to show us anything different, it would be an instrument of the Devil." And so it is today with the psychedelic experience.

R. Gordon Wasson, a former partner of the Morgan Guaranty Trust Company and now a Research Fellow of the Botanical Museum of Harvard University, is one of the world's leading experts on mycology (the study of mushrooms). He characterizes the problem as follows:

> These difficulties in communicating have played their part in certain amusing situations. Two psychiatrists who have taken the mushroom and known the experience in its full dimensions have been criticized in professional circles as being no longer "objective." Thus it comes about that we are all divided into two classes: those who have taken the mushroom and are disqualified by our subjective experience, and those who have not taken the mushroom and are disqualified by their total ignorance of the subject! As for me, a simple layman, I am profoundly grateful to my Indian friends for having initiated me into the tremendous Mystery of the mushroom. In describing what happens, I shall be using familiar phrases that may seem

to give you some idea of the bemushroomed state. Let me hasten to warn you that I am painfully aware of the inadequacy of my words, any words, to conjure up for you an image of that state.

[R. G. Wasson, "The hallucinogenic fungi of Mexico: An inquiry into the origins of the religious idea among primitive peoples." Psychedelic Review, I, pp. 32–33.]

As the work of Abraham Maslow of Brandeis University and others has demonstrated, however, most of us have had, at one time or another in our lives, an experience which, though usually not of the same intensity, is similar enough in quality to provide us with some experiential frame of reference. I recall trying to describe the psychedelic experience to a Saudi Arabian. It took me a while to get out of him a description of his feelings as he would ride his horse out into the desert at sunset and feel a deep sense of contentment and unity with the Universe. That, I assured him, was like one part of the psychedelic state. We now had a shared point of experience from which to proceed.

For many of us, those moments have been associated with experiences of profound love of one sort or another; for others, with moments of great tragedy or fear; for many women, at the moment of childbirth; and, for most of us, at the moment of sexual orgasm. These are the moments when we often "go out of our minds" in the most ecstatic sense.

COHEN

The oneupmanship game is commonly played by the LSD proselyte. "If you have never been there, I can't even talk to you about it," is the gist of his putting the uninitiated one down. Now we are even seeing a stratification of being one up among LSD takers. The 600 mcg man shakes his head condescendingly at the 200 mcg man. The "cubehead" who has swallowed 1500 mcg is top man. The only cloud on his horizon is the stupefying entrance of the 4000 mcg contender into the LSD arena.

I know many people unfamiliar with the psychedelics who were quite capable of grasping the essence of the psychedelic state when a real effort was made to describe it. Tillich, Isherwood, Henry Miller and others all comprehended the nature and the implications of these alterations in awareness. Others could not.

Just as pertinent a question might be: "How many of those who take LSD these days understand the issues?" Does the gentleman who is tense and goes on a short trip with DMT to get away from it all understand the issues? To me, it seems as though he is using a powerful psychedelic just as he might a few belts of booze. What of the girl who requires LSD before she can "give in" sexually? Or the large numbers of young folks who seem incapable of enjoyment without "pot" or "acid"? Are these the issues? I suggest that too few who have had "The Experience" are cognizant of the issues involved.

One of the political goals of the Harvard psychedelic movement was to propagandize large numbers into "turning on." In this they have been very successful. But what of the quality of the experience? Where is the enlightenment and the deep revelation? I would assume that the original disciples of the International Federation for Internal Freedom must be repelled by the motives and the effects of LSD-taking as most of it is being used these days. If they are not, then I attributed higher motives to them than they had, or they are not aware of what is going on today.

Q.

Is the freedom to take lsd
an inalienable right of man?

ALPERT

I am going to do something which is foolhardy, to say the least. I am going to quote first from a most persuasive writer discussing individual rights and LSD. Many of you who read these words will agree with him ... but I think he is wrong.

> Another element to be considered is that of risk. In a society which stresses the rights of individuals for self-direction and assumes responsibility for free and rational choice, much is made of the right of an individual to decide for himself whether he will engage in activities which endanger himself but not others. With reference to pleasure-giving drugs and LSD in particular, a person may think it is his own business. Why not take a chance if the potential gain is so great? One pays the price of psychosis or loss of job or family in those rare cases when one loses, but isn't that one's own choice? Is it? To be sure, the individual suffers, but it is the community which pays for the mental hospital and it is his wife and children who lose the support of the breadwinner and/or are deprived of normal family life. This study shows that divorce occurs if the wife will not go along with the husband's conversion to the drug movement. When that happens, it is the wife who suffers the risk as much as the husband. One must conclude that the community itself has rights, rights to protect the well-being of all its members, rights to protect itself from unnecessary expense, danger, trauma, or undermining forces. Whatever the talk of alienation, the fact is that none of us is alone and what we do does have consequences for others. That fact underlies all legislation for the control of narcotic and dangerous drugs, and it would be well for those who propose free access to pleasure-giving drugs to keep their community importance and community obligations in mind.
>
> [Edward Comber, M.A., "A police administrator comments on the drug movement." In Utopiates, op. cit., pp. 260–261. Mr. Comber is Director of the Bureau of Criminal Information of the San Francisco Police Department.]

I have, sir.
And by the way, does that include alcohol?
I quote now from sociologist Richard Blum, who edited the book from which the preceding quotation was taken:

> The notion of control is an important one. This is a control-oriented society; technology and the whole apparatus of rational endeavor work to control nature and to control men. But that effort, one which is usually considered beneficial to man's comfort and security, has generated instruments so ponderous that the individual can lose all hope of controlling the instruments themselves. The state, organizations, and the various forms of collectivity are Frankenstein monsters, for they have moved from being instruments in the hands of men to being instruments which hold men in their hands. This is the nature of bureaucracy and the culmination of an efficient technological revolution.
>
> [Ibid., p. 282.]

1. Thou shalt not alter the consciousness of thy fellow human being by electrical or chemical means.

2. Thou shalt not prevent thy fellow human being from changing his consciousness if by doing so he does not create harm or danger to others. The burden of proof that harm is being done must be left to society.

[—Timothy Leary, Town Hall, New York—April 21, 1966]

COHEN

Since the pursuit of happiness is declared to be an inalienable right of man, it might be argued that LSD is a part of our birthright. The pursuit of happiness is qualified: one should neither harm others nor oneself in its fulfillment. The right to harm oneself is not accepted in any modern society. In addition to being individuals we are also social creatures. We have individual rights and group responsibilities. Unfortunately, the weak in mind, the psychopath, and the weak in spirit are among us. It is for these individuals that restrictions are necessary. They misuse narcotics, stimulants, sedatives, alcohol, and the psychedelics and we pass laws to try to protect them and society. They debase and pervert LSD just as they do the other drugs. To survey the problem as impartially as possible, it is this minority of misusers who restrict our freedom because they inevitably provoke restrictive legislation.

Let's briefly look at the heroin, LSD, and alcohol situations in order to achieve a sensible frame of reference. Heroin produces a great "high," at least, initially. Soon, however, one is hooked and keeps shooting "H" just to keep comfortable. The things that a heroin addict has to do in order to maintain his habit are utterly deplorable. Hardly anyone thinks that access to heroin or morphine is an inalienable right. The Harrison Narcotics Act, poorly contrived though it is, has succeeded in reducing the number of addicts in this country threefold since it went into effect. Because of strong cultural disapproval and restrictive legislation, narcotic addiction may disappear one day. Alcohol is, traditionally, a socially acceptable drug. It has only a minimal religious usage. One in twenty American adults misuses alcohol to the point that it becomes a health, social, economic, or marital problem. There may be as many as six million people in this country who are harmed by their drinking habits. This is an atrocious situation. One effort at complete prohibition was a failure because the populace did not support law enforcement. We have regulatory laws against drinking by minors, drunk drivers, disorderly drunks, etc., but we are paying a tremendous price for

An intimate home gathering, watching a light show.

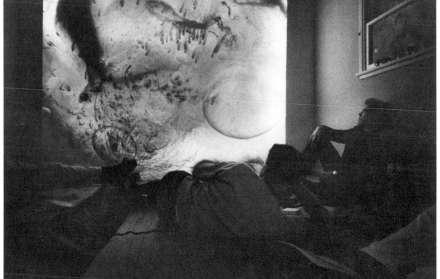

the freedom to use ethyl alcohol, despite the fact that 95 percent of imbibers use it without harm to themselves or others. LSD is a substance alien to our culture. Back in the Bronze Age of LSD usage, five years ago, it was generally taken by nonmedical explorers in a semireligious context. Now most of it is being consumed for the very same reasons that alcohol and marijuana are used. It does not addict, but we know some users who have become dependent upon it.

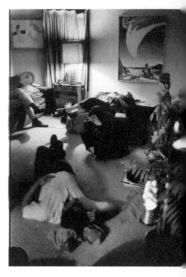

Studying the above information it would seem that narcotics control is necessary and desirable. It should be improved, but not by the so-called "English system," which seems to be failing in England and would be even less feasible in this country. Strenuous efforts should be made to deal with the serious problem of chronic alcoholism through education and by making the problem drinker culturally unacceptable. The liquor manufacturers might be well advised to use their advertising budgets for this purpose. The only visible reason for permitting the tragic destruction of innumerable familes is that drinking has been a part of our tradition since primitive man found honey that had fermented.

Just because alcohol produces harmful effects is hardly an argument for the incorporation of a new agent that might do as much or more damage. "If alcohol, why not LSD?" is as specious as, "If LSD, why not Russian Roulette?" Aldous Huxley had the fond hope that a drug like mescaline or LSD might displace alcohol and be without its deleterious effects. His death three years ago came at a time when the entire psychedelic situation was changing. Up to then supplies had been fairly well controlled; thereafter, they became plentiful. No one can speak for him, but I wonder whether the current situation would not have discouraged him. The LSD users have not decreased their drinking of neutral spirits.

To be explicit, I do not believe that we have an inalienable right to take LSD. I also believe that a person has a social responsibility, which some people tend to forget. Harming no one is fine, but what one does to oneself has reverberations well beyond oneself. One cannot resign from the human race.

Q.

What are the implications to society when we find such an extensive use of chemicals to produce a change in one's awareness?

ALPERT

The implications <u>about</u> our society are that the end product of the technological revolution, i.e., the Great Society, doesn't provide the human being with enough gratification. ("I can't get noooo satisfaction," a rock-'n-roll hit laments.) Every sociology text tells us of the "alienation" of modern man, psychiatry is booming, sleeping pills and tranquilizers are big business and getting bigger, divorce courts are burgeoning, alcoholics multiply, unbelievably huge segments of the population sit semidazed before the TV and receive their quotidian analgesic, and statistics on crime and highway deaths soar relentlessly.

The implications <u>about</u> our society are that it does not provide a sufficiently supportive setting for its members to grow naturally in a conscious and spiritual sense. The social institutions have become too calcified, the static component has

overwhelmed the fluid.

Blum, in the <u>Utopiates</u>, describes the theoretical aspects of this situation as follows:

> Sociological theory ... has moved from attending to the forces shaping social behavior to social forces shaping personality. As this has occurred, role has slowly been converted into "self" and social status into "identity." The play is reality, and persons are only actors, players, masks, or other outward-oriented, feelingless entities. There are no more persons, merely personae.
>
> Such theories reflect the natural evolution of social-science theory keeping pace with the commodity market in mass-produced personalities. It is apparent that the theory not only describes but <u>reflects</u> a rational culture of interchangeable, emotionless, and completely meaningless and nonspontaneous parts. Inner experiencing and idiosyncrasy are discounted; the person has come to be described as the product of interacting social forces alone. These theories reflect ... the experience of the contemporary social scientist, for the limitations on the vision of man must be a function of the limits of the vision of men, in this case social theorists. And anyone who has worked in a modern university will not be surprised that the scholars therein have themselves been molded to the modern view, seeing man as rational, adaptive, conforming, vocationally oriented, and psychologically empty. Such theories reflect, in our own generation, the triumph of Protestant asceticism. The theory itself, however accurate, is alienated from the feeling, experiencing, and uniquely responsive man.
>
> [Blum, <u>op. cit.</u>, pp. 281–282.]

It is not surprising to me, therefore, that in those sections and segments of society historically identified with the "leading edge"—in the large cities (high-energy centers), on the college campuses, and specifically in the age-range below twenty-five—there is the search for a way to lend meaning and dignity to life. Psychedelics have become known as one way for Western man to free himself from the molasses-like sleepwalking state for which the culture has trained him. It is a way which a sizable segment of our society is bound and determined to explore.

(Implications <u>for</u> our society? See page 100.)

COHEN

There are many subquestions that this question suggests. To be brief I shall enumerate the points I'd like to make.

1. If large numbers of people were to enter some sort of psychedelic state at frequent intervals, the time might come when the issue: "How many of these people can a society afford?" might arise. In the same manner we now ask: "How much destructive alcoholism can we afford? Will sufficient numbers remain for the sober work of making, growing, planning, healing, etc.?"

2. The converse question could also be asked. If, in some future era, most humans will have little or no work to do, might the altering of their consciousness be a satisfactory way to keep them content? It is quite likely that a state similar to the psychedelic can be achieved by implanting electrodes into specific areas of the brain. Extensive animal and some human research supports this opinion. Imagine, "nongame ecstasy" by pressing a button—or by having someone else press your button.

3. It can easily be said that something must be wrong with a society from

which so many wish to escape. A study of consciousness-changing drugs and techniques indicates that attempts to get outside oneself have concerned members of every tribal grouping from the most primitive to the most sophisticated. Today, the combination of relative affluence (the easy availability of food and shelter) and of rapid cultural change may make the psychedelic state more attractive than usual.

4. We have much to learn about training our children's perception and emotions. The relative overemphasis we place on material "hardware," social status, and the intellectualized approach to life produces an unhealthy imbalance. To see and hear completely, to feel at one with oneself and others— these attributes can be acquired early in life. Then, the psychedelics would hardly be necessary. When LSD is taken, does it provide an opportunity to correct some of these defects? It is possible. The drug alone is not enough. Strong motivation must be present along with the willingness to do the work of retraining and reeducating oneself.

Q.

What are the possible dangers involved in taking lsd? Can these dangers be eliminated?

COHEN

During the past three years I have seen so many and such varied difficulties arise in connection with the indiscriminate use of LSD that each kind of complication can hardly be mentioned here. Those interested are referred to other sources.[3,4,5] My experience has not been unique. Substantiating reports are forthcoming from neuropsychiatric hospitals, student health centers, and coroner's offices. A third of the 150 psychiatrists polled in a large city had been called upon to help at least one person suffering from a prolonged side effect.

Furthermore, not all the problems precipitated by the drug are being attributed to it. I know of two lethal automobile crashes occurring while the drivers were under the influence of LSD. The death certificates simply say "multiple injuries sustained during auto accident." Another LSD complication that does not come to medical attention is those who become psychotic, but who drift into some "beat" subculture. They may be exceedingly odd, and think, speak, or act incoherently. If those around them tolerate the strange behavior or just don't care, these unhinged creatures wander through some sort of disorganized existence.

What can happen? The adjusted schizophrenic can be thrown into an overt schizophrenic breakdown. Example: A twenty-year-old man had managed to graduate from junior college and obtained steady work in a supermarket. When he was nine years old he had some brief psychiatric assistance for excessive shyness. He was frightened of new experiences and of strangers, but performed routine tasks well. LSD was taken four times, on the last occasion in a dose of 450 mcg. After that evening he was agitated, incoherent, hallucinating, and behaving bizarrely. He claimed to be the New Messiah and refused food because he did not need sustenance. After a few weeks at a county hospital without improvement, he was committed to a state hospital. At times he screamed and

cried, at others he was quietly curled up in the fetal position. After a long course of drug treatment and psychotherapy he improved and is awaiting discharge.

A few unstable individuals have returned in megalomaniacal states. Example: The manager of a door-to-door magazine sales crew became convinced under LSD that he was the Savior. He persuaded his wife, who had also indulged, that she was Mary reincarnated. He managed to gather a few LSD apostles, and they made plans to go into the mountains and dwell there. His boss was slated to be Peter, but Peter refused to take the drug. The Savior sold his possessions and gave the money away. The incident would not have come to my attention had Peter not wanted to try to retain a previously effective sales manager. However, the salesmen were uneasy about his odd speech and behavior. During the interview the Savior was hypomaniacal, garrulous, and absolutely convinced of his omniscience. In areas which did not involve his newfound divinity, his thinking was appropriate. He was neither hostile nor hallucinating. When it was suggested to him that he might sell Bibles instead of magazines so that he could not only support his family but also do a service for mankind, he did not accept the counsel. A follow-up is not available.

A number of accidents, some fatal, have happened during an LSD paranoid reaction. A young man wandered off from a party and was seen to step off the curb on Wilshire Boulevard into the path of an oncoming car. He raised his hand and shouted, "Halt." Death was instantaneous.

Sometimes it is difficult to determine whether death was accidental or suicidal. An admittedly disturbed student and long-time user of hallucinogenic drugs told a classmate that he was going down to the beach to take the "acid." A few hours later his body was retrieved from the Pacific. Did he get the idea that he could walk on the waters, or did the life-death issue become negligible under the effects of LSD? Such fixed ideas surge up with great conviction in the psychedelic state.

Sometimes a psychosis very much like the "freakout" remains after the LSD effects are worn off. Occasionally, they pop up days or weeks after the experience for no apparent reason. Example: A married college student had taken marijuana and modest doses of LSD with very pleasurable results. He tried a 300-mcg capsule and for three weeks thereafter was very frightened, saw small animals crawling around the room, and had terrifying feelings that time had stopped. At night he walked the streets with his wife because he was afraid to close his eyes. "I would have killed myself if I didn't have her," he stated. He wondered whether he would "ever get out of this." The condition eventually subsided with psychiatric treatment.

A few homicides have been reported, but these are unusual; suicide is more apt to occur. However, with a new sort of LSD usage, aggressive behavior may become more common. I am referring to binge LSD-taking in which the "acidhead" keeps upping the dose so that he remains drunk for days. The effects resemble alcohol intoxication, with staggering gait, amnesias, confused thinking, and impulsive acting-out behavior.

The most common of all LSD complications are chronic anxiety states. A student was reluctant to take LSD but was finally persuaded by a friend to take "half a cap," or about 150 mcg. For months thereafter, he was unable to study or concentrate on anything. He had to drop out of school because it was impossible to sit still in class or prepare his assignments. There were strange feelings of the meaninglessness of life. At times everything was all right; then time started playing tricks, and objects would start moving. He wondered whether

he was going crazy and occasionally thought about suicide. With much support, reassurance, and tranquilizer therapy the condition gradually subsided.

Many other things have happened. Children have gotten into the family stockpile of sugar cubes, people have remained severely depressed after one or more LSD exposures, and, in panic, a person may run out of a window instead of a door.

The social complications are no less serious for the individual than the psychiatric ones. In tenuously adjusted people the return from Lysergia may be incomplete. Aspirations and values may be lost along the way. Nothing has any worth—study, work, and family interests dissolve. They find a few similarly disaffiliated people and form cults where speech is a pseudophilosophic jargon and the height of oneupmanship is to be "cool." A few drift on to antisocial acts. Two deculturated men sold LSD, heroin, and cocaine. Their judgment was so impaired that eventually they sold them to narcotics officers.

The physical dangers are few. Dependence occurs in some personality types. A human death directly due to LSD poisoning has not yet been recorded. But even if it has happened, most coroner's laboratories are unable to perform the test for LSD at present.

ALPERT

THE DANGER OF GETTING CAUGHT

The next biggest danger, as I understand it, is fear—which is, of course, the result of loss of trust. Timothy Leary provides us with the following list of the five most common fears provoked by the notion of consciousness expansion:

1) <u>Cognitive</u>: the terror of the loss of rational control; the fear of disorientation and confusion.

2) <u>Social</u>: the terror of doing something shameful, or ludicrous; the loss of social inhibitions.

3) <u>Psychological</u>: the terror of self-discovery; of finding out something about yourself that you do not want to face.

4) <u>Cultural</u>: the terror of discovering the painful truth about the institutions with which one is identified; of seeing through the tribal shams; of becoming disillusioned with one's social commitments and thus an irresponsible person.

5) <u>Ontological addiction</u>: the terror of finding a realm of experience, a new dimension of reality so pleasant that one will not want to return

All of these fears are frequently equated to fear of death. Each of the five elements of the ego structure are built up out of teaching, experience and habit to the point that each is taken as a part of identity. The respective fears are of a shattering, a fragmentation of this identity. And the fear of such shattering is the equivalent of, and indistinguishable from, the fear of death. But this construct of the identity is found to be an illusion. One who has the courage to undergo the shattering of the illusion will die, but will die in the mystical sense, ". . . so that he may live again." A Zen couplet says: "Be dead, thoroughly dead, and do as you will." It is the healing process which Tillich describes as "taking a walk through hell." To have courage to walk through this hell brings the transcendence that lies beyond.

Like other forms of anxiety, these five fears are related to deep yearnings and potentials in man. For each terror there is a corresponding liberation.

The cognitive terror is a negative interpretation of the desire to go out

of your mind to gain your head. Transcendence of mind makes possible new realms of insight.

The social terror of "acting out" is a negative interpretation of the ancient axiom (Taoist, Zen, Buddhist) that you must go out of your mind to reach that creative quietude which is open to enriched experience.

The terror of seeing yourself is the negative aspect of the possibility of seeing beyond yourself.

The fear of cultural disillusionment is the negative aspect of the possibility of seeing into new institutional solutions.

The terror of ontological addiction is the static and negative interpretation of the goal of internal freedom, the ability to move voluntarily from one level of consciousness to another, just as the scientist focuses his vision from the microscopic to the telescopic.

[Timothy Leary, Introduction to LSD: <u>The Consciousness-Expanding Drug, op</u>. cit., pp. 16–18.]

Q.
Why do some people have horrible lsd experiences?

ALPERT

Most horror is caused by just plain dishonesty.

There are two critical periods in inner-space journeys which closely parallel the difficult moments in outer-space travel: (1) the period during which one is "getting out there," or leaving the familiar atmosphere, and (2) the period of reentry. During the period in which a person is "out there," he seldom experiences any difficulty for which he does not have the necessary perspective.

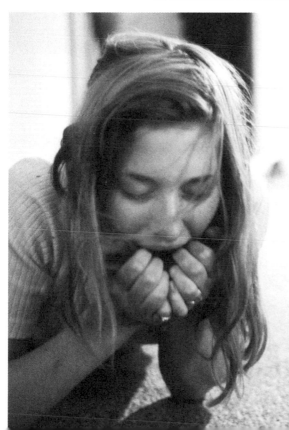

1. <u>Getting out</u>. The difficulties in "getting out" are often the result of poor preparation, or lack of either trust in one's guide or feelings of safety with one's surroundings. The difficulty usually occurs during the first hour or two of a session and usually has attendant symptoms of anxiety, nausea, extreme fear or panic about the prospect of relinquishing control, external hallucinations, and the wish that one had never gotten into the situation in the first place. This difficulty is usually encountered when something unexpected occurs, internally or externally. ("My God, my body is disappearing!") This is all part of the breaking up of the ego or familiar perceptual framework. It is the period of psychological death. Under low dosages it is sometimes possible to withstand this disintegration of the familiar perceptual matrix; to struggle in this way, however, necessitates great expenditures of energy, with concomitant symptoms of slight hysteria and hyperactivity. The person is simply refusing to "let go, trust your nervous system, and float downstream."

People who struggle in this way usually report considerable fatigue after the session. A good guide or friend can often cut through this momentary panic very quickly through his own quiet concern and calm, communicating an empathic "thereness" and understanding compassion without getting "caught" in the other person's "dance." Familiar music, a candle flame brought into view, or a simple mantra such as "Wherever your attention alights, at this very point, experience"; or, more simply still, "Yes, Yes, Yes"; or the offering of a piece of fruit—each of these at one time or another

> The key to enlightenment and serenity during the period of ten thousand visions is simply this:
> Relax.
> Merge yourself with them.
> Blissfully accept the wonders of your own creativity.
> Become neither attached nor afraid. Neither be attracted nor repulsed.
> Above all, do nothing about the visions.
> They exist only within you.
> [T. Leary, R. Metzner, R. Alpert, The Psychedelic Experience; A Manual based on The Tibetan Book of the Dead. New Hyde Park, New York: University Books, 1964, p. 121. "Psychedelic Monograph I."]

Of course the worst thing that can happen is when fear precipitates the involvement of a person outside of the session who does not experientially understand the psychedelic state.

2. Getting back. The second type of difficulty is felt during reentry. If a person tries to come back too fast (e.g., prematurely making social contacts or terminating the session), or if the setting is not loving and supportive, he may return with the sense of feeling caught, anxious, or depressed. When this happens to me, I usually just find a quiet spot and go back out through the use of a mantra such as "Eyes closed, see your inner being in detail. Thus see your true nature."—thereby finding my calm center and then making a new entry. Once you realize that you can "handle the controls" during reentry, much of the anxiety is dispelled.

There is another kind of reentry problem: the depression one can experience if one has just returned from the dimensions of light and beatitude only to be confronted, with rude force, by the former pale and appalling world of rude and ugly human "games" (the war in Vietnam, a bad marriage, etc.)—now felt as rude, now seen as ugly. But one can find such situations depressing without benefit of chemicals, and many thoughtful people will continue to persist in such depression until personal life has been put in better order and a way has been found by which one can participate even more honestly, lovingly, and responsibly in the contemporary world.

Everyone has many dark rooms in his head. And at one time or another we may choose to visit these rooms and try to poke around. Certainly this is hard but not without considerable growth value. And in a supportive setting it is well worth the illuminating candle.

It is well to meditate before a session and allow a full day for a gentle and reflective reentry.

COHEN

LSD experiences can be horrendous for a variety of reasons; some are known, a few still unknown.

1. *Difficulty in "letting go."* Some individuals find it difficult to let go of their ego controls and lose themselves. Even when they consciously want to drop their grasp on themselves, on an unconscious level they fear what may come forth

when their defenses are down. The overintellectualizer typically finds it hard to let go of his primary asset, his ability to keep a tight, rational fix on his situation. A hectic struggle between the drug and the intellect ensues.

2. *Personality Structural Disorders.* In addition to those who should not take LSD (see page 77) almost all of us have a sufficiency of repressed, buried, hurtful memories. When these happen to be unleashed they can be overwhelmingly frightening and produce a disintegration of mental functioning, fearful symbolic visions, and a tortured LSD eternity. The reason why most LSD experiences are not "bum trips" is that personal problems are bypassed and not dealt with. In certain types of LSD psychotherapy they are deliberately brought forth and, with the therapist's help, resolved. It is the unusual person who can accomplish this on a do-it-yourself basis, because instead of escaping from the painful recall, he must penetrate it repetitively. This is hard to do.

3. *The Setting.* A chaotic or confusing setting is not conducive to a positive experience. If demands are made of the LSD-taker, it can lead to difficulties. A real or imagined lack of security is upsetting. Some people have taken the drug alone and have not had trouble, others have become terribly frightened. The closeness of another human whom one trusts is important.

4. *Other Factors.* We know little about the importance of body type, the day-night cycle, the menstrual cycle, and other rhythmic alterations of the metabolism upon the resulting LSD experience. Nothing is known as to whether barometric changes, temperature, or humidity play any role. Medications alter the LSD state, with stimulants tending to enhance and sedatives tending to depress the mood. It is for this reason that it is surprising to hear that "Vodka Acid" is gaining in popularity.

We shall see increasing numbers of horrendous experiences as the drug is taken more frivolously by less and less mature individuals. The "freakout" is no complication of LSD, if it subsides with the waning of the drug effect. It is true, on the other hand, that the prolonged adverse reactions just described tend to follow the negative experience.

Q.

Why are set and setting so important in the lsd experience?

ALPERT

Set = your expectations or predispositions at the beginning of the session. Setting = where, when, and with whom you have the session.

> ... the chemical ... initiates a chain of biochemical and physiological events in the central nervous system, the end result of which is the suspension or deactivation of perceptual and cognitive structures involved in categorizing the perceived environment. The two main sources of stimuli to conscious awareness, the internal state and the external environment, are therefore capable of exerting a much more direct effect since they are not subject to the usual categorizations. In other words, there is greatly increased openness and suggestibility to both "set" (internal cues) and "setting" (external cues).

[R. Metzner, G. Litwin, G. M. Weil, "The relation of expectation and mood to psilocybin reactions: a questionnaire study." Psychedelic Review, V, 1965, p. 32.]

For about ten years in the United States, the psychedelic chemicals were labeled "psychotomimetic," i.e., drugs which mimic psychosis, make you crazy, and they were administered in mental hospitals to normal subjects to make them schizophrenic and thus learn about schizophrenia. During the ten hours of the sessions, most of the subjects went crazy!

On a certain Good Friday, the psychedelic chemicals were administered to divinity students during the religious service in a chapel—nine out of ten of the subjects had the most religious experience of their lives.

Two medical LSD researchers were at a conference sponsored by the Josiah Macy Foundation. During a discussion about the supposed addictive qualities of LSD, one of them says that he has administered LSD to over 150 subjects and not one of them ever wanted to take it again. The other doctor was somewhat surprised: he had given LSD to approximately the same number of people and "almost all of them wanted to take it again." Same drug, same dosage

The preparation for a session determines in large part your "set." Here, for example, are two preparatory sets of instructions:

> . . . You must be ready to accept the possibility that there is a limitless range of awareness for which we now have no words; that awareness can expand beyond the range of your ego, your self, your familiar identity, beyond everything you have learned, beyond your notions of space and time, beyond the differences which usually separate people from each other and from the world around them.
>
> You must remember that throughout human history, millions have made this voyage. A few (whom we call mystics, saints or buddhas) have made this experience endure and have communicated it to their fellow men. You must remember, too, that the experience is safe (at the very worst, you will end up the same person who entered the experience), and that all of the dangers which you have feared are unnecessary productions of your mind. Whether you experience heaven or hell, remember that it is your mind which creates them. Avoid grasping the one or fleeing the other. Avoid imposing the ego on the experience
>
> Whenever in doubt, turn off your mind, relax, float downstream. [The Psychedelic Experience, op. cit., p. 14.]

> Come on, Man, scoff the acid The chicks have already taken theirs. What are ya, chicken or somethin'?
> [A friend.]

I take LSD only when I "feel" ready and in a setting which I feel is supportive. Novices should pick settings where (1) the paranoia-count is low (2) they are with someone they trust, and (3) they won't be disturbed. Then they should stay there!

COHEN

The matrix in which LSD is taken, the anticipations, the fear, and the total impact of the surroundings are important in shaping the experience. They help determine whether the resulting state is sensory, sensual, inward searching, self-transcendent, disorganizing, esthetic, etc. The reason set and setting are of such consequence is that the person under LSD uses the slightest cues from

without (and from within) and overresponds to them. He is emotionally liable; what might ordinarily have caused a smile produces unquenchable laughter— or tears. He is hypersensitive, hypersuggestible, and readily influenced by the things and people around him.

In an early study using LSD we deliberately altered our attitude toward our subjects. When we were friendly, they saw beautiful patterns in warm reds and yellows and felt quite euphoric. When my co-worker and I went over to a corner and whispered, many of them became suspicious, the colors they saw turned pasty green or dark purple, even our faces became threatening and diabolical.

Banal comments carelessly made can become overpoweringly meaningful. The most trivial of statements becomes an eternal verity, reverberating down the corridors of the mind and altering the course of an entire experience.

To sort out fantasy from truth under such conditions is most difficult, especially for the mentally undisciplined. For this reason we instruct our subjects to make no decisions on the basis of their "insights" under LSD until they have been tested and retested in the days to come. Valid insights can come forth just as invalid ones can. They must be sorted out and not indiscriminately accepted. We have examined the records of a man who became convinced under LSD that he had smothered his younger brother when he was very young. He was so disturbed about this remembered murder that he went to the police and "confessed," and later required placement in a state mental hospital. Meanwhile a thorough examination of the cause of his brother's death revealed no evidence to substantiate the strong conviction that came to him under the drug. It is probable that the memory was the recall of a wish. When his brother died of another cause, the guilt of having wished him dead lay buried until released with LSD.

For the same reason we cannot assume that the structure of the universe is revealed to us once the rational mind is stripped away with LSD. One can be programmed or self-programmed to accept any reality model from the First Bardo to the First Amendment. It is easy to understand how the credulous instantly become devout converts. To deal with such powerful and heady mind-molding matters requires more judgment and maturity than most of us possess. "If you are going to put up lots of sail," Gerald Heard once said, "you had better have a deep keel."

Q.

Can one escape from the games of life with lsd?

ALPERT

"It is a pleasure to me, my dear Harry, to have the privilege of being your host in a small way on this occasion. You have often been sorely weary of your life. You were striving, were you not, for escape? You have a longing to forsake this world and its reality and to penetrate to a reality more native to you, to a world beyond time. You know, of course, where this other world lies hidden. It is the world of your own soul that you seek. Only within yourself exists that other reality for which you long. I can give you nothing that has not already its being within yourself. I can throw open to you no picture gallery but your own soul. All I can give you is the opportunity, the impulse, the key. I can help

you <u>to make your own world visible. That is all</u>." (Emphasis added.)

[Hermann Hesse, <u>Steppenwolf</u>. New York: Holt, Rinehart & Winston, 1957, p.175.]

In this sense, escape is possible, even if only for a moment; not the escape into unconsciousness as in sleep, nor the escape into fantasy as with the opiates, but escape to freedom—the freedom to take a completely new photograph of the Here and Now—to stand aside from Maya, "the whole beautiful, dreadful, enchanting and desperate kaleidoscope of life with its burning joys and sorrows," and just BE!

George Ivanovitch Gurdjieff, the Russian mystic philosopher, describes the escape from the limiting prison of one's learned conceptual mind as follows:

> You do not realize your own situation. You are in prison. All you can wish for, if you are a sensible man, is to escape If a man in prison was at any time to have a chance to escape, he must first of all realize he is in prison. So long as he fails to realize this, so long as he thinks that he is free, he has no chance whatever. No one can help or liberate him by force ... against his will ... in opposition to his wishes.

[P. D. Ouspensky, <u>In Search of the Miraculous</u>. New York: Knopf ... p. 31.]

If anything, it is escape into LIFE!

A member of Intrepid Trips, Inc. in 1966, a group known for Acid Tests–nightly gatherings meant to simulate the experience of LSD with acid-laced punch, flashing stroboscope light, and music

COHEN

The promise that the LSD'er could evade the games of life was one of the first enticements proffered by the Leary-Alpert group. Via the psychedelic experience we would drop the perennial roles which we were acting. The artificial rules, uniforms, and language of our particular game would dissolve in a shattering transcendent experience.

What has happened? From my observation only the name of the game has been changed. It is no great advance to move from the "professor game" to the "martyr game"; in fact it is retrogressive. The "hip game" seems more formal in a deliberately informal way than the "square game." It is the "no-game game" players that are worse off than anybody. Theirs is a strenuous effort to be "cool," to have no values, no goals, no future.

Now we are seeing the ultimate in ritualistic game playing, and, strangely enough, with the aid of LSD. Look around the psychedelicatessens of Boston or Los Angeles and you will eventually see a purple-painted person with plaited hair. Maybe he is wearing a large dog collar or a leather jacket with a few meaningless words scrawled thereon. He is gamy, and his uniform and speech are the last

word in gamesmanship.

What should we hope for insofar as game playing is concerned? Certainly not the absence of rules, roles, regulations, customs—not in any society of more than one person. What we must not do is mistake the game we play—for life. We must not allow our game to overwhelm us. To avoid this, we must know our game well. The thorough recognition of the roles we play lightens the load, thins the armor we carry, dissolves the mask. This awareness can be achieved with or without LSD.

Q.

Is there any significance to the kind of lsd experience one has?

ALPERT

Of the hundreds of sessions I have had, no two have yet been the same. Considering the number of possible cellular combinations in the brain, or the number of incarnations on the Wheel, I anticipate that as long as I continued to have sessions, they would each be unique.

That's certainly significant!

COHEN

The other day after leaving a talk at one of our local campuses a young man caught up with me and asked: "Why do I have a 'bum trip' every time I take LSD? Is it me?" I thought for a few steps and said, "I will try to answer that if you tell me why you keep taking LSD?" "Well, I keep hoping for a good trip." "I won't keep asking why. I'll just say that it could be you—or a dozen other things." At that meeting one of the questions asked was, "Is there much difference between mescaline and LSD? Nothing like what was described in *The Doors of Perception* ever happened to me."

"I suspect that there is more difference between Aldous Huxley and you than between mescaline and LSD," was my reply.

A few studies have been done attempting to correlate the personality with response to LSD. These were completed years ago in an effort to determine whether the drug might have value as a psychodiagnostic test. The results were inconclusive. Considering the many other factors which can alter the LSD state, it comes as no surprise that the personality is not reliably revealed. Small amounts of LSD may be more instructive about the character than huge doses. In the former instance the observer may see the ego defenses come into action, in the latter situation they are demolished.

Having one or more problem-free experiences does not mean that you have no problems. After having had a series of blissful journeys, do not conclude that you have achieved a state of grace. A little while ago a young man stabbed his mother-in-law to death while under the influence of LSD. He may have disliked the lady, but we cannot be certain of this. Ego-alien feelings may dominate certain LSD ventures. The most powerful impressions emerge in the psychedelic state: that one can read and send thoughts; that one relives previous or knows future lives; that one can see through solid objects or fly

"We plan our sessions. We know exactly what we want to do and what we want to explore. We select certain types of music and even purchase objects for our trip. Today we bought a flower."

There were four participants . . . one a mathematician, another an English major, a third a graduate student in chemistry, and the fourth a secretary-trainee.

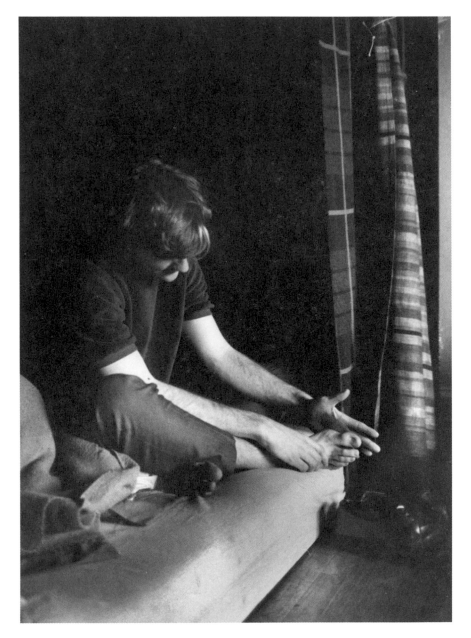

He sat alone for the first two hours.

"We want to explore"

*In a dress carefully chosen for this trip,
she stared at a gold light bulb.*

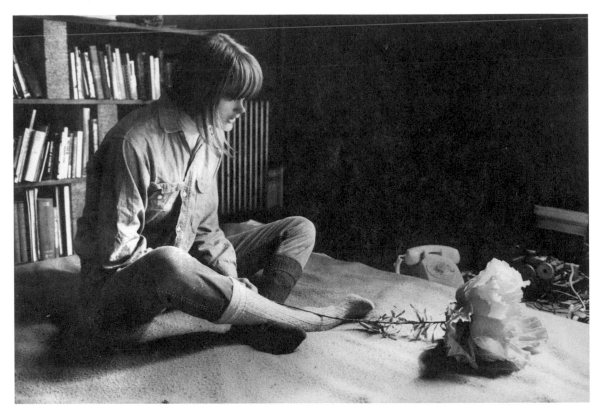

The flower was purchased earlier in the day.
Much time was spent with a toy frog.

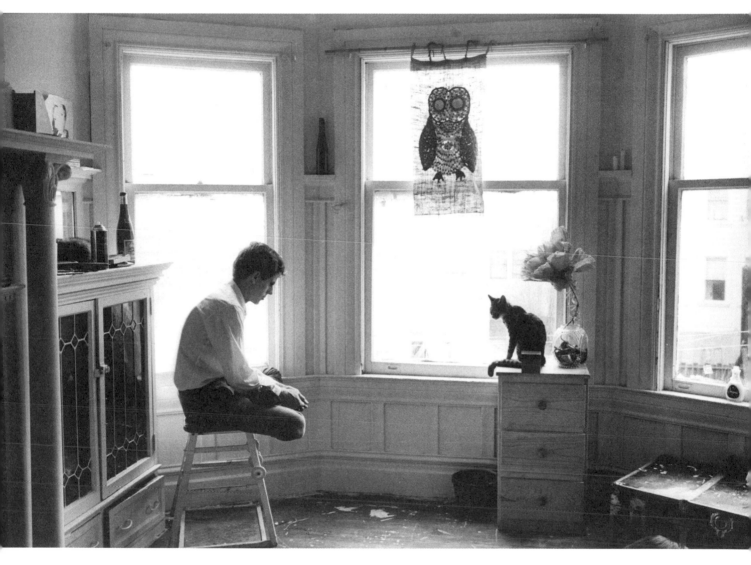

For over an hour, he sat alone with his cat.

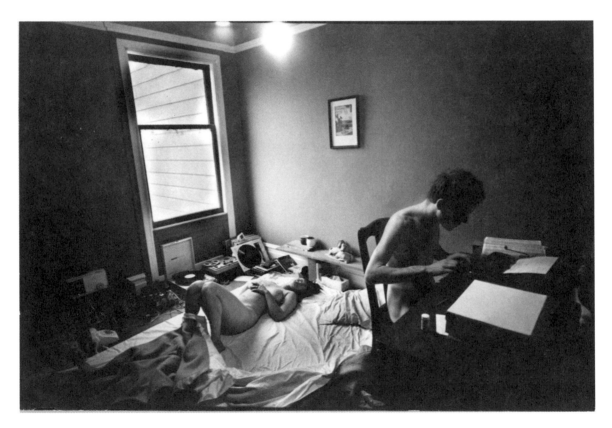

The nude part of the trip was planned from the beginning,
but at the end he sat and wrote a letter to his mother.

COHEN

I have little to say about this series of pictures. Without further hints of the content of each experience, it is unjustifiable to overinterpret what took place. A number of the pictures demonstrate the focusing of attention to a minute point in the perceptual field, a light bulb, the feel of a foot or an artificial flower. These can come to have great meaning. The last picture of the series intrigues me. If I had not read the caption, I would have imagined that the letter started, "Dear Dr. Kinsey."

ALPERT

At the root of much of the fear of the psychedelic experience is the sexual implication. Our Harvard Psilocybin Project gathered data concerning the relationship of the psychedelics to sexual activity. Our conclusions, which were quoted in Playboy Magazine in 1963 stated:

> Objective data about sexual reactivity is classically difficult to obtain. The early studies from psychological laboratories and psychiatric clinics reported that psychedelic drugs were not aphrodisiac. More recently, evidence obtained from more than twenty-five married couples taking psilocybin or LSD in their own homes seems to indicate that psychedelic substances can provide extraordinary intensification and broadening of all types of sensory experience, including the sexual.
>
> There are many factors involved, among which some of the most important are release from neurotic blocks, which enables the person to achieve healthy, mature sexual responses, and profound feelings of interpersonal communion and unity, which endow every action with beauty and significance. The increased sensitivity and awareness not only enhances the pleasurable aspects of sexual experience but also makes only too evident any manipulatory or crude seductive action on the part of any individual in the session.
>
> The expansion of the subjective time sense is another factor contributing to the intensity of the experience. There is a complex relation between dosage and the type of experience. With low dosages (less than 100 gamma of LSD), subjects report interpersonal intimacy and heightened genital responsiveness. With higher dosages, new forms of sexual experience are reported. These involve awareness of more basic forms of biological processes. Subjects tend to use such extravagant-sounding phrases as "cellular orgasm," "pulsating energy patterns," "internal fire flow," "melting and flowing of the entire body," etc., in their descriptions of these experiences. These results, interestingly enough, are quite similar to the accounts given by adepts of Kundalini Yoga and certain forms of Tantrism.
>
> [T. Leary, R. Alpert, and R. Metzner, unpublished research report.]

To incorporate sexual exploration into a psychedelic session program is a delicate matter demanding complete honesty and considerable trust on the part of the participants. Since 1963 I have had the opportunity to guide a number of married couples through sessions designed to explore their relationship with one another. Their marriages, as is the case with many marriages today, had lost the freshness and sense of discovery which keeps a marriage a living, vital contract. In some cases all that kept the couple together was the legal bonds or the children involved. But in all cases there was a desire on the part of each of the partners to grow within rather than outside of the marriage. The following is a description of one such guided session.

A Manual for Making the Marriage New

It is important that the participants be familiar with the psychedelic experience. It is assumed that both partners have previously had individual sessions, thus assuring sufficient familiarity with the unusual aspects of the experience to allow them to collaborate in a programmed session.

In preparing for the session the guide and the couple should discuss the entire plan for the session in advance—including the music to be played, the words to be spoken by the guide, the artifacts to be used, the dosage, the time involved, and the exact schedule and contract of the session.

The setting should be quiet (with no possibility of disturbance), beautiful, and comfortable for the participants. Two single covered mattresses are placed about six inches apart on the floor. Each partner lies on one of the mattresses with the guide sitting behind them. One candle is on either side of the couple.

Preparation

After ingestion of the psychedelic chemical the two partners relax quietly while familiar music is played interspersed with readings by the guide. One example of such a reading is the following from Kahlil Gibran's The Prophet.

> Then Almitra spoke again and said,
> And what of Marriage, master?
> And he answered saying:
> You were born together, and together you shall be for evermore.
> You shall be together when the white wings of death scatter your days.
> Aye, you shall be together even in the silent memory of God.
> But let there be spaces in your togetherness,
> And let the winds of the heaven dance between you.
> Love one another, but make not a bond of love:
> Let it rather be a moving sea between the shores of your souls.
> Fill each other's cup but drink not from one cup.
> Give one another of your bread but eat not from the same loaf.
> Sing and dance together and be joyous, but let each one of you be alone,
> Even as the strings of a lute are alone though they quiver with the same music.
> Give your hearts, but not into each other's keeping.
> For only the hand of Life can contain your hearts.
> And stand together yet not too near together:
> For the pillars of the temple stand apart,
> And the ak tree and the cypress grow not in each other's shadow.
> [New York: Knopf, 1946, p. 20.]

Another preparatory reading is the following adaptation of the Tao Sutra 10 by Timothy Leary:

> Can you float through the universe of your body and not lose your way?
> Can you lie quietly
> engulfed
> in the slippery union
> of male and female?
> Warm wet dance of generation?
> Endless ecstasies of couples?
> Can you offer your stamen trembling in the meadow
> for the electric penetration of pollen
> While birds sing?

Twist sinuously on the river bank
While birds sing?
Wait soft-feathered, quivering, in the thicket
While birds sing?
Become two cells merging
Slide together in molecule embrace?
Can you, murmuring
Lose
All
Fusing
[Psychedelic Review VII, p. 18.]

Stage I

As the chemical starts to take effect, the guide places next to each of the participants a mirror so that each participant can look into it and see his own face—only. As agreed upon in advance the two participants turn away from one another and each looks into his mirror. After a period of silence the guide speaks (it is agreed upon in advance that during the session the partners will not speak):

"Who am I?"

At five minute intervals he repeats the question

"Who else am I?"

(Those of you who have looked into a mirror during a psychedelic experience I'm sure recall the multiplicity of faces/the flowing changing features/the recognition that we are all all-human beings-in-One.)

As the guide repeats the question over and over, the partners see themselves in all the familiar ways in which they know themselves—both ugly and beautiful. The guide says:

"Keep going behind each face until you find your own calm center."

Stage II

(The time for the onset of this stage is determined by the guide who will sense the completion of Stage I.) He then moves one of the candles between the two mattresses and removes the mirror and extinguishes the other candle. As agreed upon in advance the partners are now to look at one another. They are not to engage in any body contact, or, for that matter, to make any social contact during this stage. They are merely to study one another. The Guide says,

"Now look at your partner and see who he or she is"

Again at intervals the guide repeats,

"And who else?"

After a number of repetitions the guide says,

"He is all men. She is all women. Keep looking behind each face until you find his or her calm center."

Stage III

(The time for the onset of this stage is again determined by the guide who senses the completion of Stage II.) He then removes the single remaining candle, joins the hands of the couple and says:

"Now, listen carefully to one another's bodies. Through their merging you shall find a new calm center."

The guide, as prearranged, extinguishes the candle, then leaves the room and remains on call in another part of the house.

This ends one example of a manual for making a marriage new.

"I am not a coward"

She recalled that everything seemed funnier and funnier.

It was 9 P.M. and they had all come from a jazz session.

One was a sculptor, another a student, one a photographer and another a high school gym teacher. The latter had been operated on, for the second time, a week before, for cancer, and consequently had had to be sterilized. She did not want to be left out and requested the acid. This was her first trip; the others had taken LSD several times before.

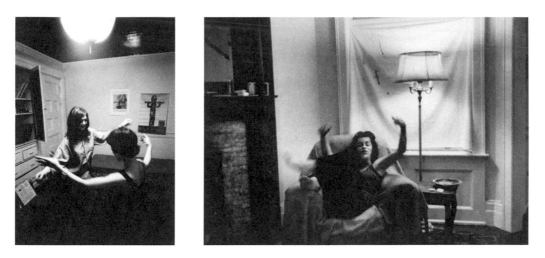

At first she danced to East Indian music. She got sleepy and waited for the effects of the chemical, not expecting anything different form getting high on alcohol.

It seemed to her everybody was howling with laughter.

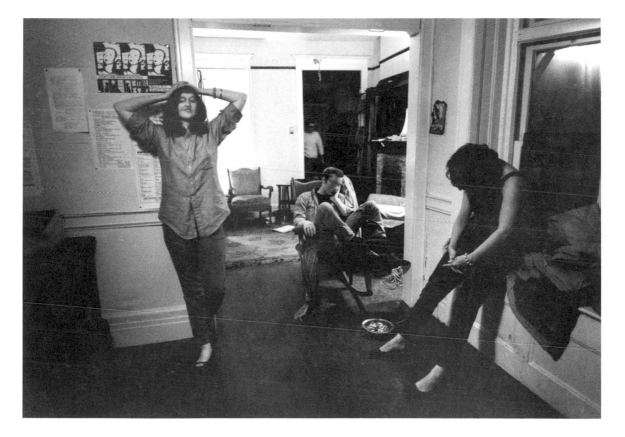

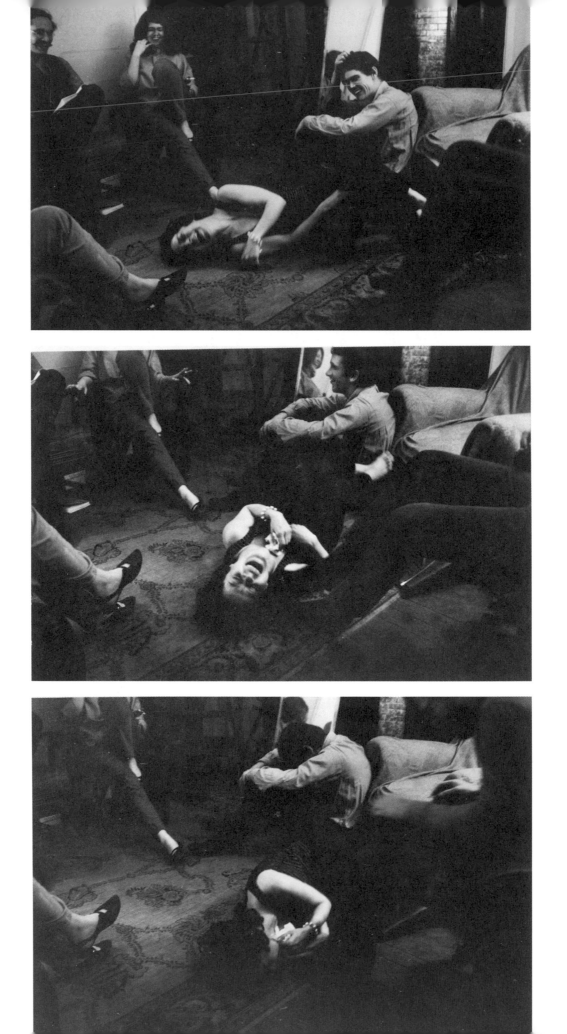

No exploration of herself was planned. "It did not even enter my mind." She was

enjoying herself. "Then I closed my eyes and visions from the past came."

Even though she did not remember being on the floor she recalled later:

"I saw myself walking through a graveyard and then I saw my family. I saw them

turn into stones in the cemetery and, as I walked by, they broke into pieces. I began

to see things that I didn't want to look at. It became a merging of what had really

happened and what I thought had happened."

"I remember getting cold, as if it was freezing, and I kept on seeing these things

happen over and over again and it made me understand whether or not I was

responsible for them. A friend of mine had committed suicide and I heard him say,

'I'll be someplace where you won't be able to see me unless you have the courage.'"

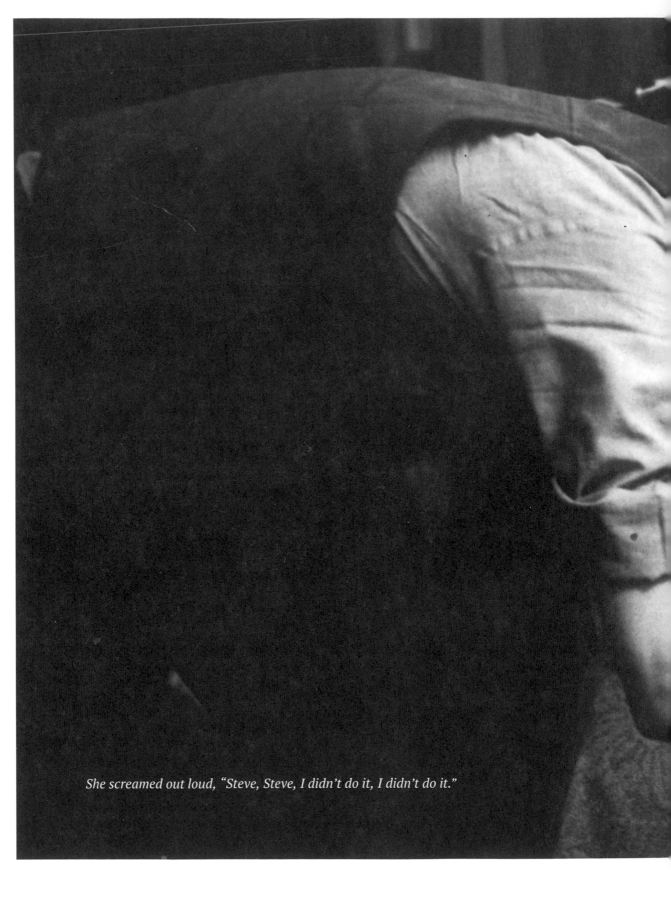

She screamed out loud, "Steve, Steve, I didn't do it, I didn't do it."

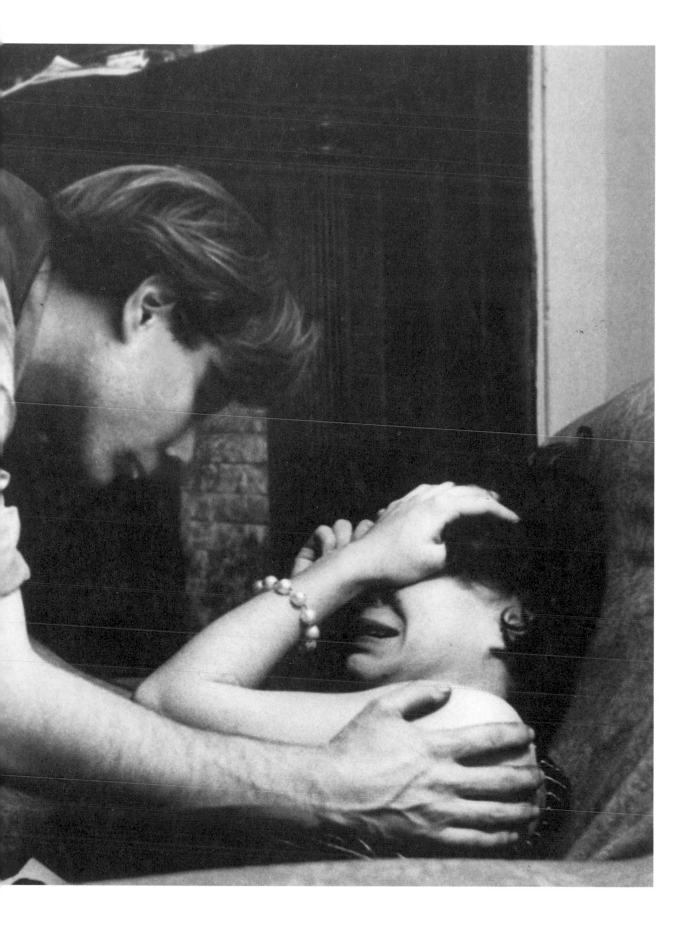

"I saw another friend get killed. I saw the auto accident.
He wasn't a lover, but I have blamed myself."

"I started to realize that I had strong feelings of guilt
and I had to deal with them on some level."

"I used to dream, but a dream was not like what I was going through.
A dream is over and you don't remember specifics.
This is more real and vivid and I remember it very clearly."

"Later, we sat upstairs in the bedroom and I talked about the guilt feelings
that I had. We discussed how I was used to fully shutting things out of my
mind. It was now obvious that at that age I was not capable of destroying a
marriage. You see, I was only six when my father left home and our family
broke up. I really don't mind reliving the suicide, and, even though it may
seem like a horrible experience, I am anxious to explore more deeply."

"About my health, it didn't enter into my trip at all. I've been operated on
twice for cancer. The first time, there was no hope. I should be dead by now.
Now they're a little more optimistic. My condition is uncertain but, of course,
I won't be able to have children. I really don't mind dying because I'm not a
coward. I may die in six months, live forever, but I may die tomorrow anyway."

"I do plan to take LSD again. I'd rather it be with a small group
and I hope to go back and deal with the things that maybe I didn't
have the courage to deal with in my previous session."

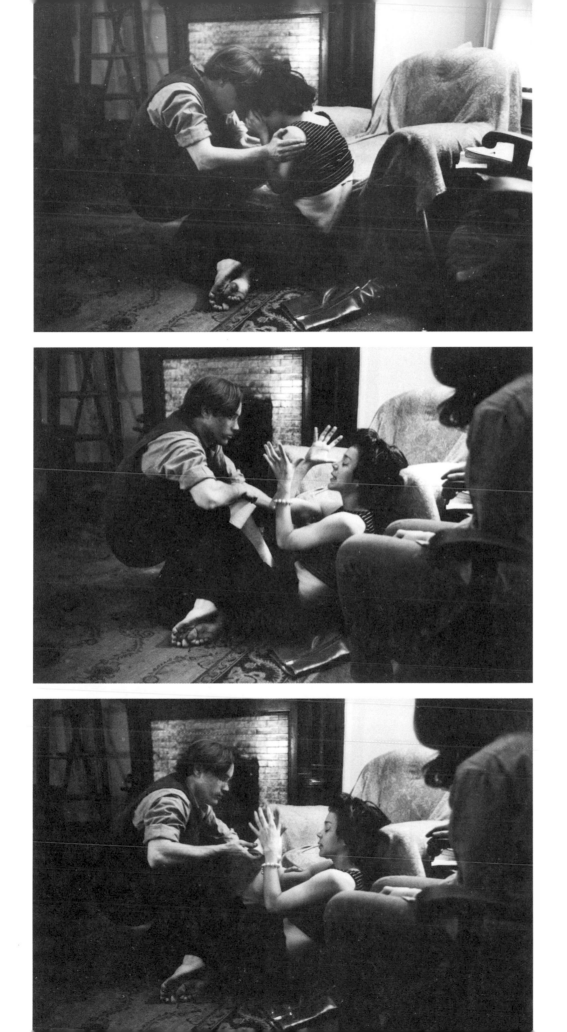

ALPERT

A CENTER FOR DYING AND BEING BORN.

It was on a Saturday in 1962 that one of the members of our research group first showed me the Evans-Wentz translation of The Tibetan Book of the Dead. As I leafed through this book, the original of which is reputed to be over 2,500 years old, I came to a passage in the section on Second Bardo Hallucinations. It brought me up short. There, in most minute detail, was a description of an experience I had had but two nights previously in a psilocybin session—an experience which I had described immediately after the session as "ineffable." How indeed could I have experienced something which had been written 2,500 years earlier as a preparatory manual for dying and being reborn? Tim Leary had already seen the parallel, and he and Ralph Metzner were already busy adapting The Tibetan Book as a manual for a psychedelic experience—with dying referring to the death of the ego, or psychological death. This adaptation we later published as The Psychedelic Experience.

But that is only the beginning of my story. Shortly after this event with The Tibetan Book I was up in Canada having cocktails with a wealthy woman in her seventies who had invited me over because of her interest in LSD. I had gone partly in the hope that her interest would lead her to help support our Castalia Foundation, but also because I was fascinated by the interest in LSD of a woman of her age. When I asked her why she was interested she said, "Well, the next big thing I have in store is to die, and I suspect that LSD might have something to do with that step."

And then there was Aldous Huxley, who drew up the blueprint for a death with awareness in his final novel, Island, in which he came to terms with what was so soon to be his own death.

> "Lightly, my darling, lightly. Even when it comes to dying. Nothing ponderous, or portentous, or emphatic. No rhetoric, no tremelos, no self-conscious persona putting on its celebrated imitation of Christ or Goethe or Little Nell. And, of course, no theology, no metaphysics. Just the fact of dying and the fact of the Clear Light. So throw away all your baggage and go forward. There are quicksands all about you, sucking at your feet, trying to suck you down into fear and self-pity and despair. That's why you must walk so lightly
>
> "The Light," came the hoarse whisper, "the Clear Light. It's here—along with the pain, in spite of the pain."
>
> "And where are you?"
>
> "Over there, in the corner. I can see myself there. And she can see my body on the bed."
>
> "Brighter," came the barely audible whisper, "brighter." And a smile of happiness intense almost to the point of elation transfigured her face.
>
> Through his tears Dr. Robert smiled back at her. "So now you can let go, my darling." He stroked her gray hair. "Now you can let go. Let go," he insisted. "Let go of this poor old body. You don't need it anymore. Let it fall away from you. Leave it lying here like a pile of worn-out clothes Go on, go on into the Light, into the peace, into the living peace of the Clear Light."
>
> [Aldous Huxley, Island, New York: Harper, 1962, pp. 304–305.]

The next chapter of my story came with the phrase "I know I'm dying . . . but look at the beauty of the Universe." That phrase has haunted me perhaps more than any other in my life. I read it originally in the World Medical News in an article by Dr. Eric Kast, who had given LSD to fifty terminal cancer patients to alleviate their pain. There were charts in the article that showed that LSD did indeed alleviate the experience of pain. But it was that quote from the lips of one of the patients that kept coming back

to me: "I know I'm dying but look at the beauty of the Universe."

It was many years ago that I read a nonfiction account by a woman of the death of her husband. The major portion of the book concerned the extraordinary efforts and lengths to which they had to go in order that he might die with dignity. A look around today tells us that he would still have the same difficulty—for even beyond the taboo of sex in our culture is the taboo of death. Even as you take your last breath you are surrounded by "cheerful" doctors and nurses and relatives and "friends" who, themselves so scared of death, constantly are reassuring you that "You'll be up and around tomorrow," or, "You're really looking better today." Is that facing death with dignity?

It was not until 1964 that I put two and two together, so to speak, and came up with a model for a "Center for Dying." Why shouldn't there be a place where a person could come to die with awareness instead of denial, where the setting, be it mountain or ocean, would be suitable for the transformation; where the staff would be trained as guides to help people with the aid of psychedelics to learn about giving up the ego and seeing the beauty of the Universe. The individual could have doctors, if he or she wished, and could die in whichever religious metaphor he might choose. But each person would have a psychedelic guide in addition.

I started to lecture about this idea in 1964 and somebody suggested that we expand the concept and call it instead the Center for Dying and Being Born . . . and include preparing mothers for conscious natural childbirth delivery, thus making the new institution a totally cyclic one.

The parable I think of most often when I think about the Center for Dying is the following:

> A man traveling across a field encountered a tiger. He fled, the tiger after him. Coming to a precipice, he caught hold of the root of a wild vine and swung himself down over the edge. The tiger sniffed at him from above. Trembling, the man looked down to where, far below, another tiger was waiting to eat him. Only the vine sustained him.
>
> Two mice, one white and one black, little by little started to gnaw away the vine. The man saw a luscious strawberry near him. Grasping the vine with one hand, he plucked the strawberry with the other. How sweet it tasted!
>
> [Paul Reps, Zen Flesh, Zen Bones, New York: Doubleday, 1961, pp. 22–23.]

No one has yet bought the idea for the Center for Dying.
But someone will.

COHEN

The first effects of LSD can be similar to alcohol for some—a release, perhaps an outpouring of laughter. Later, the gym teacher uncovered memories which had never been faced completely—they were all of death. I suspect her own possible death contributed to the direction her fantasies took.

This could have been an important experience for her. With guidance she could have dealt with the implications of her own death and gained a good deal of surcease from the encounter with her own nonexistence. The last few hours were what is commonly called a "bum trip." Actually, it was an important trip wasted, because she suffered without gaining a new attitude toward death. I hope she did learn something which will help her. Her willingness to penetrate into these matters requires more than courage, it requires direction. It is rather unusual for a person to be able to do this herself. Keeping the LSD subject on target is a job for a therapist, for our minds will sometimes play all sorts of tricks to evade the very painful and avoid dealing with it.

Q.

What is the relationship between personality change and the lsd experience?

ALPERT

LSD should be included in every Do-It-Yourself Personality-Change Kit (also called "working through Sansara").

Let me start by introducing you to the loggerhead turtle. The mother turtle digs a hole in the sand near the water and lays her eggs and then leaves. After the baby turtles are hatched, they stay around the nest for about five days and then walk down to the water and swim away. Nobody told them to do that, so it must have been built into the babies at the time of birth. Now if an experimenter places a screen between the nest and the water during the period between the fourth and eighth day (thus preventing the babies from seeing the water) and keeps the baby turtles in the nest, when he removes the screen and allows the babies their freedom, they will walk off in all directions. Only those who get to the water by chance survive. This is a demonstration of a phenomenon called critical period. Further tests have demonstrated that between the fifth and eighth day the baby turtle's retina is sensitive to the light reflected from the water, which acts as a signal to elicit a behavior pattern already built into the baby turtle, i.e., walking toward the light. After the eighth day, the eye has developed to a point where it is no longer sensitive to this particular light.

You have all seen baby ducks following their mother across a field (or at least have seen movies of this behavior). For the baby ducks, there is a critical period during which any large moving object in their field of vision elicits a following response—and whatever that large object is, they fix in their minds and follow it ever after. Experiments have been done which demonstrate that at the critical period, if the experimenter substitutes a large orange basketball for the mother duck, the baby ducklings will follow the orange basketball—even when later given a choice of the mother vs. the orange basketball. This process of fixing a specific object in mind has been labeled "imprinting."

One more example. Sheep hang out together in a field—they are thought of as gregarious. But if at the critical period of development you were to separate the lamb from the flock for a period of time, from then on that particular sheep would hang out by itself away from the flock.

One of the dramatic characteristics of these imprinted behaviors has been their irreversibility—that is, once they are formed, they are difficult to change. Recent research has demonstrated, however, that certain chemicals, when administered to the adult animal, seem to open the whole matter up anew and allow for the unlearning of old imprints and the forming of new ones.

These examples provide, I think, a good parallel to the way in which LSD could work in personality change in humans. Your early learning leaves a set of imprints or chemical photographs in your brain which determine which orange basketballs you follow. Of course you would develop a number of rationalizations for following the ball in preference to the mother—it's cleaner, rounder, less chance of Oedipal problems, etc.—but you would nevertheless live out the results of these early imprints. This is, as I understand it, what personality is all about.

Now let us say that you would like to change your personality. You notice that all the girls you have been going around with look too much like orange basketballs, so you would like to take a new picture of WOMAN. You could design a psychedelic

session such that after you ingested LSD, which would provide you with some fresh "film" in your camera, you could take a new photograph or imprint a new woman.

This is, then, what we mean by "programming" psychedelic sessions—planning the session so that while you are in a state of expanded consciousness, you can re-view certain aspects of yourself or the world and form some new chemical associations or habits in your brain. Later I shall describe in somewhat more detail an actual programmed session for a man and woman—a session which is designed to provide them with a fresh look at themselves and one another.

In changing personality characteristics with LSD, there are a number of useful guidelines:

1. Don't try to do it during the first session. You will be too busy looking around. Programmed sessions only work when you have learned how to take off and land safely (see page 82).

2. Remember that personality is in layers, that is, earlier aspects of your personality are more at the core of your chemical–neural structure and therefore more related to every other aspect of your life. To change such core habits is difficult because it involves so many changes in other aspects of your behavior. So start with some relatively superficial characteristics until you get the hang of the process.

3. When you are well into your session, direct your consciousness (most effectively through prearranged instructions from a guide) to the set of habits you wish to re-view. Reflect on these habits historically and temporally until you have the many ramifications of the habit complex in your awareness.

4. In a later part of the session, surround yourself with pictures, people, or artifacts which you would like to imprint. Let yourself become one with these people or objects.

5. Following the session, try to create an environment for yourself which is maximally supportive of the new habits. (Don't spend all your time with old orange basketballs.)

6. As time passes following the session, try to remain conscious of the habits which are still unexamined that seem to pull you back into old patterns of behavior. Use these insights as the basis for programming subsequent sessions.

One of the best arrangements I know of is where two or more people enter into a contract to collaborate in growth. They plan sessions together, serve as guides for one another, and provide environmental support for each other in their attempts to "make it new." These groups often serve as the basis for psychedelic communities (see page 100).

Remember: Translating your experience into your daily life to make your life more humanly beautiful is the goal. A goal toward which one must move gently yet firmly.

All of this—it is to be remembered—is but one use of psychedelics.

COHEN

Certain aspects of personality structure may change as a result of LSD exposures. Most superficial, and therefore most amenable to change, are moral and social values. These may be reshuffled or erased completely. The relationship we have with the world can shift—how we perceive it, how we elaborate our modified perceptions, even the defenses we employ to remain intact. A shift from one mental mechanism, anxiety for example, to denial may seem like a reduction in discomfort and therefore desirable. This may or may not be so. Anxiety about internal conflicts could motivate a person to work on their solution. An unrealistic denial of the conflicts is satisfactory if successful, but

can be devastating if it comes into direct opposition to the actual life situation. The conflicts themselves are much more difficult to reduce, for many are laid down in infancy and the patterning of response is deeply ingrained. This does not mean that they are unalterable. With or without assistance they can become understood. Methods of coping with them can become more mature. Surmounting difficult life situations, enduring loss and defeat, these are paths toward personality growth. Eventually, one can achieve a state beyond defeat.

Some LSD states are beyond all conflict. But to remain there is impossible and even if possible it would not be desirable. Whatever might be gained from the experience called satori, Nirvana, the dark night of the soul, samadhi, the rising of the Light or the Now Moment, must be brought back here and applied to living this life. The hope of some psychedelic enthusiasts that, perhaps, the next dose of LSD will finally put them beyond conflict forever is their "hang-up."

I believe I have known a Zen saint; I have yet to meet an LSD saint. Houston Smith[6] has written:

> Drugs appear able to induce religious experiences, it is less evident that they can produce religious lives. This is hardly news, but it may be a useful reminder to those who incline toward . . . lives bent on the acquisition of desired states of experience irrespective of their relation to life's other demands and components.

If LSD produces desirable personality alterations (and I believe it possible, particularly, but not exclusively, with the aid of a psychotherapist) it does so when it demonstrates the need for change. Seeing the need provides the motivation. The hard work of change itself remains, the retraining of the ineffective habits of a lifetime. No instant magic can achieve this (nor the hopelessly inaccurate use of the word "imprinting"—still less the not yet discovered phenomenon of "reimprinting").

At a San Francisco session.

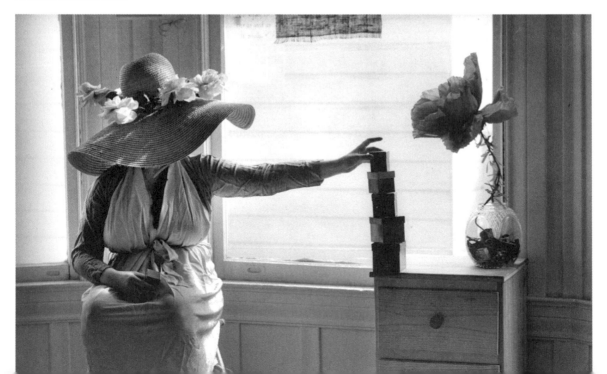

Q.

What is the evolutionary significance of the egoless, timeless, and spaceless experiences some people report under lsd?

ALPERT

I don't suppose the first creepy crawly creature to climb out of the ocean and up onto the land knew any better than I do.

Perhaps:

The entire evolutionary process is within the domain of imagination. [Meher Baba]

Or:

Evolution is just another chapter of hi(s)tory.

COHEN

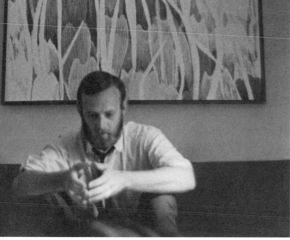

One view is that it represents a return to the earliest level of human existence—the condition before or shortly after birth. The infant is without self-identity and has no concept of time or space. It is the oceanic feeling of complete at-oneness. Perhaps this is the explanation of the profound loss of the most elemental of mental orientations—the sense of "I," the sense of time, the spacial awareness.

This condition occurs only at high dosage levels of LSD. It represents a complete inability to code not only incoming sensory messages, but also internal signals from the memory storage banks, the body sensations and the elementary function we call consciousness. The body remains, the heart beats, breathing continues. It is not sleep, neither is it dreaming. To call it a coma would be incorrect if only because upon returning from the state it is so highly regarded with feelings of awe, wonder, or personal power. It is not a disorientation, rather a nonorientation. The deep hypnotic trances and the most complete meditative states are similar. The most profound meditative states are similar. Apparently, brain-stem functioning goes on, and nothing more.

Another possibility that might be entertained is that the state of selflessness is a superlative manifestation of human mental potential. Rather than a regression to the most primordial level of functioning, it is in the evolutionary mainstream, a demonstration of what humanity will become capable of one day. As a permanent condition, it is scarcely compatible with survival. As a temporary journey from which one returns with new perspectives, it could have positive values.

No final opinion should be expressed about its significance. We can believe anything we wish, but not enough information is available to know. This is a region of vast unknowns which must be thoroughly explored one day.

Q.

What is the relationship between the chemical and nonchemical transcendental states?

ALPERT

In the East, many, many men spend a lifetime following a disciplined method of achieving transcendence. Very few of them make it. Those who do, however, obviously have created the optimum set and setting in which to Be, and thus they have a good chance of maintaining the state and functioning with full awareness at all times.

The Westerner is not prepared to undertake a discipline which one must pursue for many years on faith and with a low likelihood of success. Thus other more dramatic ways, such as the use of external chemical agents as catalysts, lend themselves more to his disposition. In but a brief hour he can achieve states of transcendence for which an Easterner must spend years (assuming, as many reporters do, that the two experiences are somewhat comparable, at least in certain aspects). And now with DMT, a chemical which provides a thirty-minute psychedelic experience of great intensity, any businessman can fit transcendence into his busy schedule during his lunch hour.

But there is a rub The Westerner can't maintain the state for longer than the duration of the action of the external chemical agent, because he has done nothing to alter his set and setting in such a way as to maintain this state. It may in fact turn out that all the external chemical agent can do is to show us the possibility (or at least point up the illusory nature of what we thought was our absolute reality). By doing this it clearly defines the journey and provides the Westerner with HOPE—the motivating impetus he needs in order to undertake the long and difficult path of getting his house in order.

The goal, as I understand it, is to be fully conscious or aware at every moment, despite your setting, and without external aids (other than those necessary for the survival of the body). The obvious advantage of such a condition is that you are unbustable—in every sense.

COHEN

Most studies indicate that important similarities between the two conditions are discernible. Of people who have undergone both, many assert that their nonchemical experience had certain qualities reminiscent of their chemical experience. We know that while some spontaneous transcendent experiences appear without apparent cause, others occur after long periods of physical depletion and mental agony. In this group, metabolic derangements of the body are likely; in effect, they have their genesis as an internal chemical disturbance. The event erupts in a moment of exhaustion, starvation, isolation, disease, or injury, with all the chemical and psychological correlates of these depletions.

Perhaps a more important issue is the significance of a spontaneous transcendent event in which the entire relationship of the self to the body and to the environment is felt in a new way—the customary viewpoint is shattered. It provides a novel look at old problems which have been plaguing the individual. Instead of breaking down into a psychotic chaos, he has "broken up" into an organized, revealing, problem-solving experience. The mazeway of daily existence is about to be restructured. One would imagine that such a spectacular

event at a crucial moment in a person's life must certainly be a turning point. He has seen, in the most impressive possible way, what is wrong and what must be done about it. A study of the subsequent life of those who have undergone such stupendous "out of the blue" experiences demonstrates that a surprising number do not alter their habitual ways and do not make the obvious necessary changes in their life. Some do, but, what is surprising, some do not.

If this is true of the much more impressive nonchemical transcendental experience, it is hardly surprising that a similar state achieved with the help of a chemical aid likewise is no broad highroad to a rejuvenated life. It seems to provide the opportunity for change just as the religious conversion experience does. Whether the individual grasps that opportunity depends upon his willingness to learn new habits, and the rewards or punishments that accrue as a result of the new behavior. I know of a few severe alcoholics who have abstained from drink for years after a single LSD experience and of one alcoholic who has assisted hundreds of drug addicts to remain "clean" by founding Synanon.

The spontaneous transcendental experience is impressive as an experience but the payoff rests in what happens afterwards. If it helps solve problems, if it leads to a more effective, constructive life style—fine. Examples of men who have reconstituted themselves and their culture as the result of a sudden conversion experience are well known. If it does not induce life repatterning, it has done nothing. Indeed, it has been known to add a further burden of guilt to those already overburdened, since they have "seen the light" and have failed to alter their course.

As to LSD-achieved transcendence, some of the differences from natural transcendence ought to be mentioned. The fact that a chemical has evoked the feeling of immanence diminishes its value in the minds of most people. The LSD form is ordinarily longer lasting, although the subjective feeling of timelessness in both may make this less pertinent. A major difference is in the preparation of the individual for his transcendent episode. Spontaneous self-transcendence tends to occur in those who have spent decades in struggling with life's conflicts or who have sweated to deliberately achieve the state. As LSD is being taken today, it is often by individuals who have fled from life's conflicts, and who also have lacked the wherewithal to persevere in the strenuous exercises which can induce it. A transcendental experience can become an unhinging event for the unprepared. For the prepared, it can be an opportunity.

Q.

Why has a link been suggested between the lsd experience and mysticism?

COHEN

The states called "mystical" are as varied as the states called "sanity." Certain common phenomena are encountered in most mystical experiences. These include: a loss of the self and a feeling of oneness with the universe; a dissolution of time-space orientation, a numinous sense of awe, wonder, or power, along with feelings of bliss, love, or ecstasy. The experience is indescribable with words, what are paradoxes under ordinary conditions are resolved, a sense of enlightenment about the nature of existence emerges, and a vision of extraordinary light and

beauty or of a visionary figure is seen.

The mystical event is a potent one and may transform the life of the person, those around him, and his culture. Very often these changes are beneficial; the person may cease a pernicious behaviorial pattern. The birth of the world's major religions is closely associated with one or more mystical experiences. In other instances either no persisting alterations result, or inappropriate beliefs of omniscience are retained.

Many of the features of the mystical state have been encountered during certain LSD reactions. Differences exist, but they are in degree, not kind. Differences in the total life experience of the person undergoing such a profound experience will determine whether or not it will have a transforming long-term value.

One is described here in part:

It was so packed with intensity of feeling, ecstasy, light, color, movement, laughter, tears and visions that I cannot describe it or remember much more than the overwhelming effect it had on me. It was indescribable, glorious, ineffable. Most of the time I was beside myself! I was carried, tossed on the creative sea of Being. Love poured through me with the power of Niagara Falls. Lights dazzled me. Colors spread out in iridescent designs. Waves of joy lifted me as in a dance and let me lightly fall again. All was in play, in rhythmic motion. There was no limit to anything. It was infinite, timeless, boundless, and I was part of it. I was penetrated and permeated with the many-splendored beauty of creation. I merged with it. All was unity. There were no barriers, no separations, no possibility of death—only transformation and an expanding consciousness of the creative wonder of Eternity. The human mind and heart could not contain it, and it swept through me shaking me to the roots of my being, shaking me like a fragile leaf in a terrific storm of incomprehensible wonder. Yet with all its power it was so infinitely tender and loving that it would not rend nor tear the leaf from its tree of life. Through all this, something in the center of me held firm and unshaken. I never felt anything like it in my life. It made me gasp for breath! I wept for joy that this inner vision was so wonderful beyond words, conception, or imagination. I was mad with love and the inability to express it. I knew I never could express it no matter how long I lived, or how hard I tried.

It is important to say that most LSD experiences of euphoria, hebephrenia, lapses of self-awareness accompanied by perceptual delights and sensory extravaganzas, have no relationship to mystical experience whatsoever. These are "trips" in a direction opposite to the mystical.

ALPERT

YOU BE THE JUDGE.

Below are seven reports or discussions of experiences. Three of them are quotes from reports of people who had ingested a psychedelic chemical, and the other four are descriptions or discussions of nonchemically induced mystical experiences. Place a check mark in the square next to the statements you believe to be produced through the use of LSD. You will find the correct answers listed in upsidedown print at the end of the answer to this question.

1. If this [primal me-ness] went, I would die because it was all that

was left of me. In this black void there was just me, I prayed accepting this death. God was walking on me and I cried with joy. My own voice seemed to speak of His coming, but I didn't believe it. Suddenly and totally unexpectedly the zenith of the void was lit up with the blinding presence of the One. How did I know it? All I can say is that there was no possibility of doubt. Down beneath, me; above, the One. Suddenly the light from above fused into the me below. Then I knew there was only God

2. I continued to look at the flowers, and in their living light I seemed to detect the qualitative equivalent of breathing—but of a breathing without returns to a starting point, with no recurrent ebbs but only a repeated flow from beauty to heightened beauty, from deeper to ever deeper meaning. Words like "grace" and "transfiguration" came to my mind, and this, of course, was what, among other things, they stood for. My eyes travelled from the rose to the carnation, and from the feathery incandescence to the smooth scrolls of sentient amethyst which were the iris. The Beatific Vision, Sat Chit Ananda, Being-Awareness-Bliss—for the first time I understood

3 an eye opens to discern various intellectual objects uncomprehended by sensation; just so . . . the sight is illumined by a light which uncovers hidden things and objects which the intellect fails to reach . . . [It] is like an immediate perception as if one touched the objects with one's hand.

4 We receive this mystical knowledge of God clothed in none of the kinds of images, in none of the sensible representations, which our mind makes use of in other circumstances. Accordingly in this knowledge, since the senses and the imagination are not employed, we get neither form nor impression, nor can we give any account or furnish any likeness, although the mysterious and sweet-tasting wisdom comes home so clearly to the inmost parts of our soul. Fancy a man seeing a certain kind of thing for the first time in his life. He can understand it, use and enjoy it, but he cannot apply a name to it, nor communicate any idea of it, even though all the while it be a mere thing of sense. How much greater will be his powerlessness when it goes beyond the senses! This is the peculiarity of the divine language. The more infused, intimate, spiritual, and supersensible it is, the more does it exceed the senses, both inner and outer, and impose silence upon them The soul then feels as if placed in a vast and profound solitude, to which no created thing has access, in an immense and boundless desert, desert the more delicious the more solitary it is. There, in this abyss of wisdom, the soul grows by what it drinks in from the well-springs of the comprehension of love . . . and recognizes, however sublime and learned may be the terms we employ, how utterly vile, insignificant, and improper they are, when we seek to discourse of divine things by their means.

5. I had the notion of "this is it—this is the moment of truth. I know that everything leads to this—complete harmony and ecstasy" We had arrived; we were unified with the ground of being, we were already transfigured—dead, and at the same time so intensely alive as never before. I experienced a sense of initiation and participation in a great mystery—everything became knowing and known. I felt omnipotent and endowed with superhuman, divine powers.

6 till all at once, as it were out of the intensity of the

consciousness of individuality, individuality itself seemed to dissolve and fade away into boundless being, and this not a confused state but the clearest, the surest of the surest, utterly beyond words—where death was an almost laughable impossibility—the loss of personality (if so it were) seeming no extinction, but the only true life. I am ashamed of my feeble description. Have I not said the state is utterly beyond words?

7 All at once, without warning of any kind, I found myself wrapped in a flame-colored cloud. For an instant I thought of fire . . . the next, I knew that the fire was within myself. Directly afterward there came upon me a sense of exultation, of immense joyousness accompanied or immediately followed by an intellectual illumination impossible to describe. Among other things, I did not merely come to believe, but I saw that the universe is not composed of dead matter, but is, on the contrary, a living Presence; I became conscious in myself of eternal life . . . I saw that all men are immortal; that the cosmic order is such that without any peradventure all things work together for the good of each and all; that the foundation principle of the world . . . is what we call love, and that the happiness of each and all is in the long run absolutely certain.

[Sources:

(YES) 1. LSD report of Wilson Van Dusen, Ph.D., Chief Clinical Psychologist, Mendocino State Hospital, California, in G. R. Jordan, Jr., "LSD and Mystical Experience." J. Bible & Religion, April, 1963, p. 119.

(YES) 2. A description of a mescaline experience. Aldous Huxley, Doors of Perception. New York: Harper Colophon Books, 1963, p. 18.

3. Al-Ghazzali, eleventh-century Persian philosopher and theologian, quoted in James, op. cit., p. 311.

4. St. John of the Cross, The Dark Night of the Soul, Book II, chap. XVII, quoted in James, ibid., pp. 312–313.

(YES) 5. Subject #142, Harvard Psilocybin Project, January, 1962.

6. Alfred Tennyson, letter to Benjamin Paul Blood, in Tyndall, Memoirs of Alfred Tennyson, II, 473; quoted in James, ibid., p. 295. The words immediately preceding the quote are as follows: "This has come upon me through repeating my own name to myself silently, . . ."

7. R. M. Bucke, Cosmic Consciousness, quoted in James, ibid., pp. 306–307.)

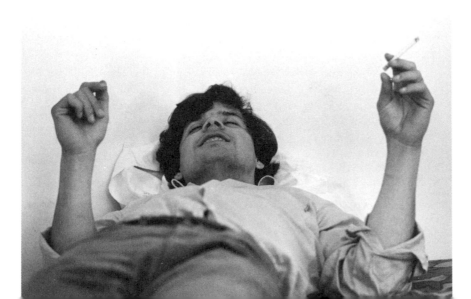

Q.
What are the implications for religion if a chemical religious experience is a possibility?

ALPERT

Many of my own experiences with psychedelics, as well as those of many of the people with whom I have shared sessions, have been so unquestionably religious that little doubt remains that the chemical religious experience is a possibility. What residual doubt I might have entertained—perhaps best termed objective doubt—was dissipated by the results of a Ph.D. dissertation research by a graduate student in the field of religion and society at Harvard University—who has, incidentally, both an M.D. and a B.D. (Bachelor of Divinity), also earned at Harvard. The following quotation describes the study:

> This investigator set out to determine whether the transcendent experience reported during psychedelic sessions was similar to the mystical experience reported by saints and famous religious mystics.
>
> The subjects in this study were 20 divinity students selected from a group of volunteers. The subjects were divided into five groups of four persons, and each group met before the session for orientation and preparation. To each group were assigned two guides with considerable psychedelic experience. The ten guides were professors and advanced graduate students from Boston-area colleges.
>
> The experiment took place in a small, private chapel, beginning about one hour before noon on Good Friday. The Dean of the Chapel, who was to conduct a three-hour devotional service upstairs in the main hall of the church, visited the subjects a few minutes before the start of the service at noon, and gave a brief inspirational talk.
>
> Two of the subjects in each group and one of the two guides were given a moderately stiff dosage (i.e., 30 mg) of psilocybin, the chemical synthesis of the active ingredient in the "sacred mushroom" of Mexico. The remaining two subjects and the second guide received a placebo which produced noticeable somatic side effects, but which was not psychedelic. The study was triple-blind: neither the subjects, guides, nor experimenter knew who received psilocybin.
>
> [T. Leary, "The religious experience: its production and interpretation." Psychedelic Review, III, 1964, pp. 325–326. Reprinted in The Psychedelic Reader, selections from the first four issues of the Review. New Hyde Park, N.Y.: University Books, 1965, pp. 192–193.]

The investigator, in true scientific fashion, had devised a checklist of nine criteria of a genuine Christian revelatory or religious experience based on a careful analysis of the Christian literature. The reports of the subjects following the experience were then rated by independent judges. The results were clear. Nine out of the ten subjects who took the psychedelic chemical experienced at least four of the nine criteria; only one of the control subjects (i.e., subjects who received the placebo) experienced one of the nine criteria of a religious experience. Few of us in social science ever get results which even remotely approach these insofar as statistical clarity is concerned.

There is an interesting sidelight to this study. Some of the divinity students as well

as ministers who have had a psychedelic experience often comment that although the experience is a profoundly religious one, it isn't quite Christian enough. By this they refer to the absence of the institutional symbols associated with Christianity. An interesting parallel was provided by a Hassidic rabbi who, upon experiencing psychedelic chemicals, danced in ecstasy with his tallith and Bible. When he was interviewed later, he remarked that the experience was truly religious but wasn't quite "Jewish enough." As the counterpoint to this recurrent theme was the comment of a Buddhist after his psychedelic session: "Yes, just as I thought!"

If we note that the great religions are based almost without exception on the mystical visions of an individual, for example, Jesus Christ, and that the institutions, such as Christianity, which grew up around these experiences provide symbolic rather than directly religious experience, we can indeed anticipate some change in religious institutions where more and more people will be able to have their own mystical visionary experience. I would anticipate that those religions which still provide an opportunity for a direct religious experience will find a place for the psychedelic chemicals as the sacraments which I believe them to be—a place which the Native American Church already provides (with respect to peyote) for its quarter million constituents. Other religious institutions with highly crystallized unbending ritual will find little place for anything that smacks of religious ecstasy. They will ultimately close ranks and unite in opposing the possibility of better religious living through chemistry!

COHEN

It may mean very little or a great deal. It may simply signify that man (not every man) has the capability to undergo the mental transaction that William James called "the religious experience." It means that the state can be triggered by certain chemicals, sensory isolation, extreme stress, intense meditation, prolonged, repetitive body movements, perhaps by sleep deprivation, by combinations of these—or by none of them.

The capacity to apperceive the religious experience may indicate that the mind has the ability to lose all its reference points in self, time, and space without chaotic disintegration, indeed, the opposite. Why? Is it a sublime sublimation of the expunged ego, a flight into bliss? Some psychiatrists would think so. Is it an aperture into cosmic order? Does it mean that we have receptors capable of receiving revelatory messages? Some believers in the validity of the state would say so. This is an unanswerable question, or answerable only on faith, not evidence. The mere fact that a minute speck of a chemical reproduces the condition does not denigrate it. Skeptics may use the LSD-induced religious experience as proof of the common ground between revelation and paranoid delusions. True, similarities exist, but also vast differences. The believer has a choice of accepting either the divine nature of some religious experience and the secular nature of others, or the sacred quality of all, however obtained.

Just as important as the significance of the religious experience is its impact. It must be restated, because it is important, that religious experience is meaningless without the vigorous, devoted diligence required to transform it into behavior. Without responsibility and discipline it is a snare, in the end, a delusion. The availability of "cheap" chemical religious experiences these days lead hundreds into illusory notions that the experience alone is enough. It is not.

Should an LSD religion be formed? Much would depend on its disciples. Disciples without discipline, adherents without purpose, and followers seeking only beatific experiences and self-indulgence are bound to fail. Such a religion would attract all those who would by temperament and irresponsibility destroy

it. With ruthless exclusion of the misfit and the unfit, stringent training procedures and considerable wisdom, an LSD religion could survive. It would be a most difficult faith to pursue, not the easiest, as it may seem superficially. Perhaps it is impractical to consider such a course at this time. The widespread debasement of LSD practices makes any group attempt to establish a psychedelic church almost impossible now. It should be noted, however, that the Native American Church, composed mainly of American Indians, legally uses peyote as a religious sacrament.

Q.

Is it preferable to achieve self-transcendence without chemicals?

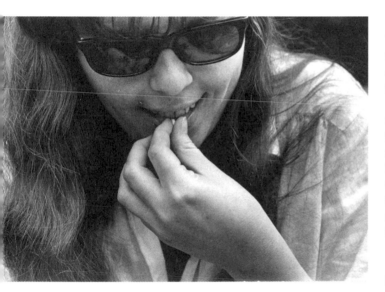

ALPERT

All experiences, all transcendent experiences, involve the biochemistry of the nervous system. What this question is really asking is whether the ingestion of psychedelic chemicals is less desirable as a means to transcendence than other means.

If the nonchemical means of achieving transcendence is extreme bodily deprivation, then I would prefer psychedelic chemicals. If the nonchemical means of achieving transcendence is crisis or terror, then I would prefer psychedelic chemicals. If the nonchemical means of achieving transcendence involves a discipline of one's set and/ or setting which does not injure one's fellow man— then I would prefer it to psychedelic chemicals.

Why?

For one thing, it is not only certain . . . but it's legal.

COHEN

One of the all too few hopeful signs in the present LSD mess is that a handful of heavy users are beginning to say that LSD cannot do it all. They have either discontinued its use or have spaced the intervals between their LSD days to a half year or so.

It must be recalled that spontaneous self-transcendence may not have taken place without internal chemical changes. Nevertheless, the element of proper life preparation is more likely to be present. The person is more apt to be ready for it. He is more likely to come back humbled from the awesome event rather than overinflated. The LSD shortcut has its pitfalls for the unprepared. The shortcut may get you to the same summit. The view may be the same, but what a difference between the one who sweated and struggled to get there, and the one who rode to the top on the back of a chemical carrier.

So if it's self-transcendence you are after, consider the hard way, the nonchemical route. Furthermore, no one will ever be able to take that freedom away

Q.

Does having reached the cosmic experience of unity assure a new way of life in the future?

ALPERT

MOST ASSUREDLY!

Before satori, one chops wood and carries water After satori, one chops wood and carries water.
[From a Zen parable.]

Consider the following excerpts from a description by George Andrews of his "Annihilating Illumination":

> the heavenly heart awakens the first beat tells the worlds
> germ in the guts of God or God in the guts of a germ
> I am that I am the same dance is everywhere
> the one law of cyclic change
> that constantly accelerating fugue of incandescent experience
> flaming sequences of rhythm patterns
> I am alive within the living God
> I throb unique among the infinite variations
> and so what if all the evolution of consciousness only leads to the
> knowledge that I am a germ in the guts of a greater being
> I am older than creation older than all beings
> the stars revolve within me
> I voyage through the inner space between my atoms
> I take space ships to the different parts of my body
> each organ becomes a constellation as I spread across the sky
> wheeling through the zodiac weaving the fate of future races
> conceive a cosmos where life does not need to kill to live
> create a system free from pain
> in the spawn and seethe of the primeval ocean
> out of chaos I pass the current
> immortal diamonds shimmering on the foam of the instant now
> scintillating images of the flux that never fixes
> explode into extreme intensities
> constantly generating golden brilliance
> face to face with the annihilating illumination
> [From Psychedelic Review, I; reprinted in The Psychedelic Reader, op. cit., pp. 60–61.]

Consider also this description by R. Gordon Wasson of his experience:

. . . As your body lies there in its sleeping bag, your soul is free, loses all sense of time, alert as it never was before, living an eternity in a night, seeing infinity in a grain of sand. What you have seen and heard is cut as with a burin in your memory, never to be effaced. At last you know what

70

the ineffable is, and what ecstasy means. Ecstasy! The mind harks back to the origin of that word. For the Greeks _ekstasis_ meant the flight of the soul from the body. Can you find a better word than that to describe the bemushroomed state?

[_Ibid._, p. 37.]

Certainly no one who has ever shared experiences such as these will ever be quite the same again.

But how then do we incorporate these experiences into our everyday lives? Some people try to radically alter their lives at once, in one great decisive effort of the will. Most will find, however, that when you try to implement your vision into your daily living, your lifetime habits and the network of expectations surrounding them undercut the frailty of your purest intentions, and with very little trouble. These radical shifts and pathetic sporadic outbursts of energy hopefully directed toward the Good almost always produce disappointment, fear, and tension in one's life space— and that of others; negative emotions which finally overwhelm and capture much of your consciousness.

Sooner or later, however, people realize that the process of incorporating one's vision into one's workaday existence is the real Work, the continuing and exacting examination of one's habits—attitudes, motives, actions—all from the vantage point of one's new awareness. This examination ever so slowly leads to many changes in the patterns of one's life . . . changes in the criteria for determining the way in which one spends one's time and shares one's space . . . changes in one's friends; the way in which one does his job, or perhaps even a change in the job itself; changes in one's goals, such as material concerns; changes in relationship to one's tribal family; changes in one's reference group to being simply "a human being"; changes in one's relationships to nature; changes in one's ability to fully and consciously experience the Here, the Now.

COHEN

Of course not! This is an illusion in which all too many believe. Having been touched by the Great White Light they conclude that everything must be different from now on. The most that such revelatory experiences achieve under any conditions is to show a way. Hard work, the very thing that they try to avoid, remains.

There is implicit in the question the assumption that the new way will be better than the old way. The new way will consist of a greater ability to love, to be serene, to enjoy, to be at one with—and so on. Some people have successfully moved in that direction. But this is no peak which one finally conquers. No one ever arrives. It is not the static reaching of a plateau from which one cannot be dislodged. It is a dynamic state; to stand still is to lose ground.

Nor need the new way necessarily be the most desirable way. I have talked to a young man who had been There and whose way of life had changed measurably. He had dropped out of school and moved into a room near the campus with a similarly oriented group. His sexual activities assumed a homosexual direction, he lived on handouts from his family. Aside from taking LSD two or three times weekly, his activities were rather restricted. I felt that it was not so much that he preferred his situation as that he was trapped in it. He could not go back without shattering his newfound beliefs. He was not going forward; he was hung up. We spoke of LSD, and then of medicine. He mentioned (a bit wistfully it seemed to me) that he had been taking pre-med courses when he stopped going to classes.

Who is to judge whether the new way is better or worse than the old way?

71

If a man is brought to a better order in all his living through LSD we assume that it was beneficial. But what about the twenty-three-year-old student who left school a few weeks short of obtaining his bachelor's degree? After taking LSD and having seen "the Absolute Reality" he lost interest in mundane matters. He and a similarly oriented friend wandered about the countryside eating a diet of brown rice and cheese. They were picked up twice for marijuana possession and given suspended sentences after being detained in jail. During our interview he disclaimed any future plans or feelings of responsibility. His only concern was whether his sugar cubes might have lost their potency since they had recently gotten moist. These were his prized possessions. When he was alone, he took them out of their foil wrapping and fondled them. The only advice I could offer was to the mother, for he could not be reached at this time. I suggested that she not underwrite her son's current way of life.

Q.

What are the possible therapeutic uses of lsd?

ALPERT

I feel that my answers to the other questions have adequately covered this information.

COHEN

When psychotherapists employ LSD they do so by one of two techniques. The first is called *psycholytic,* and it is used by European therapists. Because of restrictions the psycholytic method has had only limited usage in the United States. It consists of giving relatively small amounts of LSD (50–150 mcg) in the expectation that it will enhance certain elements of the therapeutic process. The patient's defensiveness is lessened, his recall of repressed material is improved, and he has less resistance to expressing hurtful memories. Some of the old conflicts may come forth as vivid pictorial scenes or as colorful symbols of the conflict which may not be too difficult for the patient or his therapist to understand. Emotional reliving of the event or series of events is a feature of the therapeutic experience. With guidance by the therapist who knows the patient well from previous nondrug sessions, specific problems which could hardly be worked through previously come in for special attention. The patient-therapist interaction is intensified; at times it is only his feeling of trust which permits the patient to penetrate into painful areas and retrieve, look at, and deal with the harrowing material. This is hardly a place for amateurs or even for psychotherapists unfamiliar with the LSD process. At times the patient must be forced to engage, even penetrate into, his terrifying imagery; at others he must be supported and helped through a crisis which threatens to disorganize him. Using a number of LSD sessions interspersed with nondrug interviews to deal with the material obtained, the therapist employs the drug to intensify, and, it is hoped, to accelerate the process. The brand of psychotherapy, whether Freudian, Rankian, Jungian, Adlerian, etc., does not seem to be too important. What is important is the skill, devotion, and knowledge of the therapist.

A second technique is the psychedelic one. This has been developed by North American investigators and has been used in those conditions where behavioral change is readily measured—in severe alcoholism and to a lesser degree in drug addiction and the sexual psychopathies. Single- or a few high-dose sessions (200–800 mcg of LSD) are administered in a benign setting. Problem areas may be encountered, but they are not meticulously analyzed.

Q.

What effect do our cultural values have on the psychedelic experience and its interpretation?

COHEN

Everything that happens to us is compared and interpreted in the context of what has happened in the past. Cultural values begin to be acquired very early in life and undergo constant modification with new experience. Every society has its own ideas of what is good and bad, right and wrong. Without these value judgments no culture survives. It is difficult to visualize any group existing successfully without law and order, cultural traditions and limits. If the culture's values become too impractical, or contradictory to internal and external actualities, it is destroyed.

Our values place great stock in the rational (although plenty of irrational concepts prevail), the technological (with all its desirable and undesirable features), competitiveness, achievement, goal direction, and here-and-now reality orientation. The superficialities of our aspirations, our striving for material things and for status, are all too evident. It discourages the young to see the shallow ambitions of their elders. They thrash about for better answers, rejecting the valuable in our society along with the unsatisfactory.

The time is past when the LSD experience could have been incorporated into our cultural framework successfully. It remains to be seen whether it will be acceptable for the treatment of mental illnesses and for the accumulation of scientific data. To expect that LSD, which provides an experience of unsanity or insanity, would easily become incorporated into our social structure was a gross miscalculation. This error is now being confirmed almost daily. One only has to read the newspapers to realize that the LSD movement has moved off in the wrong direction. Nor does the future use of LSD present a brighter view.

I would venture that my coauthor will be using this question to take off on the point that the nature of the LSD experience is modified by our cultural values and that in a pragmatic, here-and-now oriented society the state is interpreted as one of insanity since it is not sanity. Furthermore, it may be claimed that the very nature of the experience is made negative because of our acquired system of values. If my counterpart has made such remarks, I would only partially disagree with them. They are obsolescent issues, but these are always better to assault than current ones. Most of us agree by this time that if sanity is suspended the result need not be a variety of insanity. We know of integrative, organizing experiences beyond the boundaries of both sanity and insanity. The second point, if made, is proven incorrect by the assertion of the psychedelicists that 90 percent of their recruits achieve a positive if not a transcendental state. This can only mean that the cultural values of these individuals are easily set aside. Skinner and numerous

other behavioral psychologists have commented on the ease with which cultural and personal value systems can be completely altered—even without drugs.

ALPERT

. . . when—in the context of a scientific article—the writer reports, "Subjects experienced religious exaltation, and some described sensations of being one with God," and leaves it at that, the implication is plainly that they went crazy. For in our own culture, to feel that you are God is insanity almost by definition. But, in Hindu culture, when someone says, "I have just found out that I am God," they say, "Congratulations! You at last got the point."
[Alan Watts, in D. Solomon, ed., LSD: The Consciousness-Expanding Drug, op. cit., p. 118.]

Next year I intend to spend a period of time in Persia and India. Then I shall be in a better position to answer this question.

One of the best descriptions of a model for a culture in which the psychedelic experience plays a crucial role is contained in Aldous Huxley's last book, Island (Harper, 1962).

At some future date we predict that there will be psychedelic world tours . . . during which one has psychedelic experiences in a number of different cultures, with psychedelic plants and vegetables indigenous to the particular geographical area.

Q.
What is the relationship between the lsd experience and creativity?

COHEN

Many investigators have been interested in this question, but of the studies done, none have been conclusive. William and Marsella McGlothlin and I have been working on the first bit of controlled research into this matter. The best possible tests of original thinking and creative problem-solving were selected and given before, then two weeks after and six months after three 200 microgram LSD sessions a month apart. Some of the subjects received placebos. The sessions were held in a tastefully decorated room complete with stereophonic music, tropical fish aquarium, and special flower arrangements. The subjects were all graduate students at a nearby university. They were permitted to do as they pleased, lie quietly with a sleepshade on, walk about the room, or talk to the sitter. The expectation of the three investigators was that an enhancement of creative thinking would occur. When the test results after two weeks were compared with the results before the drug sessions, the LSD group did not score significantly better than the placebo group. The scores of the LSD group tended to be higher, but not by enough to approach statistical significance. The six months' results are not yet available. Our study is not the decisive answer to the question. It is a small contribution to the interaction of LSD and creativity.

The subjective feeling of enhanced creative powers while under the drug is unquestionable. Unique thought sequences made visible flow past rapidly and endlessly. It is most difficult to be able to produce artistic or scientific

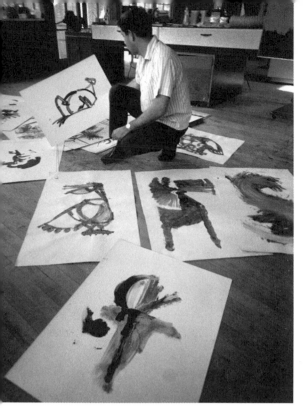

Paintings produced while under LSD.

creations during the LSD experience itself. This may be due to the frangible nature of the visualizations, the body inertia, or the formidable task of communicating. A few instances of novel ideas which have come forth during or following an LSD experience are known. A few artists have changed their styles after a psychedelic encounter, in my estimation for the better, in other instances I am not so sure. We now have a psychedelic art, psychedelic motion pictures, and, no doubt, psychedelic music. Their merit is yet to be determined.

The important point to remember by those hoping for a burst of creative composition is that it never comes to the unprepared mind. The scientist who achieves a rapid synthesis and solves an insoluble problem in a flash has all the knowledge necessary for the solution laid down in his head beforehand. Artistic inspiration can only be executed by the one who has already mastered the technique of the medium. The hopes of the untrained and undisciplined who expect that LSD will magically instill information or artistry are sure to be dashed.

The desire to produce, the drive to achieve, is another requisite for creative accomplishment. LSD will reduce motivation as often as it will intensify it. Furthermore, the person who comes to depend upon chemical sources for the exercise of his imagination tends to mistrust his ability to use his imaginative powers when not under the influence. If he has to produce, he reaches for the capsule.

Another point which hardly needs stating but is not evident to many, is that bizarreness is not creativity. Novelty alone is not enough. Neither does eccentric behavior make an artist, although some great artists have been eccentric. Nonconformity in dress, speech, or manner of living does not induce inventiveness, although it sometimes is the result of a creative life. Unfortunately, the trappings of creativity do not instill creativity in those who wear them.

Creativity, whether scientific or artistic, must have, in addition to newness, a quality of appropriateness. It must fit the problem, the need, or the times. It must be applicable to today or tomorrow.

The psychedelic revolutionaries once promised that through these chemicals we would function like geniuses. Without these drugs we were using only 1 per cent of our mental activity. With them the other 99 per cent would be activated and a brave new world would unfold, permitting a global creative enhancement. I have observed a number of people who have taken large amounts of LSD frequently. Many seem to have made little progress in their way of life or in the release of their mental potential. All too few have moved in the direction of greater maturity, wisdom, and creative productivity. The rest appear to be worse off: they are vague, grandiose, have an attenuated awareness of this life, and seem to be still waiting for the psychedelic lightning to strike them.

Just as with personality transformation, the hope that LSD alone—or LSD without discipline, responsibility, and strenuous learning—will produce creative masterpieces is a mirage.

ALPERT

Over the past five years, we have been involved with literally hundreds of musicians, painters, writers, photographers—sharing psychedelic experiences with them and watching their development. Of this experience, Tim Leary says:

Artistic and literary folks respond ecstatically and wisely to drug experience. They tell us that this is what they have been looking for. They revel in the new and intense and direct confrontation with the world about them. Poets and painters have always tortured themselves to transcend ego-space/time boundaries. They do this by every means possible (including psychosis) and have been doing it with and without chemical stimulation for centuries. They are doing it today. I would estimate that well over half of the nonacademic poets, writers, and composers in America today have experimented profitably with consciousness-altering vegetables or synthetics. I exclude our approved national narcotic—alcohol—from this estimate.

[T. Leary, "The effects of test score feedback on creative performance and of drugs on creative experience." In Widening Horizons in Creativity, eds. C. W. Taylor & F. Barron. New York: Wiley, 1964, p. 104.]

There is little doubt that psychedelic experiences involve creative perception. Whether that perception is reflected in performance will take time to determine. More and more paintings, poems, films, and musical compositions are starting to appear as clear and obvious psychedelic products. In some of these products the artist has attempted to reproduce his experience; in others he has attempted to provide a means (as with a mantra or mandala) for helping others to experience other states of consciousness. For other artists, the psychedelic experience has simply added dimensions to the forms with which they were already working.

Q.
Why study lsd?

ALPERT

I can only say why I study LSD.

1. It is the most fascinating topic, intellectually, I have ever encountered.

2. I believe that it is a key to much wisdom ... it has already brought me into contact with Eastern thought: a most fulfilling marriage.

3. It may prove to be of evolutionary significance.

4. My life has become infinitely more satisfying since my first psychedelic session, and I want my fellow human beings to have the same opportunity that I have had.

5. It's my karma.

6. It raises the most fundamental questions, scientifically and spiritually, of any topic to which I could address my attention.

7. It's great fun.

8. I am part of a pseudopod of society which is exploring inner space and, as such, I am fulfilling a responsible social role.

COHEN

The reasons to study LSD are many. We have learned a good deal about the chemistry and physiology of the brain from drugs like LSD (but not enough). We have learned something about perception, mentation, and emotion, both normal

Some of the many books about LSD and other psychedelics.

and abnormal.

From the psychotic-like LSD states, access has been gained to helpful information. Humphry Osmond has recently spoken of them.

1. It has led to a number of fruitful theories of the biology of schizophrenia and has stimulated some of the current interest in the use of drugs in the treatment of mental illness.

2. The architectural design of mental hospitals has been influenced by architects who lived through the chemically induced distortions of space, color, and perspective. The principles learned have already been applied to a number of new hospitals.

3. Those people who work with the mentally ill have an opportunity to know at first hand the thinking, feeling, and visual aberrations of their patients. The result is a more sympathetic understanding of what the psychotic's world is like. Very helpful bridges of empathy are built between the patient and those who care for him.

4. Abram Hoffer and Humphry Osmond have developed a useful and simple test to estimate the course of the schizophrenic as a result of the work with LSD.

5. The notion that the alcoholic had to "hit bottom" before he could alter his pernicious drinking pattern was the original concept behind the use of LSD in the treatment of alcoholism. It was supposed to provide an artificial "hitting bottom."

Enormous amounts of work remain to be done, not only in the above areas, but also in creativity, in the chemical mystical experience, in the nature of fantasy, in our sense of time, and in the egoless state. These are complex problems, but by no means inaccessible to imaginative scientists and scholars.

The experimental use of LSD is justifiable for those who have a thoughtful purpose in examining the state. For this purpose the administrator should be a reliable, responsible person, and every protection ought to be given the selected subject.

Q.
Who should have lsd?

ALPERT

ANYBODY THAT WANTS IT.

That's the answer I really believe, but I realize that it's not very politic or realistic (i.e., in the more limited sense of sociopolitical feasibility). So I shall offer a second answer:

ANYBODY WHO CAN PASS HIS IF TEST (see page 82).

Personally, I usually translate the question into "With whom would I take LSD?" The criteria I use are:

1. Can I trust the person? That is, does he genuinely wish to be fully collaborative?

2. Could I gain sufficient rapport with him to enter into an explicit verbal contract about the journey?

3. Is the person entering into the session in a fully voluntary and informed fashion?

4. Is this somebody with whom I want to share a psychedelic experience? The answer to all of these questions must be YES.

It must be clear, even to those in the first flush of fascination who advocated that LSD be sold in vending machines, that some people should never take a mind-stirrer like LSD. Unfortunately, the very ones for whom the drug is contraindicated are attracted to it. They must be screened out, otherwise they can have catastrophic reactions. In 1960 I wrote a paper[7] which concluded that, from a survey of the researchers using LSD, it was a safe agent. The complications were few and far between when it was employed in properly selected individuals who were carefully protected during the experience by skilled investigators. I still say that. The hundred serious sequallae of which I have knowledge happened either because the wrong person took LSD, or because it took place in a casual setting without anyone around to provide both security and the ability to manage a threatening disaster.

Who are the people who should never take LSD? First, there are the immature, for in the throes of an LSD blast, when the coping ability of the person is demolished, an immature person may remain unstuck. If anyone is to be exposed to LSD, it should be the individual with a certain maturity and stability. The unstable may not crumble the first time, but the chances are not small that he will on a subsequent trip.

One person in a hundred is in a borderline psychotic state. He manages to remain on this side of madness, but his balance is tenuous. Let him undergo a stressful LSD experience, especially with the huge doses that are fashionable these days, and he can tip over into a schizophrenic decompensation from which he may or may not return.

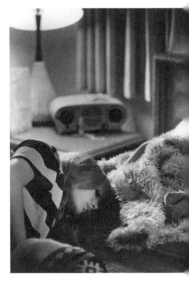

Schizophrenics do not improve particularly following the administration of LSD. Some encouraging studies with autistic (not artistic) children have been done which may make them candidates for LSD therapy.

It is not known how many paranoid personalities are around, but they are more than a few. These are the overly suspicious, the privately grandiose, or the chap who invariably is persecuted "by everybody." He might return from an LSD journey with his private ideas of grandiosity confirmed. The very nature of the LSD-induced religious experience is one which can strongly support the belief that "I have been chosen." The certain feeling of omnipotence may wear off—or perhaps it won't. We are accumulating a record number of chemical Messiahs in America these days.

There are others who might receive LSD although the risks are slightly greater with them. A very depressed patient may wind up more depressed than ever, and he will require protection. A highly anxious person may become panicky either during or after the trip.

Another group who really ought not be given LSD is children. The possibility of brain damage among adults will be mentioned later, but here it must be noted that the growing brain is much more sensitive to psychochemicals than the fully developed brain. It is, therefore, chilling to read in a recent issue of *Life* (March 25, 1966) the following quote: "When my husband and I want to take a trip together," says the psychedelic mother of four, "I just put a little acid in the kids' orange juice in the morning and let them spend the day 'freaking out' in the woods." Here, at least, is a refreshing absence of pretense that it will do them any good; it's simply a pharmacological baby sitter.

The question is who should have LSD, and up to this point I have been talking about those who shouldn't. The ideal candidate for LSD is one who is mature, intelligent, and stable, who is fairly well acquainted with himself, and whose life has been a sort of preparation for this remarkable experience. By that

I mean he has survived defeats, frustrations, and losses and has learned from them. Serious situational problems are not necessarily a contraindication.

It is evident that many poorly adjusted people "get away" with LSD-taking. This they do by never encountering themselves and dealing with their inadequacies. When they eventually come face to face with themselves, they "freak out" or "flip."

LSD may be a drug for the best, not the worst, among us.

Who are actually using LSD nowadays?

No one knows how many people have taken LSD. In the past three years since it became available on the street, a rough guess is that a million individuals plus or minus a quarter of a million have tried one of the psychedelics. Many have indulged once, others have taken them many hundreds of times.

Who are they? There is a large campus group extending from the graduate student at a university down to a few grammar school imbibers. The "beat" have partaken with few exceptions, whether they be in Greenwich Village, Venice, North Beach, or elsewhere. A fair number of artists, musicians, writers, painters, and actors know LSD from personal experience.

This is a drug which interests a few theologians, philosophers, and anthropologists for professional reasons. However, almost every social and economic group, from the unemployed Harlemite to the millionaire president of a large corporation, and from the housewife to the physicist, has some representation. This is by no means a practice restricted to the underprivileged or to minority groups. On the contrary, it is, somehow, a status symbol and many students are under pressures to try the "acid" and "be somebody."

Today, for every subject who takes LSD under research conditions, a thousand take it without medical supervision. Of that thousand, the great majority admittedly "drop their caps" for the "high" without any pretense that it will be more than "kicks." It is this overwhelming majority that is more important as a social problem than the LSD taken in research projects or for nonmedical, but still serious, purposes.

It is axiomatic that if an agent can be misused, it will be. The frenzied misuse of LSD must bemuse even the obsolescent IFIF group and make them wonder what they have helped unleash.

Q.
Who should give lsd?

ALPERT

IT IS NOBODY'S TO GIVE. LSD SHOULD ONLY BE TAKEN.

Most of the models in our culture for the administration or giving of chemicals we ingest are inappropriate for psychedelics. To involve psychedelics in any existing power relationship, either economic or doctor-patient, is to sow the seeds for a paranoid setting. The only relationship suitable to the psychedelic experience is that of human being to human being—both present and fully accounted for. Anything other than a completely straight, open, and trusting relationship for all people involved in a psychedelic session limits the depth of the experience through the involvement of one or more of the participants in some degree of paranoia.

The only distinction which is meaningful among people in a session is the degree

of experience. People who have had transcendent experiences previously (whether chemical or nonchemical) often serve as guides for the novice—but guides in a very special sense. Tim Leary has characterized the role well in the following:

The Session Guide

In the greatest sessions	If the guide lacks trust in the people
One does not know that there is a guide	Then
In the next best sessions	The trust of the people will be lacking
One praises the guide	The wise guide guards his words
In the good session	The wise guide sits serenely
One admires the guide	When the greatest session is over
It is worse when	The people will say—
One fears the guide	"It all happened naturally"
The worst is that	Or
One pays him	"It was so simple, we did it all ourselves."

[Adapted from Tao Sutra 17. Psychedelic Review, VII, 1966, p. 15 (T. Leary, "Five psychedelic prayers adapted from the Tao Te Ching").]

As a person who had been a part-time psychotherapist for the six years previous to my involvement with psychedelics, I found it difficult to relinquish my old therapist role in my work with psychedelics. But with each session I found myself increasingly able to "turn off" all of my social roles or identity and merely "be." This allowed me to experience an empathetic or unitive experience with the novice which seemed to provide maximum support for him or her.

Soon after I learned how to simply "be" in a session (or, more accurately, unlearned all the power roles which I had previously adopted), I had two unusual experiences, particularly extraordinary in their juxtaposition to one another. About an hour into a session with a rather psychopathic young fellow, I got a distinct feeling that I was inside his head. As best as I can describe it, it was like a tropical jungle—overhanging flowering vines, waterfalls, deep dark moist caves. At the moment I was quietly in the midst of this imagery, he said, "Are you inside my head?"

A week later, in the midst of a session with a university professor of political science, I once again experienced the feeling. This time it felt like a Gothic cathedral—cold, stately, precise, with the sound of echoing footsteps. His simultaneous statement was, "I have the most peculiar feeling you are inside my head."

I report the above only as two rather fascinating anecdotes. They are interesting in relationship to what I was told by one of the granddaddies of psychedelics who described how he took LSD and went into the heads of aging regressed schizophrenics, found them in their delusional system, took them by the hand (so to speak) and led them out.

Many people ask when a person is ready to serve as a guide. It is probably a safe surmise that if they are still asking that question, they are not ready.

COHEN

If it is hazardous for a variety of people to take LSD, who is capable of sorting them out? Those who are best trained for this purpose are psychiatrists and psychologists, more particularly those familiar with the wide spectrum of LSD states. One's best friend is not an adequate judge in this matter. No doubt, there are a few laymen around who have had considerable experience in eliminating the high-risk candidate. Although they may be blithely unaware of it, they assume a great responsibility, just as the investigator does when he administers LSD.

If a divinity graduate student wanted to examine the hallmarks of the LSD state as compared to a spontaneous visionary state, it certainly would be

proper to do such a study. It also would be prudent and desirable to have the medical responsibility assumed by a psychiatrist or psychopharmacologist. Even at Eleusis not every initiate was permitted into the shrine. You first obtained psychiatric clearance from the High Priest.

Some "acidheads" have the illusion that a medical setting is not conducive to a positive experience. I have not found this to be true at all and have hundreds of reports to disprove the notion. Another strange misconception is that if it weren't for the doctors nobody would have trouble with LSD. The many adverse reactions that we have become aware of invariably have been when the drug was taken on the beach, in the car, or in the pad. Then, if the adventurer could not find the way back, he or some concerned person sought the doctor out.

The chemical guru runs into difficulties with his potions less frequently, but we have treated a few of their disciples who returned unable to distinguish here-and-now from there-and-then to their puzzlement. The borderline psychotic is particularly attracted to a cult which promises instant revelation and magical release from his feelings of apartness.

Q.
Who should control lsd?

COHEN

We do not live on an Island, nor are we an Island. We live within a complex social constellation which requires checks and counterchecks to keep us from infringing on the rights of others, to protect ourselves and to protect our social system. Speaking of "Island," in the finale of Huxley's book[8] by that name the dictator of a nearby island eliminates the idyllic Moksha-eating community with a platoon of soldiers. The point is that peaceful passivity cannot survive in the presence of avaricious aggression. This misreading by psychedelic politicians of the reality situation was ruinous.

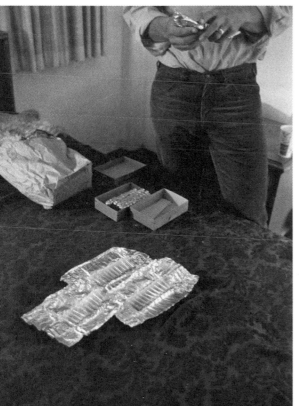

$8,000 (wholesale) of LSD being shipped to a large university.

The issue is whether we can do anything to ourselves—expand our consciousness with chemicals, for example—so long as it does no direct harm to anyone. By the way, "consciousness expansion" is a poor phrase; it should be called "unconsciousness expansion," for in that climatic state consciousness shrinks to nothing and unconscious activity expands.

According to our customs and those of every folk, we have a responsibility to and a relationship with one another. To harm or destroy oneself is to harm the social organism. The laws of the tribe may be neither cosmic nor universal—but they exist and for good reason. They can be changed; they are changing rapidly. Head-on defiance is much less successful than informed persuasiveness.

The question should be: Who shall control LSD in the kind of world in which we live? I think that control of distribution should be given to a group of behavioral scientists and philosophers, pharmacologists and historians, anthropologists, lawyers, and, yes, administrators.

That all humans should have the inalienable right of access to LSD was a question which may have been a subject

81

of debate say, five years ago. Today, the facts speak for themselves. LSD has no intrinsic goodness or evil in it. It is neither a sacrament nor the devil's brew. The way it is used can make it so. Therefore, the thrust must be toward guiding its use to the best possible end—to diminish the likelihood of great harm and enhance the possibility of great good. Controls, laws, rules, regulations—these are unfortunate necessities of civilization. Anarchy has never been successful. When constrictions on our freedom are wrong or unnecessary, they ought to be fought, but I do not believe that the current Federal legislation involving the hallucinogens is unnecessary or wrong.

Recently, I recklessly allowed Richard Alpert to drive me to a meeting. I was very relieved and pleased to find that he drove on the correct side of the street, stopped at every red light, and obeyed every traffic law. Apparently, he accepts this restrictive infringement upon his freedom. The distinction, he might maintain, is that this was a restriction on his external freedom, not his internal freedom. But there is no separating the two. Going to jail is both internal and external imprisonment, for, along with physical captivity, the mind is barred from its sensory nourishment and significant emotional needs. LSD also has both internal and external sequellae.

The closer knit the society, the greater the requirement for the individual to fit into it. This does not lead to a surrender of the freedoms to think or to feel. An examination of our relative freedom to act now as compared to a few decades ago might provide the interesting possibility that we are not losing our freedoms. On the contrary they may be greater. The freedom to disrupt the culture will surely be met with crushing resistance.

We are not an Island but part of a continent. The LSDer knows this best of all.

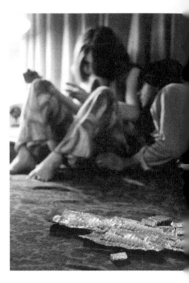

Testing the quality of the acid by mainlining.

ALPERT

AN OPEN LETTER

JOHN W. GARDNER, Secretary
Department of Health, Education, and Welfare
Washington, D.C.
Dear Secretary Gardner:

I hereby propose the formation of a Government agency devoted to psychedelic exploration, i.e., matters of Internal Flights. Thus, the Agency would most appropriately be called I.F. Similar to the Federal Aviation Agency (F.A.A.), the I.F. Agency would be responsible for the quality of the conveyance (in this case, for example, LSD) and for the specific training in the basic safety rules of flight (set and setting) of anyone over sixteen years of age who wished to become a licensed I.F. pilot. This of course would only allow the pilot to fly with another licensed pilot. Further training would be required for solo licenses and for instructor's (in this case, guide's) licenses.

The I.F. Agency would undoubtedly require—again, similar to the F.A.A.—some minimal physical health requirements for its pilots.

The I.F. Agency would provide maps and charts for pilots wishing to make special trips and would provide special consultants for particularly extended or unusual voyages.

The I.F. Agency would further provide national communication service facilities—again, similar to the F.A.A.—at which ground control men would be stationed around the clock, prepared to offer assistance at any moment.

I believe that the I.F. Agency, if it limited its powers and functions thusly, (1) would put an end to the black market and the criminal overtones associated with psychedelics almost immediately; (2) would be respected in its authority by most psychedelic users—who (sociological studies assure us) are not criminals in any other

sense than in the manner in which they obtain their psychedelic chemicals; (3) would prevent a number of fatalities which we might otherwise anticipate; and (4) could probably keep its accident statistic lower than its sister and model agency, the F.A.A.

Respectfully submitted,

Richard Alpert, Ph.D.

Q.

Why are state and federal prohibitive laws being enacted against the psychedelics?

Why is the establishment trying to prohibit the use of these drugs?

COHEN

We now have an amendment to the Federal Dangerous Drug Act which makes LSD manufacture, sale, and transportation felonious. A number of states have or are considering legislation which will make traffic and possession illegal. The Federal law places the burden of proof on the prosecution to show that the possession of psychedelics was not for personal use.

Why do we have such laws? They can be considered a reaction to the extreme statement of the enthusiasts that the drug was something for everybody. The rising demand that followed the enormous publicity deliberately encouraged by the LSD movement created multiple sources of supply.

When babies started getting into the family stockpile of sugar cubes, and juveniles started going off their heads, a predictable and inevitable response occurred: prohibitive laws were passed. I have a copy of a letter addressed to California legislators from the parents of a twenty-year old student "who committed suicide on March 3, 1966 due to the drug (LSD)." Letters of this sort about a strange new agent, pictures of grotesquely painted youths carousing during an acid-test party, and above all the irresponsible talk that still continues—these have brought the laws into being. I am amazed that those who claim such expansion of consciousness should have such nearsightedness. They directly provoked the laws, now they denounce them.

I am not aware of any evidence that the Establishment has had anything to do with the regulatory laws concerning psychedelics. This query is often asked during the question-and-answer period of a lecture.

It exemplifies the paranoid thinking processes of some overwrought "acidheads." I recently asked one questioner what the Establishment was. He replied: "Anyone over thirty."

Most people probably mean the tobacco and liquor interests when they speak of the Establishment, but why should these companies be concerned? The smokers are still smoking and the drinkers still drinking, just as they did before LSD. If exceptions exist, they are uncommon.

"If tobacco and alcohol are permitted, why not LSD?" is a question often put to me. Such logic is specious. Both tobacco and alcohol can be harmful. Alcohol, particularly, is misused by millions. This is no reason to introduce additional harmful agents into the culture without great care. What is more reasonable is to reduce the hazards due to excessive drinking and smoking.

I believe that LSD is a dangerous drug as defined legally. It cannot be used indiscriminately, carelessely, or lightly without serious harm to some. We return to the issue of our freedom to harm ourselves if we wish. I do not think that we have that freedom in a civilized society. Just as the individual has his freedom, the group has its freedoms. One is the freedom to protect itself from the dangerous individual—for example, the individual made dangerous by drugs.

ALPERT

"A grandmotherly panic." [Alan Watts.]

The first realistic step toward making the legislation concerning control and use of psychedelic chemicals based primarily on light rather than heat is public education. Toward this end I submitted to the Government this spring a request for a PUBLIC hearing. The text of this request follows:

HEARING CLERK

DEPARTMENT OF HEALTH, EDUCATION AND WELFARE
ROOM 5440
330 INDEPENDENCE AVENUE, S.W.
WASHINGTON, D.C. 20201

LSD and the other psychedelic[1] (mind-manifesting) chemicals represent a new fact for our society. These chemicals, the most powerful mind-altering substances known to man, are presently being researched for their therapeutic potential with alcoholics, drug addicts, autistic children, psychoneurotics, and prisoners, as well as for their potential to increase man's creativity in problem-solving and their value to the military. Significant research has also demonstrated that these chemicals are capable of altering the perception of terminal cancer patients in such a way as to alleviate their fear of dying. The Native American Church continues to use peyote as a medicine in its religious ceremonies.

In addition to these "authorized" uses of psychedelic chemicals, there is, as a result of increased restriction on who is considered a "qualified researcher" with psychedelics, a significant increase in "private research," i.e., research not authorized by the U.S. Government. The data from a variety of public and private sources indicate that this extralegal activity is not limited to any specific segment of society. Among these private explorers are numbered religious leaders of all faiths, scientists in both the natural and social sciences, medical men specializing in general practice as well as psychiatry; writers, artists, performers, musicians, educators, students, journalists, psychic researchers, businessmen, housewives, mystics, philosophers, lawyers, socialites, engineers, and "beatniks."

When these chemicals have been ingested with suitable preparation and in a supportive setting, by far the majority of these psychedelic researchers have reported that their experiences with the chemicals have enriched their life experience, helped them to feel a greater sense of satisfaction. For some of these people the experience has provided this increased satisfaction spiritually, for others through helping their marriages to achieve new depth and meaning, for others in their professions, and for the majority through their ability to experience each day more fully with a sense of increased awareness.

1 Psychedelic chemicals have been variously labeled to reflect various attitudes regarding their significance. The F.D.A. currently refers to these chemicals as "hallucinogens."

There is at the present time no statistical evidence that psychedelic chemicals are either dangerous or physically addictive. In terms of suicides and psychosis, psychedelics used in currently recommended dosages are considerably safer than, for example, a four-year liberal arts education.[2] As far as psychological risk (post-experience depressions, etc.) is concerned, most of this can be prevented by education and preparation of the researcher as well as design of the setting.

At present in our society there is no existing social institution which provides a citizen with the opportunity to utilize psychedelic chemicals to explore <u>his own</u> brain or consciousness in order to increase his awareness should he so desire, be it for spiritual, educational, therapeutic, or esthetic reasons. The potential for mankind in these chemicals cannot be realized under existing governmental policies. Thus the presence of the psychedelic chemicals as well as the growing public interest in serious exploration with them poses a real need for CREATIVE LEGISLATION. It is to be hoped that our vision and our commitment to growth of the individual and the society will prevent us from legislating out of existence one of man's greatest chances to expand the boundaries of his mind, his individuality, and his culture.

Lyndon Johnson speaks of "The Great Society." It is interesting to speculate whether such a society as he envisions has a place for a genuinely new institution which could significantly alter the institutions of the society itself.

Since 1963 many of us who are deeply concerned about the welfare of mankind have attempted to interest the Government in a genuinely open-minded search for a constructive program regarding who should use and who should control psychedelics. We have suggested that Government-controlled privately supported centers be created under limited licensing (a policy presently used with radioisotopes) which would provide a suitable setting and assistance for any responsible member of our society to carry on explorations of his own consciousness with psychedelics for whatever purpose he chose. Not only has the Government failed to seriously consider this proposal, but every indication is that the restrictions are mounting, and the Government is attempting to ignore the uniqueness of the situation by treating psychedelic chemicals as similar to other drugs.

It will become increasingly difficult with the implementation of new and more stringent restrictions for free and open research to proceed with these chemicals in the United States. According to the new Drug Abuse Control Amendment, an individual can possess psychedelics for the use of himself or a member of his household but cannot legally purchase or receive the chemical. The results of such control without simultaneously making provisions for the opportunity for responsible citizens to research their own consciousness legally will be predominantly unfortunate, leading to, for example: (1) an increase in the manufacture of homemade psychedelic chemicals having little or no quality control; (2) an increase in the paranoia connected with psychedelic chemical usage which in turn will increase the danger of negative psychological reactions to the experience; (3) an increase in the number of responsible and useful citizens who, because of their deep conviction about the value of psychedelic research, will continue such research and thus become criminals in the eyes of law; (4) an attempt by the Government to enforce an obviously

The first reaction only moments after mainlining.

2 Cohen, S., and Ditman, K. S., "Prolonged adverse reactions to lysergic acid diethylamide." <u>Arch. Gen. Psychiatry</u>, 8:475–480, 1963.

85

unenforceable law because of the numbers of citizens involved, thus re-creating the effects of prohibition, during which time the Government enforcement agencies lost respect in the eyes of the populace; and (5) a possibility of losing what might be a key for man to free himself of the limitation of his own present vision which has caught him so deeply in alienation and paranoia, be it at the personal or national level.

It is in view of the situation as outlined above that we hereby request that the Commissioner of the Food and Drug Administration hold public hearings concerning the inclusion of psychedelic chemicals as listed in the Federal Register, January 18, 1966, under the Drug Abuse Control Amendment. We further request that these hearings be addressed to the following questions:

1. Does the inclusion of psychedelic chemicals under the Drug Abuse Control Amendment unnecessarily curtail an individual's rights provided by the First Amendment of the Constitution? Specifically we wish to explore the implications of this Act for religious freedom.

2. Is there indeed sufficient evidence to warrant Government control of psychedelics on the basis of real danger to the public safety?

3. What is a "qualified research investigator" in the field of psychedelic chemicals?

4. Are medical practitioners, in view of the nature of their training, suitable supervisors for the administration of psychedelic chemicals?

5. Were the Commissioner to bring a chemical under the control of his department based on a categorization of the chemical as producing "ecstasy" or "impairment of acquired social and cultural customs," (Federal Register, December 18, 1965), would he not be setting a dangerous precedent concerning ideas and experiences which could significantly contribute to the growth of the society?

6. Has the Commissioner heard sufficient testimony concerning the sociological, psychological, educational, philosophical, and spiritual implications of controlling psychedelics to determine his decision to include these chemicals within the Act, on a sufficiently broad cultural basis?

7. Does one have the right to decide for himself whether he wants to explore his own consciousness or change the nature of his own consciousness?

8. If, with the knowledge that the ingestion of psychedelic chemicals by some people leads to negative reactions, an individual chooses to ingest a psychedelic agent in order to explore his own consciousness, does the Federal Government have the right to interfere with such a person who is willing to assume the risk? Is the Government by so doing assuming the right to protect an individual from himself?

9. Does the Food and Drug Administration have the right to initiate punitive action in connection with psychedelic chemicals where the individual has not harmed himself or society? Does the Food and Drug Administration have the right to impose punishment for effects of altered consciousness, or is the criminal law and punishment only reserved for actual wrongdoing and harm to society?

10. Does the end justify the means? Can enforcement of the Food and Drug Administration law under consideration occur without gross invasion of the right of privacy? How will a violation come to the attention of the Food and Drug Administration? Will the willing possessor of psychedelic chemicals report a violation of this law?

11. Is it desirable for a law to be enacted that creates an estimated 100,000 to one million criminals?

12. Will the Food and Drug Administration be brought to the same level of respect as the Prohibition Unit of the Federal Government during the Prohibition era? Will the promises offered by the Prohibition Unit that "if we can have stiffer penalties and more Prohibition Agents, alcohol will be stamped out" be offered by the Food and Drug Administration when it finds itself unable to "stamp out" the prohibited substance? If the Prohibition Unit failed in enforcement of the Volstead Act and the Eighteenth Amendment despite every effort, will not this similarly unenforceable and corruption-breeding Food and Drug Administration law meet with a similar fate?

13. Finally, we request that the hearing be addressed to the matter of inclusion of another "drug" as fulfilling the criteria for inclusion as "hallucinogen" (Federal Register, December 18, 1965) under the Drug Abuse Control Amendment. This drug is commonly referred to as "alcohol." We wish the Food and Drug Administration to justify how it can impose controls upon psychedelic chemicals because of "dangers" and "abuse" in view of the comparative statistics concerning the "dangers" and "abuse" attendant to the use of alcohol.

RICHARD ALPERT, Ph.D.

Q.

What will be the effect of restrictive legislation on the use of psychedelics?

COHEN

Restrictive legislation is a poor solution to the problem, but what is a better solution to control the growing misuse of LSD? To do nothing would be an inferior alternative. A good deal will depend upon the attitude of the public. If they do not want the law enforced, it will fail. The Volstead Act prohibiting alcohol was "a noble experiment" but a miserable failure. The Harrison Narcotics Act with all its defects has decreased the number of addicts substantially.

When drafting legislation consideration should always be given to the possibility that making an act illegal might attract those who want to defy authority. The psychedelics are attractive enough. Whether any additional people will indulge in them primarily to flaunt authority is dubious.

Although the legislation permits scientific research, these legitimate investigations will inevitably suffer. Scientifically controlled human research with heroin and marijuana is unknown. LSD may be added to the list of unresearchable drugs. Another small group of people will suffer from the new laws. They have been using LSD quietly, cautiously, and infrequently for years to explore themselves and their world. Now they have become casualties of the abuse of the drug.

Some opponents of legislation against the psychedelics object because it will drive the black market underground or into the hands of organized crime. It is there now. Manufacturers and sellers are making fortunes. They also speak of an educational program rather than prohibitive laws. I have spoken for hours to people who had been in great difficulties after LSD. Some would never go near the stuff again, but my efforts to educate others have not been very encouraging. Education is for the future, the problem is in the present.

ALPERT

All laws which can be violated without doing anyone any injury are laughed at. Nay, so far are they from doing anything to control the desires and passions of men that, on the contrary, they direct and incite men's thoughts the more toward those very objects; for we always strive toward what is forbidden and desire the things we are not allowed to have. And men of leisure are never deficient in the ingenuity needed to enable them to outwit laws framed to regulate things which cannot entirely be forbidden He who tries to determine everything by law will foment crime rather than lessen it.

[Baruch Spinoza.]

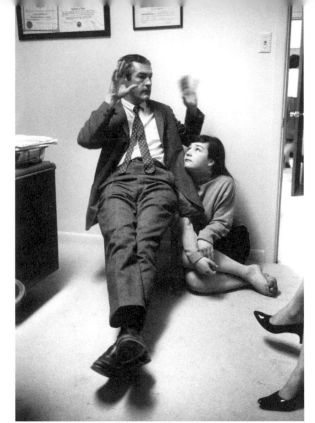

Dr. Timothy Leary and his daughter, Susan Leary.

See pages 84–87.

It's just about gotten to the point now where if you want to have an LSD experience legally, you either have to become an alcoholic or psychotic and thus be eligible as a research subject; be very rich, very powerful, or very famous (publishers, ambassadors, TV and movie stars, and staff of the National Institutes of Mental Health never have any difficulty); or be a friend of Sidney Cohen's.

Now is the time for the U.S. to apply a lesson learned from Prohibition. LSD is too potent for the law to ignore but too easy to make to try to prohibit.
[That's LIFE, April 29, 1966 (Editorial), p. 4.]

Q.
What is the relationship of marijuana to the psychedelics?

COHEN

Marijuana is a weak psychedelic. The effects are quite reminiscent of low-dosage LSD ingestion except for its tendency to produce drowsiness. Hashish, a stronger marijuana, has been used for thousands of years in the Near and Middle East. Its history demonstrates the lesson we are now learning from LSD. At one time it was used as an aid to meditation among Indian mystics. Later, the sects of Thugs and Assassins were given hashish to provide courage or as a reward for their acts of violence. What was once a laudable use turned into a disreputable one.

In this country "pot" is generally smoked to achieve a "high." Being "high" is not only feeling good but includes a distancing from frustrating life experience and a sense of adequacy. It is not difficult to envision that some discouraged, frustrated, or inadequate individuals are inclined to solve their problems with "grass." Hardly anyone pretends that marijuana smoking is for sustained benefit or for religious purposes. In like manner LSD is slipping from a position of serious self or spiritual exploration to its widespread current use as a high "high"—from

consciousness expansion to "kicks."

Who is against fun? Chemical fun may have implications beyond those immediate, personal ones already mentioned. The very groups that are protesting against the encroachment on our freedoms may be opening the door to 1984. Is it too great a leap to imagine the transition from turning oneself on to being turned on with the same chemical by your Friendly Acid Man? Will good behavior be rewarded by a trip courtesy of Big Brother?

Is marijuana dangerous? I have seen teen-agers make it a way of life—a substitute for engaging in living. I have not seen the psychotic reactions or the crimes of violence that are reported. Escalation to narcotics? The Chinese had both and preferred opium. Despite the fact that most heroin users began with lesser drugs, usually marijuana, it cannot be concluded that "pot" leads to the most stupid game of all—heroin. Many people use marijuana as a social relaxant just as others do alcohol. I have no argument against this—except that marijuana carries a rap. There is nothing noble about marijuana. A marijuana martyr is a martyr without a cause.

ALPERT

People have told me that Marijuana is the mildest of the psychedelic plants and vegetables. In India, bhang and ganja are other names for the derivatives of Indian hemp (Cannabis sativa) which are used extensively by large sects of Hindus in their religious practices. In the United States, marijuana—scientific evidence to the contrary notwithstanding—has remained mistakenly listed as a narcotic along with the opiates. As recently as March of 1966, a subcommittee of the Medical Society of the County of New York reported that "Marijuana . . . should be removed from the opiate-cocaine category." At the present time there are 6,000 people in California jails alone for breaking marijuana laws,[3] despite the findings of the White House Conference on Narcotics and Drug Abuse in 1962 which declared that:

> "It is the opinion of the Panel that the hazards of marijuana per se have been exaggerated and that long criminal sentences imposed on an occasional user or possessor are in poor social perspective."

and despite the fact that the Supreme Court of California decided in 1962 that to prohibit members of the Native American Church from using peyote (certainly a far stronger psychedelic than marijuana) would violate their constitutional right to the free exercise of their religion.

On Friday, March 11, 1966, in Laredo, Texas, Dr. Timothy Leary was sentenced to thirty years in prison and fined thirty thousand dollars for the possession of less than one-half ounce (about three dollars' worth) of marijuana. Timothy is, in my estimation, the one person most responsible for introducing LSD into our culture as a folk sacrament rather than as a psychiatric tool for the study of model psychoses. The severity of his sentence was primarily the result of his reason for pleading not guilty. The defense was based on constitutional grounds. It was argued that the current laws concerning marijuana are unconstitutional in that they violate the First, Fourth, Fifth, Sixth, Eighth, and Ninth Amendments. Specifically, Dr. Leary defended his rights to pursue spiritual goals and scientific research, and to live in his home and raise his family according to his beliefs—as long as such acts do not present a clear and present danger to society. At this moment the case is being appealed to higher courts, and help is being sought through the Timothy Leary Defense Fund, 78 Fifth Avenue, New York, N.Y., 10011. Although this appeal is not aimed directly at the reform of existing

3 Ken Kesey, author of the recent best-selling novel One Flew Over the Cuckoo's Nest waits and watches from somewhere else. rather than face a long California prison sentence for possession of marijuana.

marijuana legislation, it will undoubtedly help bring to light the many superstitions as well as actual facts concerning marijuana and other psychedelic chemicals.

Often people experience little or no effect the first time they smoke marijuana. With later experiences, they report mainly changes in sensory awareness.

If a person has had a profound transcendent experience either with the aid of other chemicals such as LSD or through nonchemical means, then marijuana often is sufficient to reproduce these experiences. In the absence of such previous experiences, it is rarely that marijuana is able to undercut the defenses sufficiently to provide a profound psychedelic experience. The most delightful and comprehensive reference on this topic is Norman Taylor's <u>Narcotics: Nature's Dangerous Gifts</u> (New York: Dell Publishing Co., 1963), in the chapter "The Pleasant Assassin: the story of marijuana."

Q.

Should lsd be given to anyone without his knowledge and informed consent? Should a person be persuaded to take lsd?

COHEN

No one, but no one, should be given LSD without his knowledge and consent. It is unfunny, it is an odious and asinine assault upon the mental integrity of the victim. Only a mindless or murderous individual would do this. Unfortunately, we have a few around. If a person gets LSD in his cup of tea unbeknownst to him, consider what goes on in his mind. Everything looks different, his thinking is askew, his body is behaving as though it were made of rubber. Without any explanation for these changes, he thinks he is going mad—and he may—or he may commit suicide. This is a real danger at present because LSD is so freely available to the irresponsible.

Likewise, nobody should be persuaded to take LSD. This usually happens at parties or mass gatherings. Obviously, these are poor places to give or take LSD, especially when searching for spiritual enlightenment. If an individual is reluctant to indulge, this attitude should be respected and no social pressures brought to bear. "Come on, everybody had 'acid,' don't be a 'square,'" is the usual pitch. The reluctance may stem from very sound reasons, or it may only be an intuitive feeling that this is not for him.

A sophomore at college took a "half-cap" of LSD at a party after much persuasion. He had been in psychotherapy for about six months while in high school. The LSD experience was "interesting, but disturbing." Afterwards, it became very difficult for him to concentrate, attend classes, or study, and he dropped out of school. He felt "philosophically confused" and had a sense of meaninglessness to life. At times he was panicky and very upset; on the other hand, there were days when he felt almost normal. During the first two months he was very concerned about going crazy, and ruminated about suicide. He refused to seek help because he didn't want to be put into a mental hospital. His family finally persuaded him to see a psychiatrist. With considerable support, massive reassurance, and tranquilizer therapy he gradually improved.

ALPERT

NO.

The readiness of an individual for a powerful transcending experience is something which only he can possibly know. If a person asks whether or not he is ready to have a psychedelic experience, I tell him he isn't. Were I to say yes, he might recall at a moment of fear in the session that it was I who got him into this and that I am to blame for his fear. If, on the other hand, he makes his own decision, he does not lose trust in me, and I may possibly be able to share his fear with him and thus help him through it.

This injunction against giving LSD to anyone without his knowledge and informed consent should apply to researchers as well. Many researchers have administered LSD to subjects in a variety of well-meaning experiments without advising the subject of what the chemical was, let alone obtaining his informed consent.

The instances in which a person has taken LSD accidentally or had it placed in his food or drink secretively are surprisingly few. In most cases when the person who ingests the LSD unknowingly begins to feel the effects, he or she experiences considerable panic. What happens next in these instances depends almost totally on how sophisticated the people with whom this person comes in contact are regarding psychedelic reactions. Almost without exception, when the person comes into contact with the police, hospital staffs, psychiatrists, and family G.P.'s, who are not familiar with and thus are not relaxed about the psychedelic experience, the negative effects escalate as the fear and panic reverberate from person to person.

On the other hand, if the unsuspecting psychedelic voyager experiences his panic in the presence of understanding hospital staff members, or psychedelic kin, they are usually able to "cool him out" or help him through quite rapidly without any escalation of the panic. Many times we have been called on the telephone in the middle of the night by a person experiencing terror or by the friend of such a person. After a while one gets quite adept at communicating the calm faith which one feels in the process. In airplane terms, this is called "talking a person down."

The single exception I can think of to the injunction against giving LSD to a person without his informed consent involves autistic children, children who have failed to make contact with the outside world in their earliest developmental stage. I have indeed been privileged to be present during the administration of LSD by Dr. Gary Fisher to a nine-year-old autistic child with a mental maturity of about six months. There was one point in the session when the child "looked around" as if for the first time. I don't ever recall anything which has shone as brightly as the wonder in his eyes except the sun. The first step, I felt, of the journey out.

We carried on a debate in the Bulletin of the Atomic Scientists a few years back in which we answered a doctor who suggested strong control of LSD lest an enemy place it in our water supply. Our answer to his article suggested that education rather than control was called for.

The public should be advised that if they started to experience certain effects, they could go to their doctor and ask for thorazine, a chemical which counteracts the effects of LSD. If, on the other hand, they had the day free, they could have the greatest experience of their lives.

I often think of the U.S. Army movie on LSD in which the soldiers who had been given LSD laughed in response to their sergeant giving sergeantlike commands. I guess the implication is that our soldiers would become ineffectual in battle were they given LSD. Not necessarily. You cannot generalize from an experimental situation to a battlefield. Although I prefer to remain quiet during psychedelic sessions, I have, in emergencies, performed acts requiring considerable coordination and skill—and performed these successfully and with ease.

Q.

Why do lsd users
like to turn other people on?

COHEN

In the early days of the nonmedical use of LSD it was not uncommon for the fellow who had a supply to share it with a pal without charge. Those altruistic days are fairly well gone, and the arrangement now is more businesslike. The charge is cost or cost plus the trip. One can even hire a sitter with experience in Greenwich Village who will whisper the Bardo Thödol into your ear.

The desire to introduce someone to the world of LSD is probably a matter of giving pleasure to another plus the good feeling of power in having the capacity to do so. More sinister motives may occasionally exist, but I think that ordinarily they play a secondary role. The LSD movement introduced people in positions of power to the drug as part of their politics. Marijuana is also shared, and so is heroin under certain circumstances. The penniless wino in Skid Row can always get a drink. This hospitality is more a form of insurance against the time when the donor himself may be down-and-out. It is unnecessary for the neighborhood pusher to convince anyone to take LSD. At present, it is a seller's market.

Then there is the zealot who preaches LSDism with a religious fervor. He is convinced that everyone ought to be "on." When Mr. Ferguson, Secretary of IFIF, visited me a few years ago, he made a memorable statement. I pointed out that I have been seeing a number of adverse reactions, including those in a few IFIF members. "So what if a few people do commit suicide?" he asked. "What about the greater good?"

ALPERT

LOVE.

A businessman in his early forties had his first psychedelic experience in August. Because his current identity was paying off so well, he found it difficult to give up his ego—if only for a moment. During the first part of the session, he struggled; later he "gave in," allowed himself to "float downstream."

About a month later he telephoned to say that his experience had enriched his life immeasurably and that what he now wanted more than anything else was to share the experience with his wife. Two weeks after his wife's session, she telephoned to ask if I would guide her sister, with whom she was very close, through a session. That session in turn led to one with the sister's husband.

It was the following March that the two women invited me to meet with their mother, a handsome healthy woman in her middle sixties. Her children were grown, her future financially secure, but she could not free herself from her need to be needed; she could not free herself to live in the here and now. The daughters in their tribal wisdom understood that they could not experience fulfillment in their lives unless they had done all that they could to help her have an opportunity to "take a fresh look."

The mother lay on the couch in her living room, a setting familiar and loved by her. I sat on the floor next to the couch and held her hand. The session, from the first strains of Debussy's La Mer to the joyful Hallelujah Chorus of the Messiah as the sun rose, was one of the most profoundly calm and beautiful experiences I can recall.

Q.
What are the implications
of frequent large doses of lsd?

COHEN

A husband and
wife take their LSD
on the street.

We do not know the answer to this important question. It is only during the past two years or so that human beings have exposed themselves to massive amounts of LSD and like items, the purity of which is also open to question. Oh, we know of the 100 tripper, even of the 500 tripper. But more recently someone else has come upon the scene. This is the gentleman with an unlimited supply of LSD, who sells part of his wares to make a living and consumes the rest in a new way. If he were to take the same dose of LSD daily, after four days the effect would drop off to almost nothing. This is the well-known onset of rapid tolerance to the drug. At one time long ago, I thought that this was a built-in safeguard against overindulgence. I was wrong. A simple if precarious way to stay high longer than the usual eight hours is now known. By doubling the daily dose and spacing the "caps" through the day, a chap can go on an LSD binge for a whole week. The gentleman mentioned above used to start on Monday with 250 mcg. On Tuesday he would take 500 mcg, on Wednesday 1,000 mcg, on Thursday 2,000 mcg and on Friday 4,000 mcg. These figures are not completely accurate since he did not remember exactly how much he "dropped." Whenever he felt that he was coming down, he popped a few more "caps" into his mouth along with a "bennie" or two. By midweek he was dizzy, confused, and staggering, in other words, drunk. Aside from the absence of the odor, one could hardly distinguish his behavior from a person in alcohol intoxication. Over the weekend he slept it off with the help of a few goofballs. He had long periods of amnesia for time and events. He was seen in Los Angeles, but did not remember how he got out of Sacramento. This is no isolated instance; three-day binges are becoming stylish. The doses also seem to escalate every few months.

Whether permanent brain damage occurs is always asked by those who have a personal interest in the psychedelics. The question is unanswerable at present, for the experimental work in humans was done with relatively small doses and with pure material. Now it is being consumed frequently, in enormous amounts, and the product is of dubious quality. We have no idea of the nature of the contaminants and what they can do to the brain cell. What the huge doses of LSD are capable of is quite unknown.

Since this experiment is one no researcher would do, perhaps a few people who have taken the equivalent of 250,000 mcg of LSD in their lifetime would donate their brains after death for clarification of the matter. Some fragmentary work done on rats by Adey,[9] and cats indicates changes in the brain-wave pattern and the ability to learn for weeks after a single high dose (25 mcg/kilo, or 1,750 mcg for a 70-kilo man). Hoffer[10] expressed the opinion that those weak psychedelics which required large amounts of indole-containing substances plus contaminants such as morning-glory seeds contain might result in eventual tissue damage. Hollister[11] mentions nerve-cell damage to mice following large amounts of LSD. The brain-damage question will have to wait a few more years for a definitive answer.

An infrequent convulsion has been described, but I have never seen one. They are not necessarily high-dosage effects. They may be more directly related to "mainlining" LSD.

93

The better known implications of frequent high-dose taking of the psychedelics are the possibilities of psychologic difficulties. Some of these people become vague and have trouble with reality-testing even when no overt psychosis occurs.

ALPERT

When enough courageous explorers take frequent large doses of LSD for long enough, in optimum settings, we shall find out the possibilities. I personally have participated in an experiment (described on page 95) in which I ingested an average of 2,000 micrograms a day for about three weeks. The experiment was very interesting but inconclusive. Among other things, the experiment certainly suggested that this is an interesting experimental strategy for exploring ESP.

Q.
What are the implications of remaining in the lsd state permanently?

COHEN

A permanent residence in the LSD state is not impossible to anticipate. Either the enzymes which degrade LSD might be blocked, or another LSD-like drug which does not produce tolerance may be found. Another good possibility is the implantation of a microsyringe into those brain areas responsible for the LSD effect. Electrical stimulation of these same areas is also feasible.

Whether it is desirable to exist in Lysergia perpetually is very dubious. If we are speaking of a permanent, high-dose LSD state, the condition would probably eventuate in insanity. Even if it did not, it does not seem attractive, but this may be a matter of personal taste. As I have already indicated, permanent nondrug self-transcendence is not the goal. Permanent chemical self-transcendence sounds like a dream within a dream from which one never wakes.

If the lesser LSD states are meant, a condition of tranquillity, the ability to see beauty around us, living in this world, but without its immediacy, then this state can be achieved either with or without LSD. It certainly does not require incessant LSD refills.

After three months of constant LSD use he committed himself to a hospital.

> My activities are no different from the activities of all men,
> But I myself am in unison with them.
> No acceptance, no rejection,
> Everywhere no resistance.
> Oh, the miracle, oh, the supernatural wonder of drawing water, of carrying firewood.
> —Hakaji

ALPERT

Which LSD state? If by "LSD state" we mean the state of total illumination, referred to in The Tibetan Book of the Dead as the First Bardo, it would be great, but it would necessitate what is called "dropping the body." On the other hand, if by "LSD

94

state" we mean living with full awareness at every level at every moment, then I'm all for it. In that state I would be at the highest human level at all times and thus of optimum benefit to my fellow man.

Whether or not this can be done with LSD is open to question. A group of fellow explorers joined to determine the length of time we could remain "high." In order to override our refractory periods, we ingested about 400 micrograms every four hours, or about 2,000 per day. My participation in the experiment lasted roughly three weeks and ended because we had not arranged in advance our contracts with the society around us to sustain the experiment longer. Had we carried on further, we might have been able to organize our environment and relations in such a way as to stay in a superaware state at all times, with or without chemicals. This of course would ultimately have had to involve the making and maintaining of mutually beneficial economic contracts with the society around us.

I do not now know, without further research and meditation, whether the possibility entertained in the experiment described above is real or illusory.

Q.

What are your assumptions regarding

a. Man's goal;

b. The goal of research;

c. The use of subjective experiential data;

d. A suitable method for increasing man's knowledge and wisdom?

COHEN

A. Man's goal is an understanding of the nature of life. Central to this search is to approach an understanding of what we call God. The trend of the past few centuries seems to be toward de-anthropomorphizing God. His manifestation is order—an order which the scientist, the artist, and others may glimpse and bring to the rest of us. The order extends from the microscopic to the macrocosmic. A repetitive structural pattern appears, demonstrable on many levels of organization. A basic relationship between the animate and the inanimate, and from the very small to the very large, seems to be emerging. If so, it is neither accidental nor incidental .

Searching for such absolutes and universals is a prime goal of man. Living according to them is another.

Man has acquired the unusual ability to be aware of his own awareness—a precious gift. He can look at himself, at the Earth, at the universe, and ask "Why?" and "How?" Why is much more important than How, but experience has taught us that when we know enough about How, Why can be answered. Methods help explain cause. It is important not to get lost in How.

This is a period of enormous change. The security of tradition and monolithic faith is gone for many, the turbulent interval of transition is upon us. Today's cottage is tomorrow's skyscraper. Today's faith is tomorrow's absurdity. It is no wonder that so many yearn for magic. It is quite understandable that we should want the reassurance of an answer *now*.

An answer may be too much to hope for even over the millennia. Can we endure not to know? Can we be content to be part of a perennial process? Can we be satisfied seeking answers toward *an* answer?

Because that is man's goal.

B. The goal of research lies within the goal of man. No researcher believes that he is investigating eternal truths. If the research has any validity it is, directly or indirectly, adding a thread to an endless tapestry. For a moment when a Newton or an Einstein appear, a bit of the tapestry is illuminated. That light may only be sufficient unto the day thereof, or it may glow far into the future.

C. Subjective experience is man's first and sustaining encounter with external and internal existence. It has an importance and sometimes a validity. Consensual validation of subjective experience is helpful in increasing the degree of proof, but it is far from proof itself. Let us not forget those who saw witches at Salem, ghosts in haunted houses, and levitations at seances.

Our subjective information tells us that the Earth stands still and that railroad tracks come together in the distance. For centuries man was a slave to his senses; he was left superstitious and fearful of his fantasies. We have in the last few centuries partially emerged from the fallacies of some of our sense data. We can now cross-validate our senses with more objective measurements. Both are necessary; one's senses can be trusted to a point, but they are far from infallible. Seeing is not always believable. Our percepts and our concepts are locked into a time- and culture-bound model which makes the search for absolutes particularly difficult. Complete trust in one's subjective experience has led to many human catastrophes—war, for example.

The subjective experiential data gained under the influence of LSD are particularly liable to distortions even though they seem utterly real. LSD experiences should be carefully validated; they may be a web of fantasy. The gullible and credulous can be overwhelmed by LSD. The productions of the LSD state require testing and study with the best sanity we possess.

D. Knowledge is one thing: the accumulation of the best possible information. This takes discipline, study, formal training. I have strong feelings that most of our current educational methods do not provide the discipline, the training or the lust to learn. The training of the intellect is emphasized in schools; even so, it does not exploit our intellectual potential. The training of the emotions is shockingly ignored; perhaps so many of us are aliens in an affluent land because we never learned from the very beginning of life to know love and belonging, identity and group identity. Too many are emotionally underprivileged; this book is concerned with one aspect of our emotional malnutrition. The training of the senses must also some day become a part of growing up. We should require no artifice to see, really see, to attend completely and to eliminate the distractions.

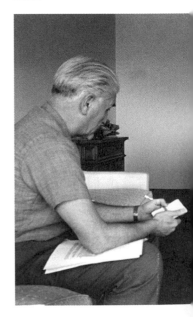

Drs. Cohen (left) and Alpert discussing the issues.

Wisdom is another: knowledge hammered into a tool for the sharpening of judgment, of insight, of understanding. Wisdom is the best aspect of sanity—sprinkled with a dash of unsanity. Instant chemical wisdom does not exist, neither does instant knowledge. They do not require the same hard, circuitous route for everyone, but they cannot be created in an unprepared mind. What may LSD do with respect to wisdom? It is a new level of experience and may make a contribution. Rarely, all too rarely, will it reshuffle the prepared mind into a pattern of sagacity.

ALPERT

A. Man's goal is to find his harmonious place in the universe.

B. The goal of research, or re-search, is to look everywhere one can for objective

answers to the basic questions of life:

> 1. <u>The Ultimate-Power Question</u>: What is the Ultimate Power or Basic Energy which moves the universe, creates life? What is the Cosmic Plan?
> 2. <u>The Life Question:</u> What is life, where did it start, where is it going?
> 3. <u>The Human-Destiny Question</u>: What is man, whence did he come, and where is he going?
> 4. <u>The Ego Question</u>: What am I? What is my place in the plan?
> [T. Leary, "The religious experience . . ." in <u>The Psychedelic Reader, op. cit.</u>, p. 196.]

C. Subjective experiences are eyewitness reports of what is, essentially, a private experience. They are our most important data. There is a dramatic current parallel between the psychedelic situation and flying saucers as to the credibility of eyewitness reports and the zeal with which the Establishment explains away each one. Somebody must be laughing somewhere.

D. We do not at present possess the wisdom to use our extraordinary fund of knowledge to realize man's goal. The only intelligent course is to keep our minds and hearts open to all possibilities and, in our ignorance, be very kind to one another.

Q.

How has lsd affected your life?

COHEN

I have taken LSD seven times over the past thirteen years. The first occasion was with a dose of 75 mcg. I had been looking for a reliable deliriant to use in a study in order to understand the array of mental alterations seen in a delirium. Knowing these, perhaps an improvement in its treatment would result. I had read Stoll's and Rinkel's reports that LSD produced illusions and hallucinations, so I tried it. The psychologist who was going to do the study with me was there. After a few hours I told him that this was no delirium, but that this was the drug we were going to study. My report of that event can be read elsewhere ([12'] p. 106).

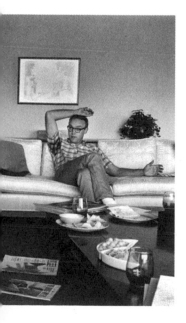

Since then I have taken 25 mcg, a just perceptible amount, 50 mcg, 100 mcg, 125 mcg and 150 mcg, the latter twice. The second time I took 150 mcg was in our sensory-deprivation chamber under conditions of complete darkness and almost complete silence with someone standing by outside. I have also had 400 mg of mescaline once. This amount is equivalent to about 100 mcg of LSD.

All have been interesting experiences and LSD has taught me a good deal about mental functioning. It has altered the course of my research efforts, although I have also worked with tranquilizers, antidepressants, and other psychochemicals during the last dozen years. It has involved me in too much writing and speaking.

Enhanced creativity? I doubt it; the capacity for hard work rather than creative inspiration is more descriptive of me. Empathy into the emotional and thought disturbances of others? I think so. Increased awareness of self? Intensified esthetic appreciation? A better construct of the nature of the universe? A better person? I cannot say—these are difficult things to know. Certainly, no drastic changes can be described, but then, subtle ones are important, too. May I sum up my impressions in a single sentence? The people I have met because of LSD have been at least as valuable as the LSD experiences themselves.

ALPERT

For three days now I have been trying to formulate an answer to this question (which I suggested in the first place). All I can say is, "It sure feels different inside." At last count, I had ingested psychedelic chemicals (other than marijuana) 328 times, and in the past five years it has become patently obvious to me that we (human beings) are on a journey. Hesse spoke of this journey metaphorically in his <u>Journey to the East</u>. The description which comes closest to my own feelings is in his Nobel-prize-winning novel <u>Magister Ludi (The Bead Game)</u>:

> I never thought of these awakenings as manifestations of a God or a demon or even of an absolute Truth. What gives them weight and credibility is not their contact with truth, their high origin, their divinity or anything in that nature, but their reality. They are monstrously real in their presence and inescapability, like some violent bodily pain or surprising natural phenomenon My life, as I saw it, was to be a transcendence, a progress from step to step, a series of realms to be traversed and left behind one after another, just as a piece of music perfects, completes, and leaves behind theme after theme, tempo after tempo, never tired, never sleeping, always aware and always perfect in the present. I had noticed that, coincidental with the experience of awakening, there actually were such steps and such realms, and that each time a life stage was coming to an end it was fraught with decay and a desire for death before leading to a new realm, and awakening to a new beginning.
>
> [Herman Hesse, <u>Magister Ludi</u>, New York: Holt, 1949, p. 3.]

In the course of this journey of awakening I have sought out and found of great value many guides and maps. Most recently I have looked to an Eastern mystic, Meher Baba, for further clues. I have been drawn to him through his writings,[1] which, more than any other books, reflect the universe as I understand it to be. He has suggested that while LSD and the other psychedelics may start one on the spiritual journey, or be of therapeutic value, their value as a way to the highest levels of consciousness is illusory.

It will be only, I suspect, after considerably more meditation that I shall know for myself in which direction lies the next "new beginning."

Q.
What is your estimate of the future of psychedelics?

COHEN

The future is best understood when looked at in the perspective of the past. The LSD story in retrospect had three phases. The first was the scientific phase which began about twenty years ago. For half that time LSD was believed to induce a "model psychosis." During the past decade, the potential of LSD was broadened well beyond its use as a model of madness. The scientific epoch is slowing phasing out.

The second phase, beginning in 1960, was the idyllic psychedelic interval. LSD was going to revolutionize man, the full potential of his mind would finally be unleashed and a great leap forward in our evolutionary process would take

1 <u>God Speaks, Listen Humanity, Discourses</u>, etc. obtained through Sufism Reoriented, 1290 Sutter Street, San Francisco.

place. *Homo faber* would finally evolve into *homo sapiens*. The zenith of that era probably occurred when a bemused poet, toward the end of his first LSD session, decided that if only Kennedy and Khrushchev would take LSD together, the world would live happily ever after. He called the Kremlin. The line was busy.

The third phase began about three years ago and is overshadowing phases one and two. It might be called "the cubehead revolution." It is a mindless, sensory-sensual winging from which the occasional casualty who fails the "acid test" is spun off.

WHAT COULD BE THE FUTURE? In a more perfect world we would use these compounds to investigate a great array of scientific and humanistic problems. From a scrutiny of the molecular events at the synapse (the connection points between nerve cells) to a survey of belief systems, from precision knowledge of their value in psychotherapy to an understanding of their role in religion, all these questions and others would be answered. Why is man capable of visionary experience? Can LSD reduce the anguish of dying for a few people? Can it serve as an ordeal or a psychological turning point when administered at the right moment? Are there doors of fantasy, of dreams, of perception, of attention, that can be unlocked with the drugs? Do they have a place in our culture beyond the therapeutic and scientific, and how can they be incorporated?

WHAT WILL BE THE FUTURE? It is difficult to be hopeful about the future of the psychedelics at this time. Research activities have been slowed. The only legitimate source of LSD and psilocybin in this country has recently ceased their manufacture. The people who earnestly seek spiritual answers with the psychedelics are forced to choose between criminal activities and abandoning their theochemical search. The time may come when the psychedelics will join goldfish-swallowing and panty raids into whatever limbo juvenile fads disappear. This will not happen in the foreseeable future. The next few years will see only greater consumption and greater abuse. Some shocking incidents will occur in connection with LSD, and it will become more and more discredited. It will be a long time before much of the necessary research with this drug can be resumed.

The hedonistic cults take over, the dance gets wilder, everything goes, the music is louder, the strobe lights flash faster, every stimulus maximizes.

The capsules which two years ago contained 250 mcg of LSD now have been fortified to 700 mcg. More. Stronger. Longer. Forever.

Let's not speak of the dangers. "Sure, some people fail the acid test, so what?" Let's just talk about where the young people go from here. Where do they go after all the stresses and strains, all the strivings, all the frustrations, all are gone? No more work, no more values, no more reason, no learning, no planning. No becoming, just being. Where do they go from here? NOWHERE.

A San Francisco bookstore devoted only to psychedelic material.

ALPERT

The psychedelics pose a new fact for mankind—neither good nor evil. They are here to stay. Trying to legislate them out of existence at this point is very much like closing the barn door long after the horse has escaped. There are enough unanswered questions about the psychedelics, and enough mature and serious human beings (young and old) curious to know the answers, to ultimately assure a FAIR hearing, instead of a FEAR hearing. It may turn out that psychedelics will prove the fad of the 60's, soon to be forgotten; many frequent users of LSD have already turned their attention to other means of expanding their awareness. Or, it may turn out that psychedelic use will penetrate deep into our culture and immeasurably enrich it. The data are not in by a long shot.

It seems to me, however, that there are a number of short-term predictions that one can make with considerable confidence in view of present trends:

1. The respectful introduction of Eastern thought, music, and art on a large scale into our culture, along with the increase in popularity of Eastern methods of expanding awareness such as yoga, diets, meditation, and karate.

2. The creation of some form of training centers and licensing for safe use of psychedelics similar to the model of our center in Zihuatanejo, Mexico, closed in 1963 by the Mexican government. (See page 82.)

3. The creation of legal centers for broad exploration in psychedelics as a response to public demand. (Perhaps we might call them Ecstasy Centers.)

4. An emergence of psychedelic tribal groups seeking to live and work collaboratively. Thus the formation of communities (Om Homes) perhaps even living in more natural structures such as Om Domes, with a return to small cottage industry (Om Industry).

5. The appearance of the products of expanded awareness and for expanding awareness nonchemically—everywhere. Groups such as Psychedelic Enterprises in New York and the Psychedelic Shop in San Francisco will proliferate. Light and sound machines, mandalas, manuals, records, paintings, films, dashboard ornaments—all serving as alarm clocks to wake people up to the Here and Now—will appear in more and more places.

6. The introduction of the Discotheque–Church–gathering-points for people of all generations to share nonchemical ecstatic moments together—to have a Human Be-in.

7. The stabilization of the Psychedelic Review now under the extraordinarily competent editorship of Dr. Ralph Metzner. In its third year, struggling, its scholarship and literary merit will assure it its rightful place in the literary and scientific marketplace.

8. Scheduled sailings of ships (perhaps old Liberty Ships) on consciousness-expanding cruises to NO(W)HERE.

In the near future, two interesting battles may surface:

1. The Army Chemical Corps has been researching LSD extensively on human beings. All of its results are secret at the present time. Again we are seeing what we just recently lived through with the freeing of that other energy—nuclear energy: the struggle as to whether the new energy is incorporated into a model for the benefit or destruction of mankind.

2. At the present time, Russian scientists are using psychedelics in research into the area of extrasensory perception. Perhaps this is the start of the inner-space race.

And finally, for the long-term predictions, we must look to the next generation—the first of the psychedelic generations. Over 51 percent of our

population is now under 25 years of age. Soon enough they shall be the priests of the Establishment and be faced with the responsible use of this unique key—I suspect they will dramatically alter existing social institutions, especially in education and international relations. It is an exciting challenge to anticipate the possibility of new types of social contracts based on collaboration, mature acceptance of sex, death, and world citizenship, and a respect for the Here and Now.

But perhaps what is even more obvious than all of the above is that we may certainly anticipate effects yet beyond our imagination.

COHEN

IN CONCLUSION

Dear Richard:

I have just finished reading your manuscript except for the conclusion, which I look forward to seeing in the galleys. Naturally, I was curious these past few weeks about what your piece would be like. I wondered whether I'd be buried in psychedelic brilliance (328 times not counting pot). Why you consumed more on a single trip than I in all my puny excursions. I also wondered whether we would collide or soar past each other without making contact. It seems we have done both. Despite head-on disagreements on many issues, we concur on a few, but occasional agreement should not alarm either of us. Only in a few questions do we seem to be playing in different ball parks.

Overall, I am satisfied that my point of view will prevail with the reader who approaches the book for information. Your point of view will prevail with those who want confirmation of a point of view that resembles yours.

When you start off by saying that words and pictures can only describe the trivial about the psychedelic experience, I disagree. I think that Larry Schiller's photos are remarkable and worthy of study. They tell a story that has never been told before. They will bring the LSD situation home as our words cannot.

Your preface goes on to say that you will be inconsistent. You are. That you will not take any position. You do. You call Tim Leary the most creative thinker in the psychedelic field. To hear this after reading his material, listening to him, and learning of his self-inflicted travails, I am less hopeful of the creative potential of LSD. I hoped you might turn out to be the party theoretician—the brains behind the High Priest.

I have a few minor and two major adverse reactions to your text. The minor ones first: I find that whenever you settle down to earth, many deviations from accuracy spring forth. When you are Out There—who can evaluate, but when you get down to facts you trip over them. I have no intention to nit-pick at your numerous errors, but they do reflect on a well-expanded consciousness.

You want proof, you say? Very well, here are a couple of lesser ones from the very first question. Remember where you said: "I am LSD. I look like this"? It should read: "I am not LSD. I do not look like this." Maybe the copy editor will catch those "N's" and put them back into the ring where they belong. As to your little mathematical equation, I'll be generous. I'll only call it silly. This sort of rushing into minor mistakes runs through your manuscript, but I have more weighty things to mention than your freedom from fact.

Some of your tidbits of misinformation are more serious, and I must bring you to heel. For example, you describe one drunk-driving accident in which six were killed. This, you allege, is more deaths than LSD ever produced. Why, the information in my files alone exceeds that number, and mine are far from

complete. While on the subject of dangers, how can you say at this late date that LSD can't hurt you? This is a great big fib. Or is prolonged insanity preferable to prolonged sanity in your judgment? Come sit in my office for a week and see what I see. Or wait a few months for the reports from the major hospitals to start flowing out. They are on the way.

I really must mention that curious foible about LSD being less dangerous than a four-year liberal-arts education. I had heard it before, and idly wondered where that fiction came from. Now I know. *It came from me!* When you palmed that one off on page 85, you gave a 1963 article by Keith Ditman and me as your source. I have been misquoted before, but your fabrication wins the Münchausen award. I don't like to trouble you with facts, but not one of the nine prolonged adverse reactions we reported in that paper were in college students. We made no guesses about the incidence of complications. Nowhere did we say that it was safer than a four-year liberal-arts education. But this is how rumors start, and I have no doubt I will hear the tale again somewhere. Rather than belabor this resounding fiction, I offer to send a copy of the article to you or anyone who does not have access to a medical library (self-addressed envelope, please).

I winced at the violence you did to that word "imprinting" on pages 58–59. This despite the fact that I knew you would, and had included my forebodings in the last sentence of my response to that same question. Imprinting is an early, transient state of rapid learned behavior never found to exist in man or in adult animals. Why louse up a precise word with metaphorical meanderings?

At the end of your response on page 80 you left the reader and me with the impression that aging, regressed schizophrenics can be led out (cured?) by a person in a psychedelic state because he can find the delusional system. If true, this is worth a Nobel Prize. Please call me collect and give me the reference to that astounding piece of work. If untrue, it is careless writing and cruel to the families of chronic schizophrenics, raising false hopes that their loved ones will be "led out." You do have a way of raising expectations on other matters, too, on scanty data.

An aside: This refers to your remark on page 100. Do you know which drug has been used most successfully in ESP experiments, including the Russian work? Booze.

Well Richard, these have been serious, but not crucial matters. They leave me slightly disappointed and slightly unimpressed with the quality of your expanded consciousness. I would like to deal with what I consider two major subjects, one important to our readers and one important to you.

First, you say practically nothing of today's LSD situation. Your stuff could properly have been written four years ago. Don't you know about the kids who are peddling themselves for LSD? Come around and I'll have you talk to a fourteen-year-old who buys LSD and Methedrine with her proceeds. Do you know about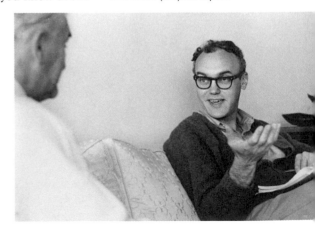

Drs. Cohen (left) and Alpert.

the "bum LSD" that is starting to show up? No LSD in them at $5.00 a cap. You know about the mainlining. Do you know about the Criminal Establishment who are in the LSD business today? About their planes and helicopters to transport it across the border? About million dollar caches filled with LSD? Does any of this remind you of the story of another drug? It starts with an "H." Paint it black. Do you have nothing to say about this? Or are you going to blame it on restrictive laws that have not yet gone into effect as of the date this is written?

My final point: I see that you are absolutely and completely sold on the goodness of the chemical psychedelic state without reservations. Oh yes, just one reservation (page 34). "Above all, *do nothing* about your visions. They exist only within you." Why

do nothing about them? After all, when you have succeeded in going out of your head, everything is true and for real isn't it? I am incredulous at your credulity. You say again and again, "This is It." If there is anything to be said without hesitation it is: "This is not It." This is only a piece of It. From what I have written you know I think it is a significant state, but one which we must look at, consider, try to understand, yes even measure. And there are hard-core mystics who agree with me.

I like your Meher Baba. His quote: "They [the psychedelics] may start one on a journey or be of therapeutic value, their value as a *way* to the highest levels of consciousness is illusory." With this I can agree, it is not a way of life, an interminable, repetitious career. Give him my greetings and respects.

And now, to conclude this summing up on a constructive note I would like to list five minimal restrictions for the use of the psychedelics. I believe that you are in agreement with these:

1. The sugar cubes should not be carelessly left around the house. Let's prevent children from accidentally finding them.

2. LSD should never be given to people without their knowledge and consent.

3. Adequate preparation and protection of the psychedelic taker is desirable. I recognize that "preparation and protection" means different things to each of us.

4. Extremely large doses and solitary taking of the drugs should be avoided by those who have never taken them.

5. It is not advisable to persuade a person to take LSD.

Perhaps one day we will find other areas of agreement.
Sincerely,
Sid

ALPERT

THE YIN AND YANG OF IT

"Nowhere" is Sidney's prediction of where the psychochemical (r)evolution is taking the "young people" who are exploring inner space. I prefer to read that word as NowHere, and fervently hope that he is right—that LSD is bringing man back "to his senses," to an appreciation of his everyday world as one of miracle and beauty and divine mystery.

The astute reader, I'm sure, will recognize the two camps in this book for what they are: the two poles of the illusory continuum of the static vs. the fluid (e.g., the Establishment priest vs. the visionary)—opponents in the great debate which has not only characterized the recorded history of man's progress, but in fact provides the dynamic tension which underlies the balance of Nature.

Do not be confused! The issue is not LSD. Rather it concerns your rights and responsibilities with regard to your consciousness, your soul, your internal freedom—issues not to be lost in the confusion and fear created by tabloid sociology. Your control and access to your own brain is at stake. It is not a matter to be delegated to the philosopher, theologian, or medicine man. It is our responsibility, yours and mine, and we must study[2] and reflect upon these matters in order that our collective wisdom will determine the course of human events—a course which just might lead us to the realization of who we really are.

Those who have eyes will see: those who have ears will hear!

2 An extensive reading list on consciousness-expansion is available.

The acid test

In 1967 the "Acid Test" was incorporated under the name of Intrepid Trips, Inc. They advertised, "Can you pass the Acid Test?" Their original financial backing came from the writer Ken Kesey, and the aim of the group is to simulate an experience similar to that produced by LSD. They charge admission, open the doors at 9 P.M. close at 6 A.M. and sometimes serve punch containing acid.

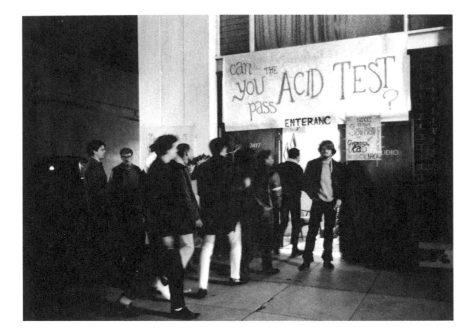

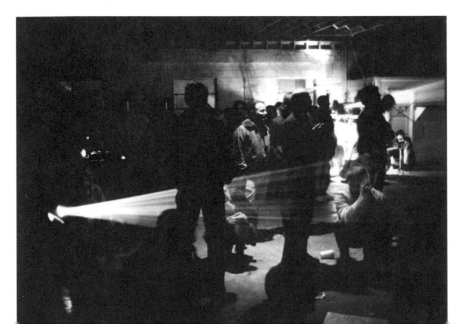

On a Saturday evening in the heart of Hollywood, California, light beams from several movie and slide projectors which run simultaneously.

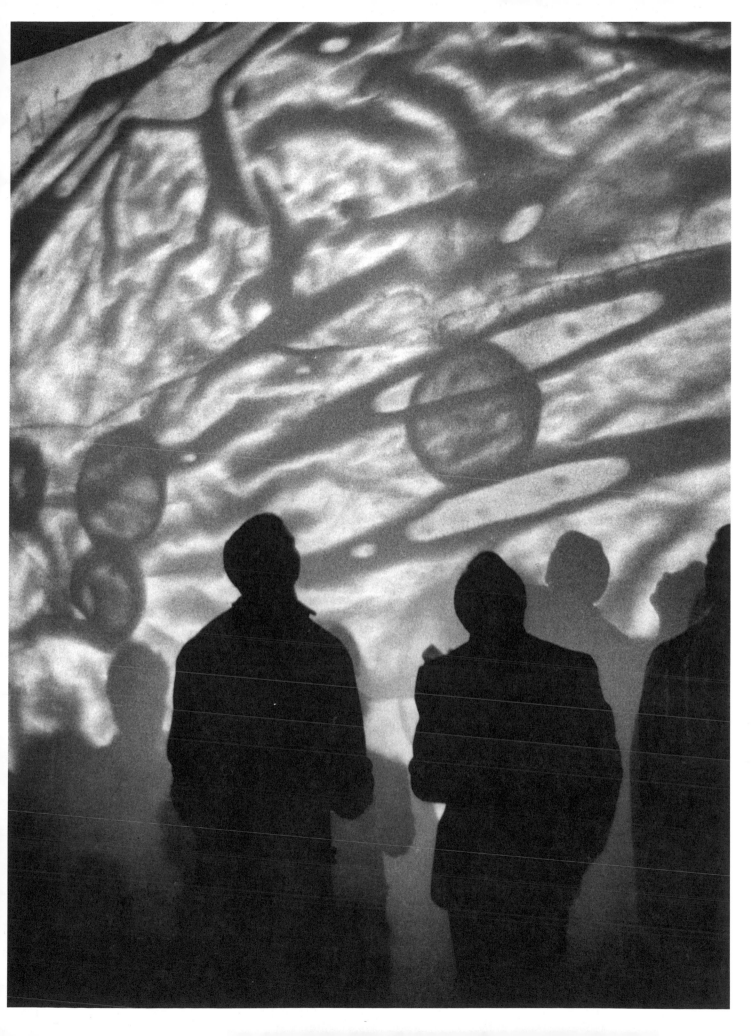

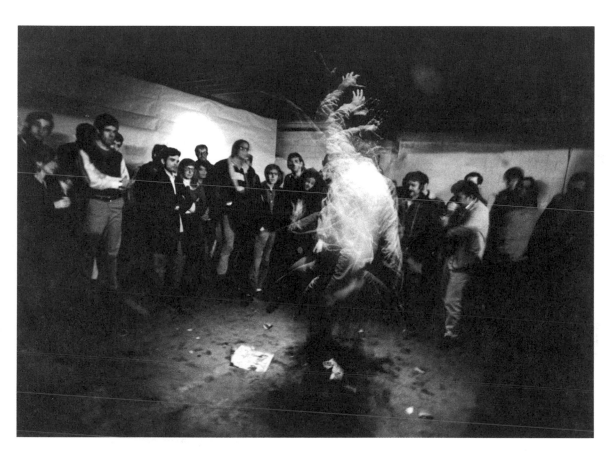

Several members of the "Acid Test" dance beneath a flashing stroboscope light which heightens the effect of the LSD.

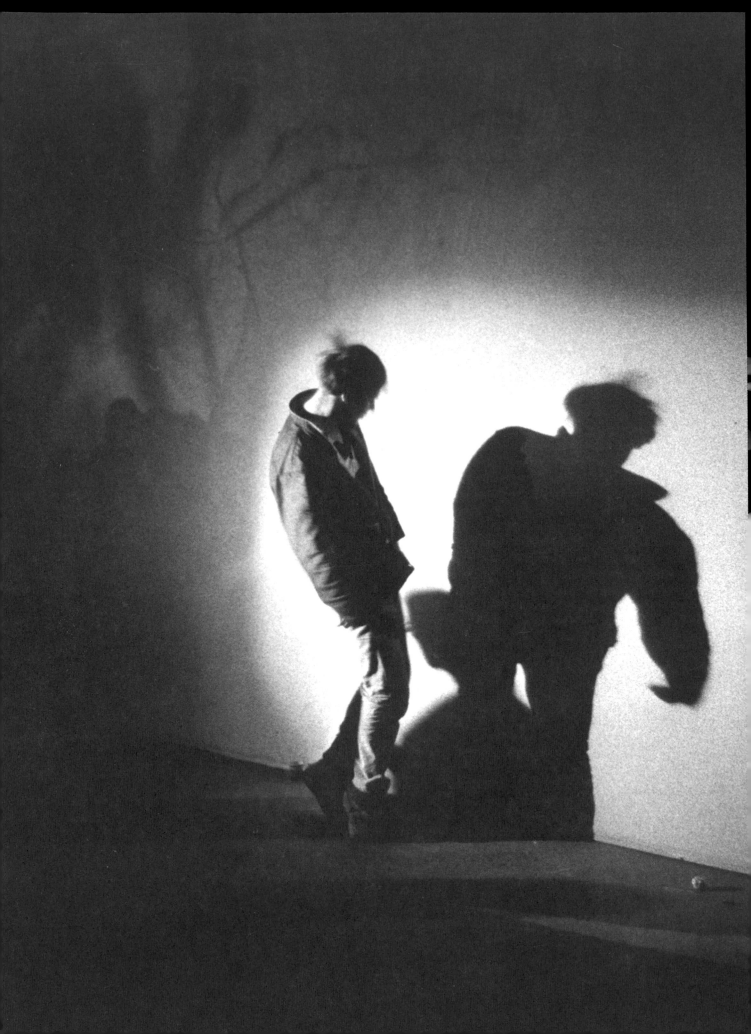

ALPERT

Eternity
The Universe
Dear Shiva,

Last evening I was going through some old papers and came upon these pictures. I thought they might be a pleasant reminder to you of the old days.

They are pretty yellowed with age but as well as I can determine they were taken at some religious ceremony. As I recall those church services I think mostly young people participated in that particular religious ceremony. They danced to a powerful rhythmic beat, were dazzled by magical lights all about, and all in all quite transcended themselves and entered into states of ecstasy.

I'm sorry that I can't make out the date on the back of the pictures. I can't even determine what millennium it was. But then I guess it doesn't really matter.

There were some disks with the pictures. I assume they must be the sermons that were preached during those ceremonies. Here is a whole list of them which I thought you'd get a kick out of:

lets go get stoned . . . tell me what you see . . . every little thing . . . universal soldier . . . candy man i'm into something good . . . i got a dream on . . . going out of my mind . . . nineteenth nervous breakdown . . . wasn't that a time . . . crying time . . . counting flowers on the wall . . . stoned . . . the sounds of silence . . . only a pawn in their game . . . youve got to hide your love away . . . help . . .

turn turn turn . . . with God on our side . . . the times they are a-changin . . . chimes of freedom . . . set you free this time . . . go where you wanna go . . . like a rolling stone . . . gone to the moon . . . to try for the sun . . . homeward bound . . .

earth angel . . . oh how happy i am . . . it's all over now baby blue . . . over and over . . . glad all over . . . its only love . . . why not stop and dig it while you can . . .

do you wanna dance . . . down at the scene . . . dancing in the street . . .

yes, indeed . . . hold my hand . . . the word is love . . . time is on our side . . . it's all right . . . what the world needs now . . . in the name of love . . . we follow the sun . . . i see the light.

I miss you.
Eternal Love,
Kali

COHEN

I am incapable of seeing the goodness of this sort of LSD usage. It is frivolous, orgiastic, without particular meaning, and potentially harmful to some. The whole thing is haphazard, escapist, and irresponsible. The line, "I called for louder music and stronger wine," comes to me as I look at these pictures. The "acid test" play on words is not quite that, for those who pass are no more fit than those who fail. It is this sort of thing that has repelled the public, stifled research, and brought the more serious explorations with LSD to a virtual halt. It is also bringing us prohibitive legislation. The next following step, inevitable after this freakish production, has already been taken—"mainlining" the punch. Where do we go from here?

A weekend party

After spending hours roaming the Sunset Strip, in Hollywood, and attending teen-age night clubs, where any one of them could have purchased a capsule of acid, these high-school and college students assembled to turn on. For some in the group, it was a weekend party. For others, it was their first trip and several were true "acidheads."

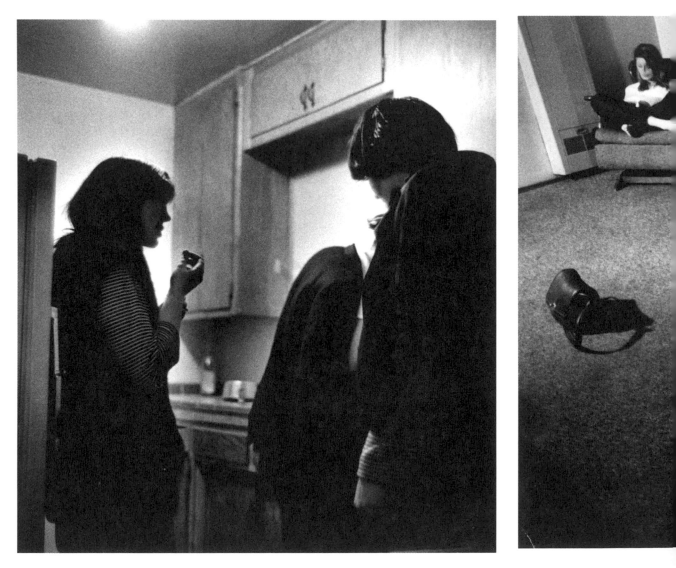

*Everyone dropped acid in the kitchen, and for
the first half hour they sat around listening to music.*

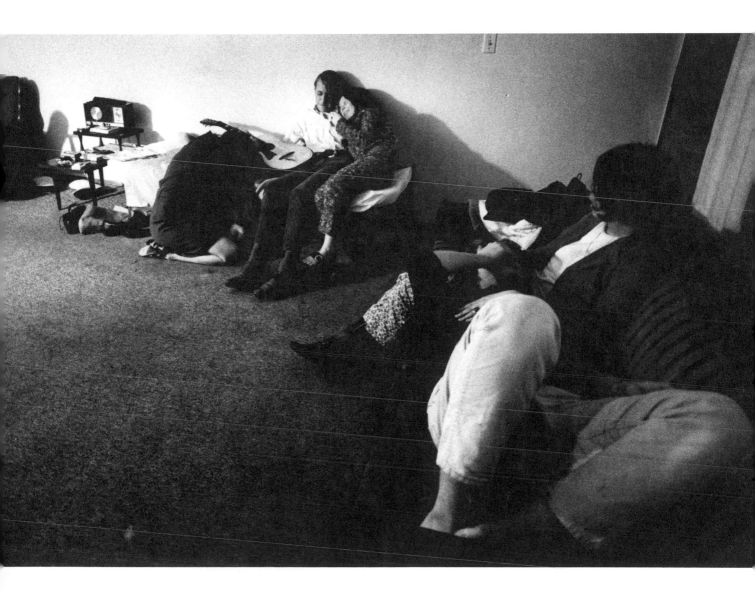

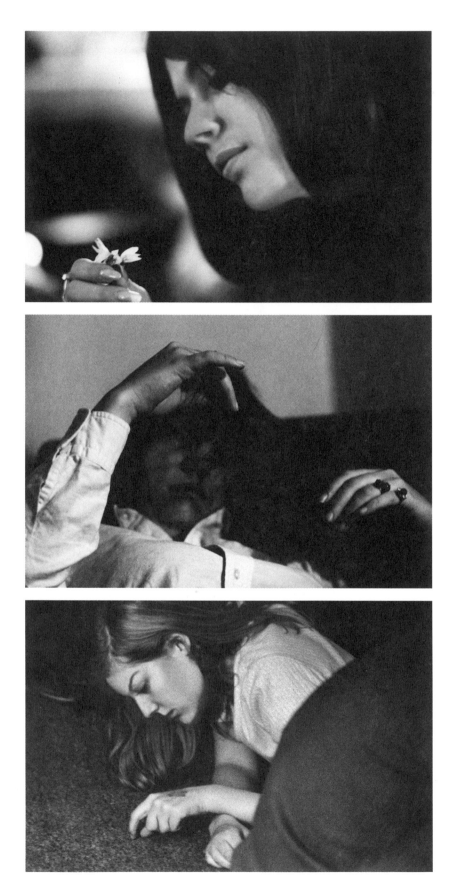

*It was
now the
second
hour.*

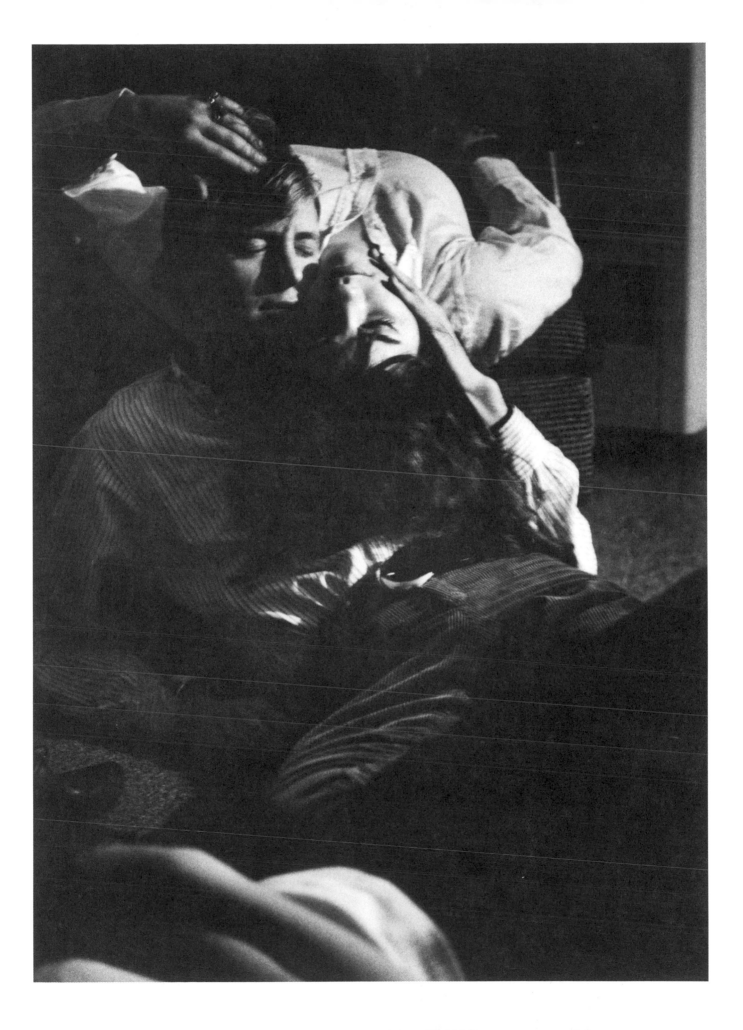

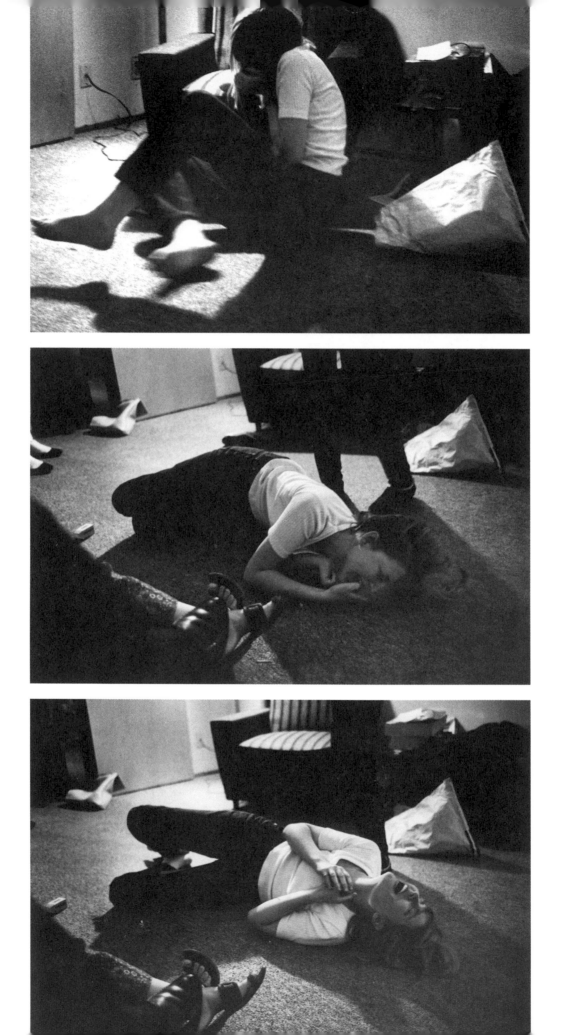

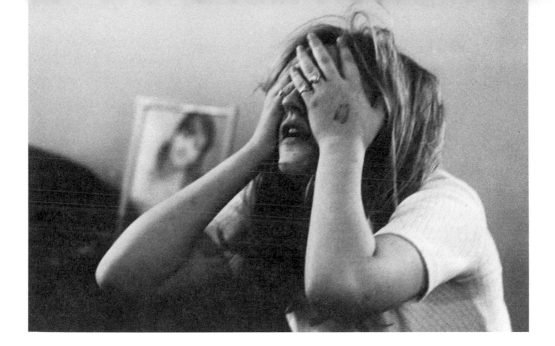

A month after her first trip she described her experiences.
"It was just terrifying to me.

I don't know why. I seemed to get angry all of a sudden.

Then I got scared . . .
but not afraid that I wouldn't come out of it,
and then I was afraid to be left alone.

I experienced the desire to die but not actual death . . .
very strongly the desire to rip my skin off
and pull my hair out and pull my face off."

"It was like a shower on the inside."

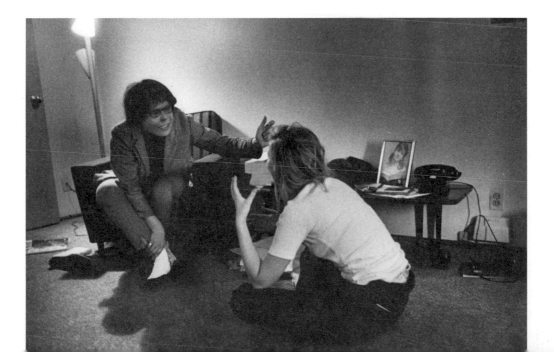

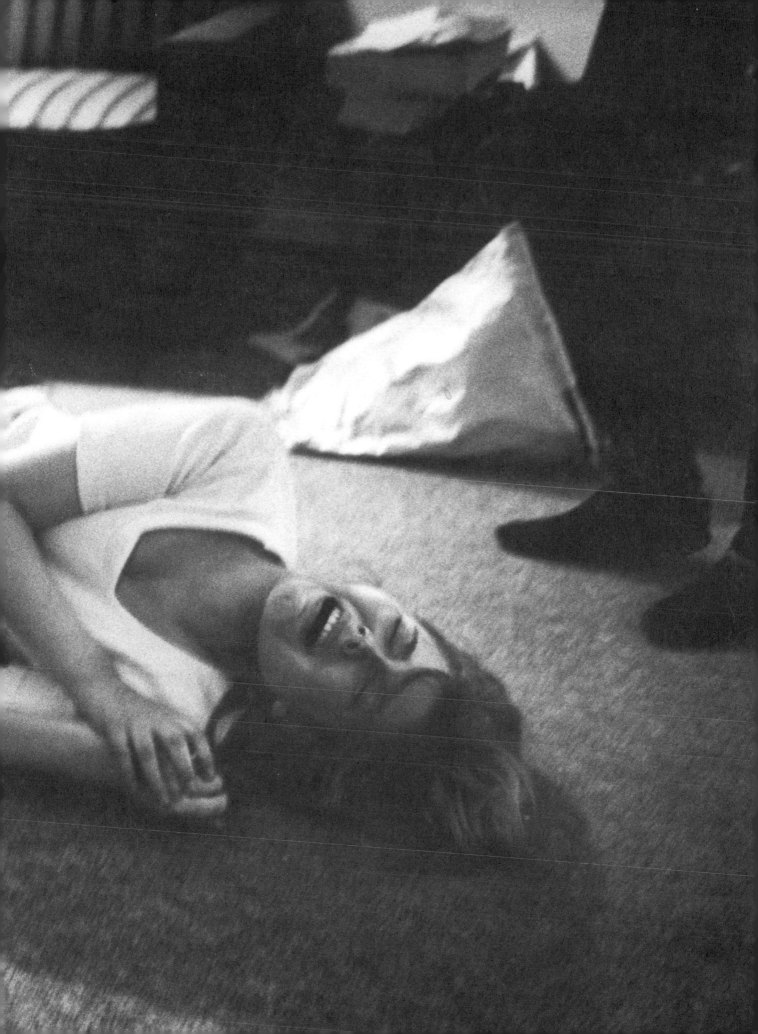

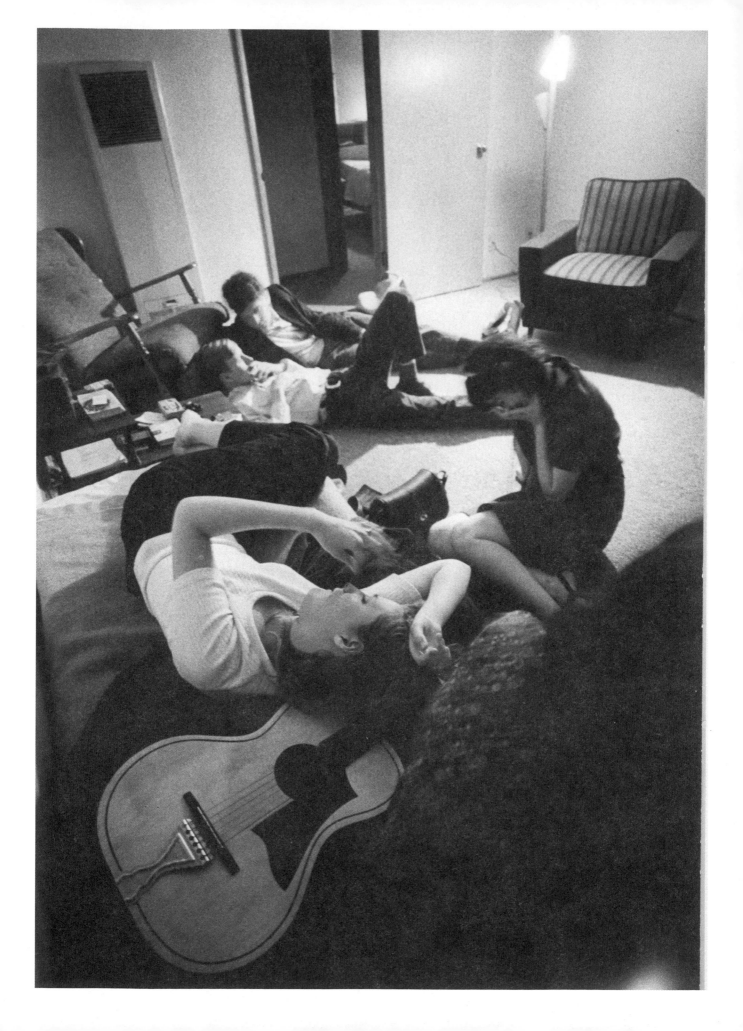

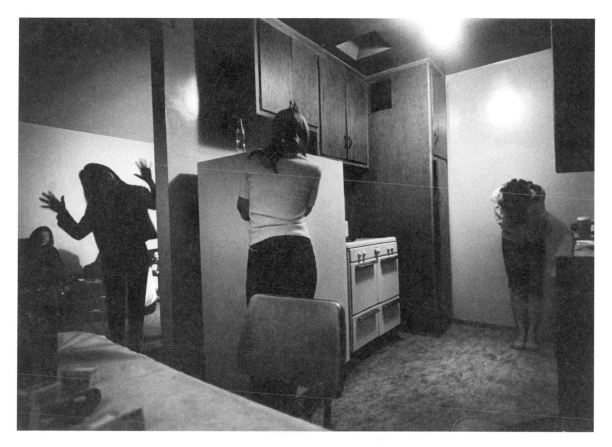

*After three hours the music was still playing
in the living room while another girl seemed to trip out.*

*He gazed at the lights
coming through the window
as a guide comforted a friend.*

ALPERT

Some of your youth seek pleasure as if it were all, and they are judged
 and rebuked.
I would not judge nor rebuke them. I would have them seek.
For they shall find pleasure, but not her alone;
Seven are her sisters, and the least of them is more beautiful than pleasure.
Have you not heard of the man who was digging in the earth for roots
 and found a treasure?

<div align="right">—Kahlil Gibran op. cit., pp. 79–80.</div>

Flower in the crannied wall
I pluck you out of the crannies,
I hold you here, root and all, in my hand,
Little flower—but if I could understand
What you are, root and all, and all in all,
I should know what God and man is.

<div align="right">—Tennyson, <u>Poetical Works</u>, Houghton Mifflin Co., 1898, p. 274.</div>

O Nobly born, listen well:
You are now in the magic theater of heroes and demons.
Mythical superhuman figures.
Demons, goddesses, celestial warriors, giants,
Angels, Bodhisattvas, dwarfs, crusaders,
Elves, devils, saints, and sorcerers,
Infernal spirits, goblins, knights, and emperors.
The Lotus Lord of Dance.
The Wise Old Man. The Divine Child.
The Trickster. The Shapeshifter.
The tamer of monsters.
The mother of gods, the witch.
The moon king. The wanderer.
The whole divine theatre of figures representing the highest reaches
 of human knowledge.
Do not be afraid of them.
They are within you.
Your own creative intellect is the master magician of them all.
Recognize the figures as aspects of yourself.
The whole fantastic comedy takes place within you.
Do not become attached to the figures.
Remember the teachings.
You may still attain liberation.

<div align="right">—T. Leary, R. Metzner, R. Alpert, <u>The Psychedelic Experience</u>,
University Books 1964, p. 137</div>

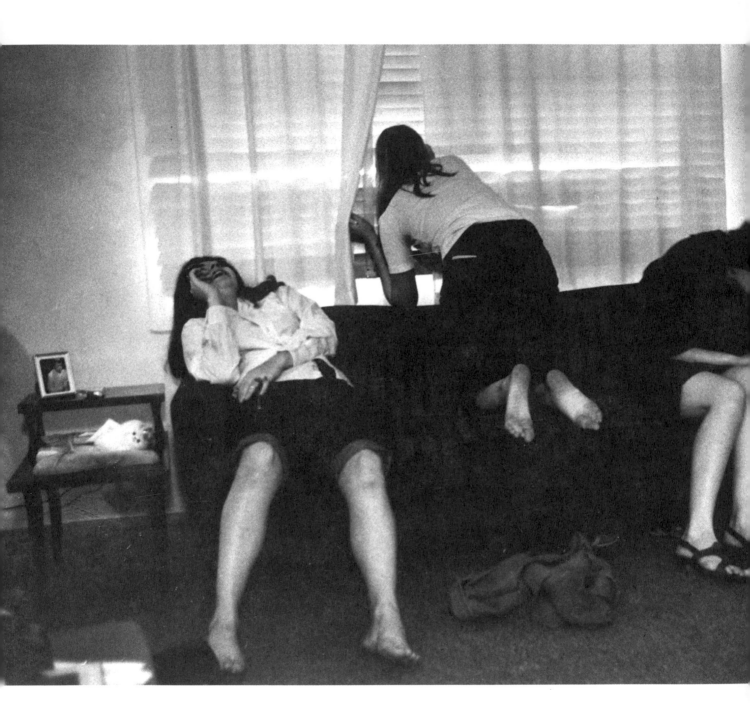

Turn your mirrors
Your onesided eyes
To the dark mountains
Where salamanders
The fearful phoenix
The firefly
Die and are born.
Come fleshless over the coals
That I have walked
And know my monsters
Fabulous, terrible, eternal
And once called by name,
Beloved.

—Excerpt from Progress of Pilgrims,
unpublished poem by Clara Hoover.

What happened yesterday?
Nothing!
What happens tomorrow?
Nothing!
It all happens Now, the Eternal Now
...from the beginningless beginning to the endless end.

—Meher Baba

COHEN

No hits, no runs, at least one error. Since these pictures were taken, one member of this party is now in a neuropsychiatric hospital trying to get back to his pre-acid state. For some it was a high "high," for others a low. Something was lost; what was gained?

Beauty

*On a warm Saturday afternoon, a computer programmer, his wife,
and their friends carried several flutes, a small harp, and some food
into the woods. There was nothing planned.*

It was an afternoon of exploration with the aid of LSD.

As one explored the river another played.

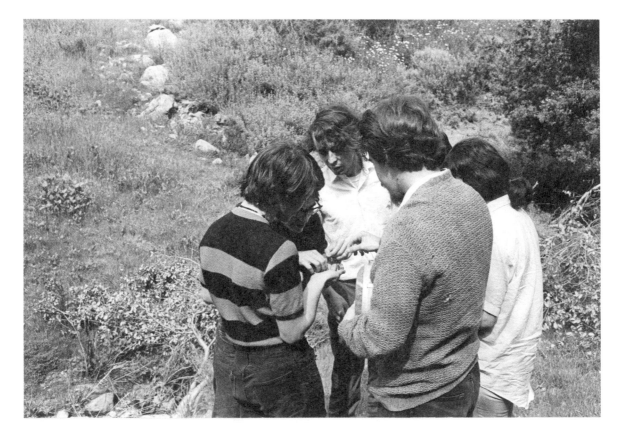

They each took a capsule with some apple cider.

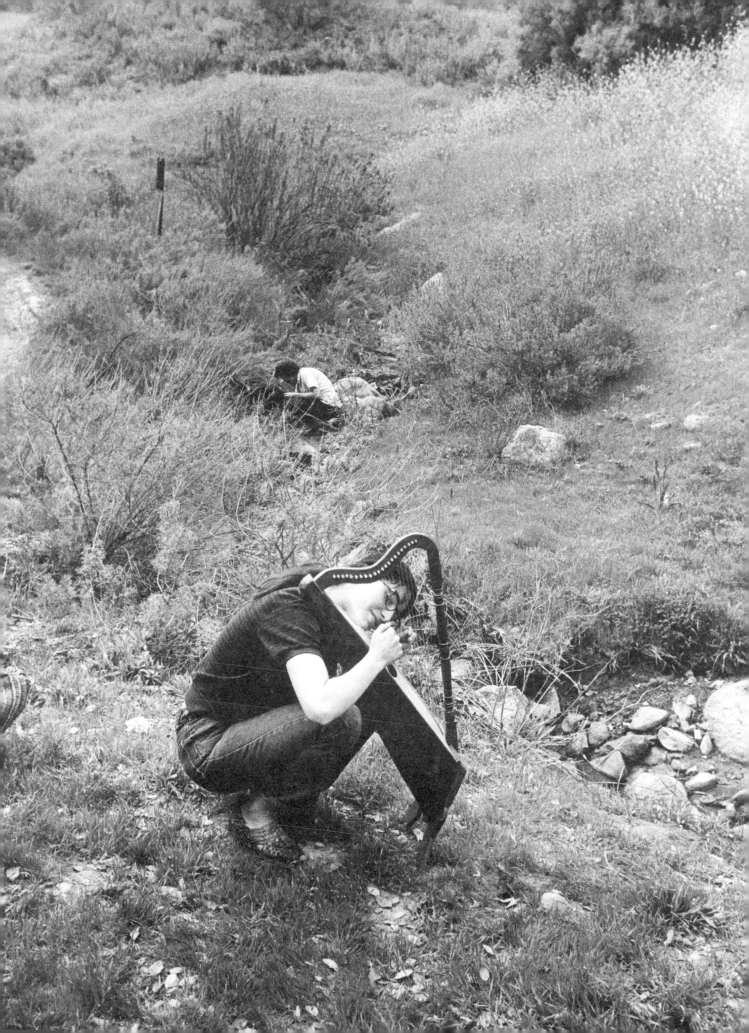

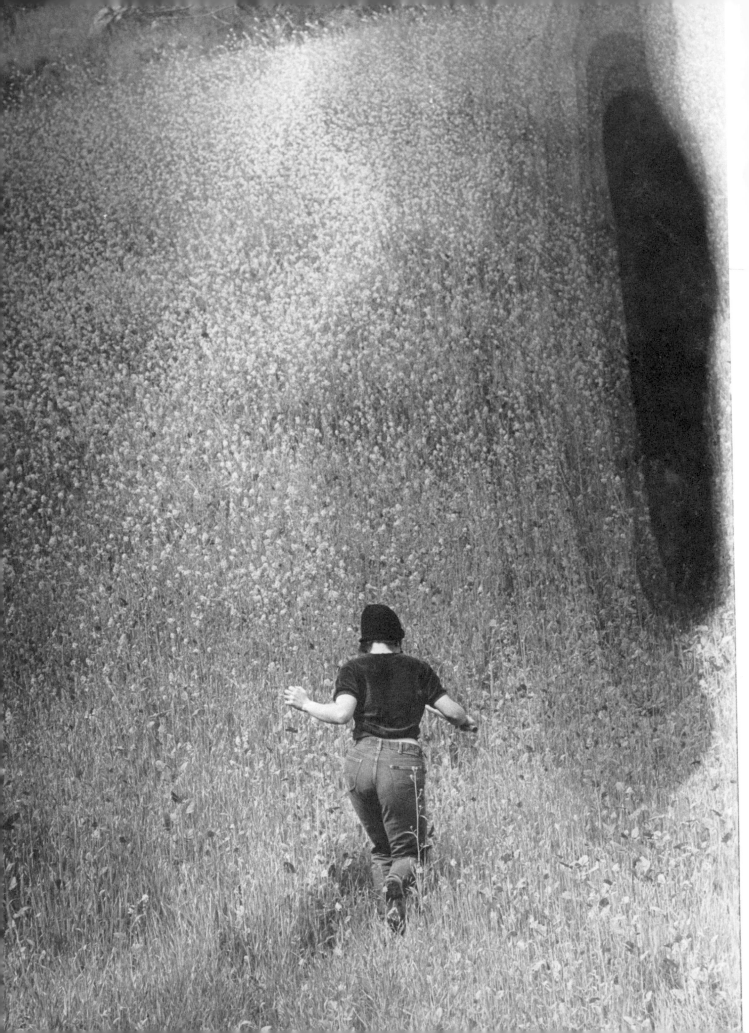

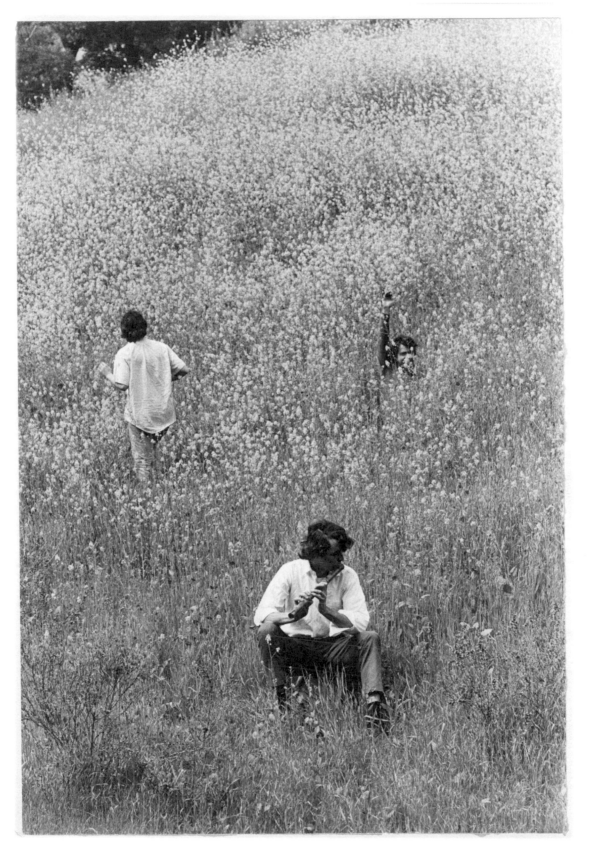

For half an hour, she played the flute.

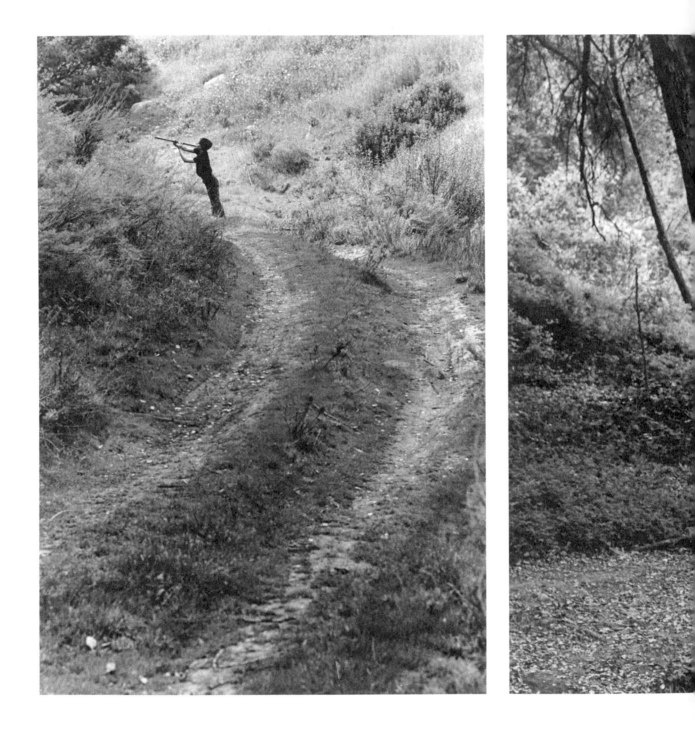

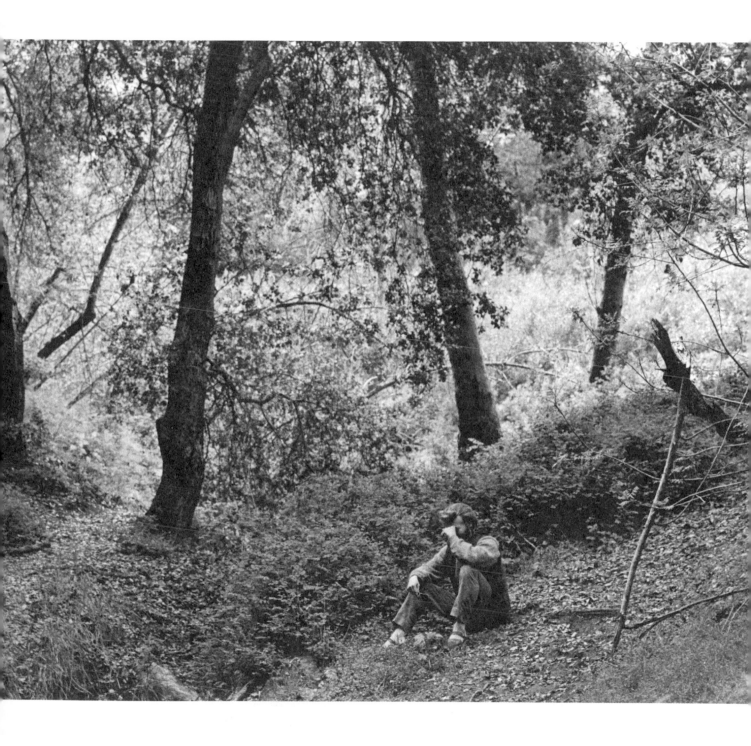

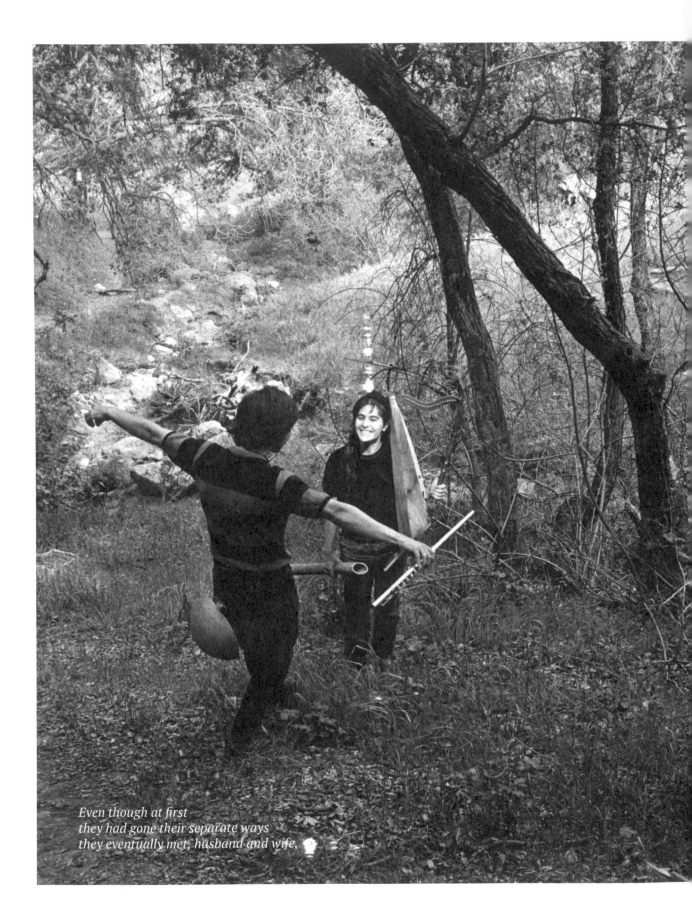

*Even though at first
they had gone their separate ways
they eventually met, husband and wife.*

COHEN

This is an idyllic Sabbath. One hopes that these people are capable of similar woodland adventures in their sober state, too. It would be discouraging to think that they need a chemical boost in order to enjoy. The pictures illustrate the separateness of many LSD group states. Instead of a communion, it is a withdrawal into oneself. The *religio* (binding together) is not visible here. However, self-centeredness rather than group centeredness is no less valuable. Again, one can only hope that something worthwhile and lasting came out of that holiday.

ALPERT

My most profound psychedelic experiences have been outside—in the ocean, or the forest, by a stream, under the stars, in a meadow at sunrise . . . in settings untarnished by man's mind.

> I wish to speak a word for Nature, for excellence, freedom and worthwhileness, as contrasted with a freedom and culture merely civil—to regard man as an inhabitant, or a part and parcel of Nature, rather than a member of society . . . When I would recreate myself, I seek the darkest woods, the thickest and most interminable and, to the citizen, most dismal swamp. I enter a swamp as a sacred place—a sanctum sanctorum. There is the strength, the marrow of nature. The wild-wood covers the virgin mold—and the same soil is good for men and for trees. A man's health requires as many acres of meadow to his prospect as his farm does loads of muck. Such a soil grew Homer and Confucius and the rest, and out of such a wilderness comes the Reformer eating locusts and wild honey.
>
> [Henry D. Thoreau, An essay: <u>Walking</u>, Harvard Classics, New York: P. F. Collier Publisher, 1910.]
>
> Nature never wears a mean appearance. Neither does the wisest man extort her secret and lose his curiosity by finding out all her perfection. Nature never became a toy to a wise spirit. The flowers, the animals, the mountains, reflected the wisdom of his best hour, much as they had delighted the simplicity of his childhood.
>
> [R. W. Emerson, <u>Nature, Addresses and Lectures</u>, Philadelphia: D. McKay Publisher, 1845, p. 12.]

During a recent flight from San Francisco to New York I was sitting next to a Vassar student. I showed her this set of pictures without in any way identifying myself or the project with psychedelic drugs. I asked her to describe into my battery tape recorder what she saw. Here is the transcription:

> Well, I see young people communing with nature and they look very happy . . . and they are playing musical instruments and somehow I get the feeling that they're playing and receiving something from nature, somehow it's kind of a two-way kind of action. They're very unusual; I've never seen any pictures like that It's an unusual composition And something like this figure over here with his hand up who looks like he's kind of going under a sea of dandelions, like he's calling out for help . . . no, like he's waving. The things that the people are doing are unusual. I never saw anybody sitting on the ground hunched over playing the harp. You get the feeling that the people are playing instruments but it's kind of hard to tell exactly . . . like I don't know what that pole is. They're very pleasing pictures. I don't know what else to say
>
> [A Vassar student on an airplane.]

131

COHEN

REFERENCES:

1. *Journal of Abnormal and Social Psychology.* 51:677, 1956.

2. Leary, T., Metzner, R., and Alpert, R. *The Psychedelic Experience.* New Hyde Park; University Books, 1964.

3. Cohen, S. "A classification of LSD complications." *Psychosomatics,* to be published, 1966.

4. Cohen, S. and Ditman, K. S. "Prolonged adverse reactions to lysergic acid diethylamide." *AMA Archives of General Psychiatry.* 8:475–480, 1963.

5. Frosch, W. A., Robbins, E. S. and Stern, M. "Untoward reactions to lysergic acid diethylamide resulting in hospitalization." *New England Journal of Medicine.* 273:1235–1239, 1965.

6. Smith, H. "Do drugs have religious import?" *Journal of Philosophy.* 61:517–530, 1964.

7. Cohen, S. "Lysergic Acid Diethylamide: Side effects and complications." *Journal of Nervous and Mental Diseases.* 130:30–40, 1960.

8. Huxley, Aldous. *Island,* New York: Harper and Row, 1962.

9. Adey, R. Personal communication.

10. Hoffer, A. Personal communication.

11. Hollister, L. E. Panel at Foothill College, Los Altos, Calif., April 1966.

12. Cohen, S. *The Beyond Within: The LSD Story,* New York: Atheneum, 1964.

ALPERT

The figure on page 14 was originally obtained from J. Expt. Med. Sc., Vol. V, No. 2, Sept. 1961, p. 35. "Chemical Pharmacology and Medical Aspects of Psychotomimetics."

Thanks to Sidney Cohen's suggestion, P. 92, the following is provided as an equally valid method of printing the formula.

From Current Studies on the Nature of Brain Function #2 published by the Schering Corp.v